Ordinary People
Extraordinary Lives

Ordinary People
Extraordinary Lives

A Pictorial History of Working People in New York City

DEBRA E. BERNHARDT AND RACHEL BERNSTEIN

A Project of the Robert F. Wagner Labor Archives, New York University

New York University Press • New York and London

NEW YORK UNIVERSITY PRESS
New York and London

Library of Congress Cataloging-in-Publication Data
Bernhardt, Debra E.
Ordinary people, extraordinary lives : a pictorial history of working
people in New York City / Debra E. Bernhardt and Rachel Bernstein.
p. cm.
"A Project of the Robert F. Wagner Labor Archives."
Includes bibliographical references and index.
ISBN 0-8147-9866-7 (alk. paper)
1. Working class—New York (State)—New York—Pictorial works.
2. New York (N.Y.)—Pictorial works. I. Bernstein, Rachel Amelia,
1953– II. Robert F. Wagner Labor Archives. III. Title.
HD8085.N53 B47 2000
305.5'62'097471—dc21 99-050742
 CIP

New York University Press books are printed on acid-free paper,
and their binding materials are chosen for strength and durability.

Manufactured in the United States of America
10 9 8 7 6 5 4 3 2 1

Please visit the *Ordinary People, Extraordinary Lives* companion
web site, featuring photos, audio clips, and links to online resources:
http://www.nyupress.nyu.edu/labor

This book has been printed by members of
Graphic Communications International Union Local 898-M
at the Vail-Ballou Press, Inc.,
Binghamton, New York.

We thank Catherine Keating Daly for the cover photograph of her father, Philip Keating, a bridgepainter, on the Queensboro Fifty-ninth Street Bridge. Keating, the son of Irish immigrants, fell to his death while painting another bridge seven years after a fellow worker snapped this shot in 1949. We dedicate this book to the memory of Keating, to the thousands of New Yorkers who suffered injury or death on the job, and to those extraordinary people who have dedicated their lives to improving conditions for working people and their families.

This book tells a few of the countless stories of the men and women who built New York City—those who worked in factories and sweatshops, on docks and bridges, in homes and offices. It provides a glimpse of the traditions they carried with them and, in the cauldron of New York life, transformed into a unique culture of solidarity.

Preserving the history of working people in New York is the mission of the Robert F. Wagner Labor Archives. The New York City Central Labor Council, representing 1.5 million New York union members, urges you to add to this story by contacting the Archives.

Brian McLaughlin, President
Ted H. Jacobsen, Secretary
Ida Ines Torres, Treasurer
New York City Central Labor Council

WHAT DOES LABOR WANT?

We want
 more school houses and less jails,
 more books and less arsenals,
 more learning and less vice,
 more constant work and less crime,
 more leisure and less greed,
 more justice and less revenge,
 in fact,
 more of the opportunities to cultivate our better natures.

From a speech by American Federation of Labor founder
Samuel Gompers, 1893

Contents

Acknowledgments xi

Introduction 1

1 New Yorkers at Work: Building the City 11

2 New Yorkers at Work: Faces of a Changing Economy 43

3 Creating a Culture of Solidarity: The Cradle of the Labor Movement 91

4 Rebuilding a Culture of Solidarity 145

5 New York Labor Enters the Twenty-first Century 181

Afterword by John J. Sweeney, President, AFL-CIO 191

A Timeline of New York City Labor History 193

Suggestions for Further Reading 207

Sources 209

Index 211

About the Authors 221

Acknowledgments

We could not have completed this project without the steadfast support and generous help of a great many people, and we are grateful for the excitement, meaning, and often pure joy they have given to our work lives as archivist/historians.

The project has its origins in the founding of the Robert F. Wagner Labor Archives in 1977 by labor attorney Stephen Vladeck, Tamiment Institute head Ben Josephson, Tamiment librarian Dorothy Swanson, New York University dean of libraries Carlton Rochell, and New York City Central Labor Council president Harry Van Arsdale. Mayor Robert Wagner agreed to lend the name of his father, the late senator and author of the 1935 Labor Relations Act, to an archives which would preserve and disseminate the history of labor in New York City. Housed in the Tamiment Library at NYU's Bobst Library, the Wagner Labor Archives built upon the rich collections assembled for the working people of New York by the Rand School for Social Science, founded in 1906. From its origins, the Tamiment Library embraced an ecumenical collecting policy, understanding that only with the free flow of information and ideas can social progress be made.

Since 1977 the Archives staff, guided among others by the late Harry Avrutin (Union Label Trades and New York City Central Labor Council secretary), Howard Molisani (International Ladies Garment Workers Union), labor educator Barbara Wertheimer (Cornell University), and Frederick O'Neal (Associated Actors and Artistes), has amassed some two hundred collections of the papers of individual activists and the archives of labor organizations. We conducted and collected scores of oral history interviews, a few of which we present here, for a documentary radio series entitled *New Yorkers at Work*. The radio series, broadcast on WNYC and other National Public Radio stations in 1981 for the centennial of the founding of the American Federation of Labor, is still available as a curriculum unit.

We thank our funders, without whom the Archives and this project could not have progressed: affiliates of the New York City Central Labor

Council, the Communications Workers of America, the New York State AFL-CIO, and Ed Cleary and now Denis Hughes for their assistance in obtaining state funding, the Documentary Heritage Program, the National Historical Publications and Records Commission, the National Endowment for the Humanities, the Littauer and Atran Foundations. We also thank Sonny Hall, chairman of the Wagner Labor Archives Board and John J. Sweeney, chair emeritus.

The book itself has been in the works for many years. To lay the basis for it, we first enlisted historians and archivists to assess the adequacy of documentation of twentieth-century social history in New York. This two-year search resulted in two conferences and a series of recommendations issued in *Ordinary People, Extraordinary Lives: An Assessment of Archival Sources Documenting Twentieth Century New York City Social History* (1994, edited by Debra Bernhardt and Rachel Bernstein). Labor economist Lois Gray and historians Betty Caroli, Joshua Freeman, Alice Kessler-Harris, Beatrix Hoffman, Philip Ross, and Daniel J. Walkowitz participated in the conferences and contributed to grant proposals. They went on to help with book proposals and to draft essays for a larger, more scholarly book that should one day be written. They have most generously read the current version and helped to improve it.

We could have spent another decade working on this book had newly elected New York City Central Labor Council president Brian McLaughlin not approached the Archives with the idea for an exhibit to celebrate labor's contributions for the 1998 centennial of the unification of the boroughs into New York City. With the help of a committee including Paul Cole (New York State AFL-CIO), Ted H. Jacobsen (NYC Central Labor Council), Willie James (Transport Workers Union Local 100), Annie B. Martin (CLC Trustee), Lenore Miller (Retail, Wholesale and Department Store Union), Edward J. Malloy (NYC Building and Construction Trades Council), Margaret Samuels (NYC Central Labor Council), and labor historian Dorothy Fennell (Cornell NYSSILR), a fraction of the material we had collected for the *Ordinary People* book took on a life as a traveling exhibit. That exhibit has been on view constantly since it opened in the rotunda of City Hall for Labor Day 1998. We thank the committee, Cindy Miller for her design, and all of the others who helped with the exhibit.

We thank people who read and commented on all or parts of this manuscript: Brian McLauglin, Ted H. Jacobsen, Edward J. Malloy, Henry Foner,

Dorothy Fennell, Martha Foley, Miriam Frank, Bob Wechsler, Adele Arico Hector, Jon Bloom, Connie Kopelov, Paul Mattingly, Arieh Leibowitz, and David Montgomery. Bob Greenberg and Bob Harris, retired history teachers, stepped in in the last stages to help out.

Our fellow workers at the Wagner Labor Archives, Gail Malmgreen, Peter Filardo, Andrew Lee, Janet Greene, Jane Latour, Mimi Diamond, Karl Dunkel, and Bruce Kayton, have given greatly of themselves both for the book and the repository upon which it depends. Wagner non-print curator Erika Gottfried put up with much more than anyone else on this project, as we rifled through the collections under her care and asked for information about them that was often unavailable. We also thank her predecessors Mary Alllison Farley and Katie Kirwan, who started the Tamiment-Wagner non-print collection. We also depended greatly upon our oral history transcriber, Patricia Logan, born without sight but never lacking in courage or vision.

Archivists from many other institutions have been most helpful, including Kenneth Cobb, Katie Kirwan, and Leonora Gidlund from the New York City Municipal Archives; Lynda DeLoach from the George Meany Memorial Archives; Richard Strassberg and Paulette Manos from the Kheel Center for Labor-Management Documentation at Cornell University; Mary Ison from the Library of Congress; Lucinda Manning from the United Federation of Teachers; Lizette Aguinaldo from the Joint Electrical Industrial Board Archives; Jim Huffman from the Schomburg Center for Research in Black Culture; and Nélida Pérez from the Centro de Estudios Puertorriqueños, Hunter College, City University of New York.

All of the unions and the people with private collections listed in the Sources have been exceedingly generous with their time, often sending us packs of photos, only to have us not use any of them, and nevertheless being willing to help the next time around.

Students and workers at the Archives have always contributed in ways beyond their job descriptions. Special thanks go to Maria Concepcion, Martha Vanderpot, Stacey Kinlock-Sewell, Derek Gray, Keri Myers, Jason Chappell, and a most amazing intern, Anna Strout.

We would also like to thank all those who gave of their time in being interviewed, those quoted here and the great many more who are not. From them we have learned the details and nuances, facts and interpretations of labor history in New York City.

We are grateful to our editors and designers at New York University Press, Niko Pfund, Elyse Strongin, Andrew Katz, David Updike, and Despina Papazoglou Gimbel, for their enthusiastic commitment to this project. We thank Elliot Linzer, our extraordinary indexer, for his work.

We thank the special people who sustained us: Doctors Lisa Anderson and Etta Frankel, sisters Andra Ladd and Sarah Bernstein, friends Susan Metz, Nancy Greenberg, Adele Hector, Miriam Frank, Gabby Sindorf, and Molly Welch, and our children—Alex, Sonia, Joel, and Tamara—husbands, and parents.

Introduction

Ordinary People, Extraordinary Lives fills a blind spot in historical depictions of New York City. It provides a different angle of vision, focusing on photographs and stories of working people. Samuel Gompers, founder of the American Federation of Labor, called New York "the cradle of the modern labor movement," and more than a century after the AF of L's founding, the city had the highest density of union members anywhere in the country. However, the story of New York workers and the organizations, culture, and politics they struggled to build has yet to be written. This book begins to outline that story and to bring to light some of the extraordinary images, events, and lives that document it.

The complexity and volatility of the city itself make writing its history a challenge. New York is a city of extremes—from the size and diversity of its population, to the dominance of its financial sector, to its leading role in many arts and sciences. For most of the twentieth century New York City was the nation's leading population center. Between 1880 and 1919, 17 million immigrants entered the United States through the port of New York, the vast majority of them from Europe. In 1900 fewer than 20 percent of family heads in the city had two American-born parents. The port of New York handled more than two-thirds of the nation's imported goods at the turn of the century. The city's 36,000 factories made it the nation's largest manufacturing center, producing 10 percent of all American goods and employing fully half of the city's labor force. Its banks held deposits almost as large as those of all other cities' banks combined. It was the center of the publishing industry and of the national vaudeville circuit.

Now, at the beginning of the twenty-first century, New York is a world capital in finance and entertainment and it remains the nation's largest city, but much else has changed. Fewer than one in ten New Yorkers works in manufacturing; most of the city's labor force works in service-producing rather than goods-producing industries. In 1996 six of the ten top employers were in finance and services. No longer a shipping center, the port sees more leisure boats than commercial vessels. The twentieth century began with immigrants and their children making up more than 80 percent of the city's

population. Restrictive immigration laws drove this percentage down through the middle decades, but by the end of the century immigrants and their children were again in the majority. However, these new immigrants are more likely to be from the Caribbean and the Far East than from Europe. Black New Yorkers, once primarily migrants from southern states, are now just as likely to be immigrants from other countries.

The challenge of capturing this vast city in any one narrative is further complicated by the question of representation. In a society where "work" is more often than not conceived as a four-letter word, depictions of the people who perform it are, not surprisingly, scarce. The New York cabbie, Marlon Brando in *On the Waterfront*, Jackie Gleason's *Honeymooners*, Carroll O'Connor's Queens curmudgeon Archie Bunker—what other images of New York workers have achieved prominence? If work is a dirty word, how much more so is "union." Except, perhaps, for the 1911 tragedy of the Triangle Shirtwaist Factory Fire, the dramatic events of the city's strong and vocal working-class movement have been almost erased from collective memory. Avoided even more assiduously is the concept of class.

As imprecise and ideologically laden as the term "working class" can be, working New Yorkers have shared experiences, values, and assumptions that have united and continue to unite them. We call this a *culture of solidarity*, one in which many working people went beyond the American dream of individualism, and saw hope in working toward the welfare of the many. We attempt to trace this culture of solidarity in its different forms over the course of the twentieth century, through moments when it had considerable strength (such as the pre–World War I era and the 1930s and 1940s), and in times of setback and division.

These movements helped to realize, for a time—though perhaps not quite in the form envisioned—a society that attempted to care for its ill and elderly, educate its young, create democracy in the workplace, and achieve other measures of social progress. Though only a small number of participants would have used the phrase, these were working-class movements that succeeded in large part because of shared goals and a sense of a common cause. Over the century much has been gained in the lives of working people, though the victories are not always permanent and many have needed to be won over and over again.

This history features the words and photographs of the people whose story this book represents. We selected resonant voices and images that

evoke the *chutzpah*, tenacity, creativity, and fire of working New Yorkers. The stories and photographs help to tell the story with an understanding of what it felt like. But the story itself could not have been written, and many of the details of this history would not be known, if we did not use these untraditional sources. Printed archival documents give a fragmentary picture of working-class life. When the documents are added to thousands of photographs and oral histories, a few of which we present here, we can begin to piece together this hidden history.

The photographs are from many sources, including the archives of newspapers and unions and the collections of individuals, as well as the more than half a million images in the collections of the Robert F. Wagner Labor Archives. Some, like the cover photograph of Philip Keating, are family treasures. Others were taken by unions to document their institutions, educate their members, or further their agendas.

Ed Roth, a member of the District 65 Camera Club, founded in 1938, explained the role that amateur photographers played in the union:

The original concept of the Camera Club was [for it to be] part of our [the union's] recreation program. They used the darkroom and they went on field trips like any little camera club has. That was their original intent. But since they were union men and they attended the strikes and the picket lines and whatever, they themselves began to take pictures. So the union would use the pictures in the paper. And that's an amateur's life's ambition, you know, to have your pictures printed in the newspaper. In fact, they called themselves the *Union Voice* photo staff. They did stories on different parts of the union, like the industries, the outings, whatever came. The only thing was the technical quality wasn't good because a lot of them didn't have really good cameras. These were low-paid workers. So the Union decided to go out and buy a Speedgraphic, which was the camera in use at the time by the press. And we learned how to use it. We had people from the Photo League that were, you know, sympathetic to our cause [who trained us]. They would orient them to what your function is as a photographer. You've got to remember who you are. Like if there's a crowd of people, you can't hesitate to push your way to the front and get the pictures. You're a witness for it could be hundreds or thousands of people, maybe millions.

The book's stories and photographs focus on people—working, playing, protesting—rather than on buildings and cityscapes. They show something of the actual experience of work in various occupations and often draw the reader in to another time and place. We sought to avoid familiar images,

though there are places where there seemed to be no other choice. The most familiar images can at first be the most visually engaging, for there is a collective visual memory, partly determined by what we are accustomed to seeing. Iconic images shape our collective memory of the past. They create a visual shorthand that can tell much about an era, but also creates an assumption of understanding instead of a challenge to observe the past more closely. We have searched for images that are as resonant as the oral histories that accompany them—both are chosen to make readers stop and think anew about specific historical moments.

Finding images that tell the story of work and workers was challenging; finding images that working people have used to portray themselves was even more so. Some of the photographs are powerful aesthetic creations, in which the art and skill of the photographer is apparent. But this is not a book dedicated to the art of photography, and the large majority of these photographs were taken by or for the people whose lives are portrayed. Some of them show their age, corners creased and tape marks visible. Others reveal their origins as illustrations from pamphlets or photos marked with grease pencil to be cropped for use in a union newspaper. Photographs of work and working people, as other genres of photography, follow stylistic conventions. These conventions shape the pictures that are taken and also help determine which pictures are saved. The union-sponsored Camera Club Ed Roth describes above was unusual; even more unusual is the fact that their work—in its entirety—has been preserved and identified.

Picket lines and demonstrations are featured in some of the most interesting shots, and some of those most likely to be saved. Such shots document memorable moments of action and historical agency. Unions also saved more formal, posed photos—legislation-signing ceremonies, annual dinners, conventions, and inaugurations that were photographed to document the dignity and political power of the union and its leadership. The photo of the 1947 banquet of the International Ladies' Garment Workers Union Local 25 is one of thousands in the Wagner Labor Archives alone, and is typical of those found on the walls of many union headquarters.

Photographs of people on the job are much rarer; everyday life is not a common subject for photojournalists of any sort. Companies or government investigators were more likely to take photographs of people working, but most of these images attempt to convey something very specific about the job. Investigators were often documenting the dangers at a job site or the

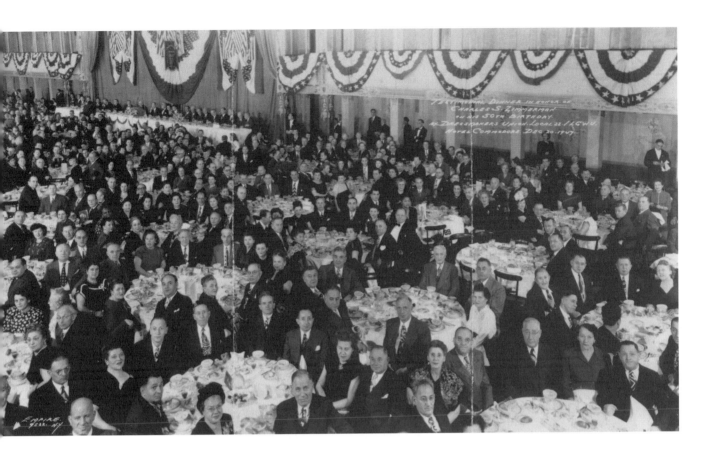

onerous nature of the job, while company shots tend to glorify a job and portray the worker as competent and content. The photo of tunnel workers in Chapter 1 (p. 27), for example, was taken by city engineers to document the job, while the that of workers in a Brooklyn wire cable factory (p. 50) by the New York State Factory Investigating Commission was evidence of hazardous working conditions. As Erika Gottfried, the curator of non-print collections at the Wagner Labor Archives, constantly points out, generic photographs do not exist. Each shot is taken at a particular point in time, from a particular angle, and for a specific purpose.

Nevertheless, sifting through thousands upon thousands of similar pictures revealed patterns of style and subject, and hints of a history of labor photojournalism that is still largely unwritten. Many of the photojournalists who dedicated their lives to chronicling working New Yorkers worked freelance for union papers, some for daily newspapers. All were influenced by the country's developing fascination with images, as the technology to capture action on film developed over the course of the twentieth century. The documentary tradition of social realism that reached its apogee in the 1930s overlapped with the workers' movements that are at the heart of this book.

Probably the best-known photographs of working New Yorkers are by Lewis Hine—spectacular, socially concerned photos of immigrants and

Testimonial dinner in honor of Charles S. Zimmerman on his 50th birthday, New York Dressmakers Union Local 22, ILGWU, Hotel Commodore, December 20, 1947. *(Robert F. Wagner Labor Archives, Jewish Labor Committee Collection)*

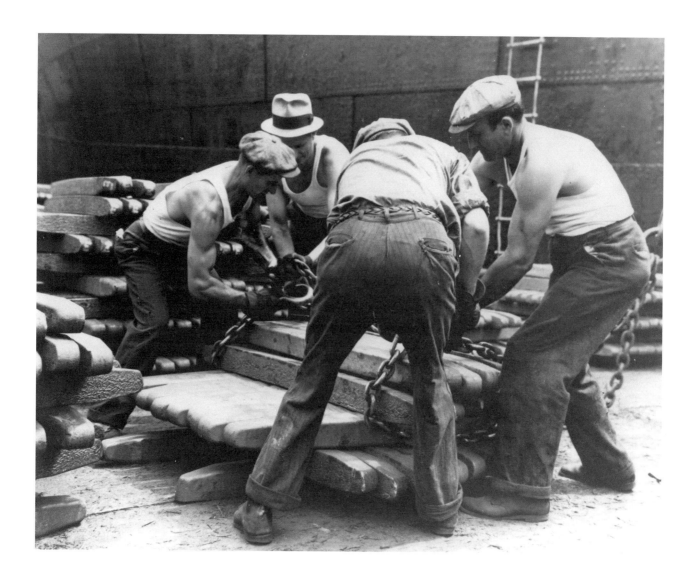

workers from the first three decades of the century. Extraordinary though they are, and familiar enough to be symbols of New York for many, we have sought out less frequently seen images. The photo of the longshoremen above has some of the qualities of Hine's work—the men are viewed with respect by a sympathetic camera eye; the focus is close-up, not for a traditional portrait of faces, but for a portrait of muscles in motion, at work. The shot was taken by Victor De Palma, a photographer who worked for the Black Star photo agency in the 1940s and 1950s.

The photo by Mildred Grossman on the facing page also represents the socially concerned documentary tradition. A public school teacher who had joined the Photo League about 1947, she became a professional freelance photographer after she was suspended from teaching for insubordination in refusing to answer questions about her past political affiliations. She worked for the Teachers Union and Hotel Workers Local 6.

About some of the other photographers we know a little. Hungarian-born John Albok owned a tailor shop at 1392 Madison Avenue, where he worked and lived for sixty years. At night, he transformed his shop into a darkroom. A man with a strong social and political conscience, Albok was indignant at seeing the same poverty in the United States that he had seen in Hungary after World War I. He created lasting images of the Depression in New York City, May Day and Labor Day parades, and neighborhood life.

Between 1947 and 1975, Sam Reiss, son of an immigrant tailor, documented the day-to-day life of the labor movement as a professional freelance photographer working primarily for the Retail, Wholesale and Department Store Workers, Amalgamated Clothing Workers, International Brotherhood of Electrical Workers, New York City Central Labor Council, and District 1199. So, too, did Dan Miller make a livelihood principally as

Teachers Union legislative director Rose Russell addressing City College students during a strike in April 1949. *(Robert F. Wagner Labor Archives, United Federation of Teachers/Mildred Grossman Collection)*

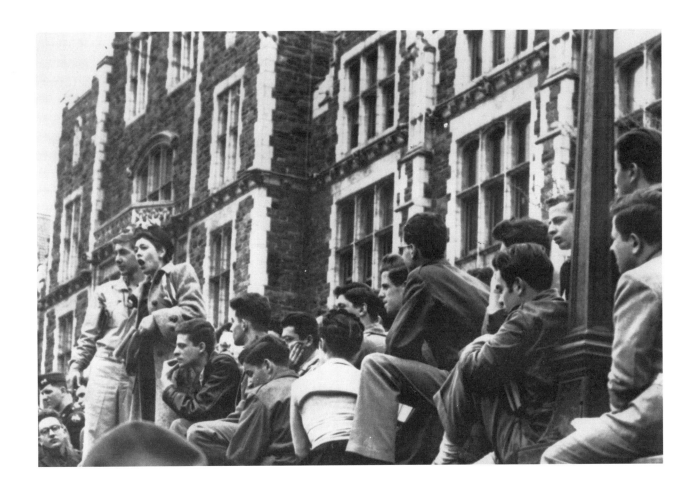

a labor photographer. The life's work of both men is preserved at the Wagner Labor Archives.

The anti–Vietnam War and occupational safety and health movements gave rise to another generation of labor photojournalists. We have included a sampling from the photo morgue of Liberation News Service, also preserved by the Archives, as well as photos by those currently working for the labor movement, including Dorothee Benz, George Cohen, Earl Dotter, Bob Gumpertz, Donna Ristorucci, and Gary Schoichet.

Despite our best efforts, we do not know the identity of most of the photographers in this volume. Please contact us with any information you may have about the photographers or their subjects.

Oral history testimony can also draw the reader into a world past, and like photography, it can evoke a feeling of immediacy and authentic personal experience. We have distilled these excerpts from hundreds of hours of life history interviews, checking each against more traditional historical sources and accounts in order to piece together the story. While the photographers' identities have more often than not been lost, in the case of the oral history we know who was speaking, and often to whom they were speaking. This knowledge adds considerably to our ability to place this testimony in a larger context. Interviewees' experiences are both unique and representative. We sought stories that fit in with the picture we built up from a wide range of sources, but that tell a tale with such individual power that we feel for a moment present in the time and place of the narrator's story.

Our story begins with two chapters on employment. They examine what jobs were available at different points during the century, and who was hired to do them. The two questions are closely linked because the city's economy grew as it did by relying heavily on the huge numbers of immigrant workers. We begin in the first chapter with the building of the city—not the monumental buildings and the miraculous infrastructure that permits New York's millions to live here, but the hands and minds and faces of those who did the work. In the second chapter we sketch the changing structure of employment in the city over the past century.

The next two chapters chronicle New York's complex working-class culture and history, intellectual and material origins, and some extraordinary individuals and moments. A heady mix of homegrown traditions of craft unionism and political and cultural traditions of new European immigrants sparked

the workers' movements of the early twentieth century that begin chapter 3. The organizing drives of the 1930s, and the labor unity imposed and strengthened by government policy during WWII led by mid century to a union culture that for many New Yorkers was all-encompassing. The culture of solidarity at its height is documented at the end of chapter 3 with photographs taken by members of the District 65 Camera Club Ed Roth describes above. This culture was undermined by consumerism, hostile legislation, and divisive issues and events including the Cold War, labor racketeering and the Vietnam War. Unions first responded by finding consensus on more limited issues and, in the wake of the 1960s, launching new initiatives to organize occupations, ethnic groups, and identity groups to rebuild a more inclusive labor movement. We conclude with a brief look at working New Yorkers entering the twenty-first century, captured by some of today's labor photographers.

New York City has been home to a wider range of immigrant groups, skilled workers, and workers' organizations than could ever be included in one volume. This is not an encyclopedia—nor even a very long book, as books about New York City go—and thus it can only highlight the stories of some working New Yorkers. However, the book is the tip of an iceberg—it comes out of nearly two decades of projects designed to recover and preserve the records and the voices of New York City labor.

We hope readers find themselves in this history, or hear a familiar story that suddenly links to the larger picture. We hope this book will be one of many to develop a history of the people who have often been the unacknowledged source of so much of the cultural and material wealth of this city. As we have chronicled workers' movements of the twentieth century, an ethic of solidarity and self-sacrifice comes alive. Among the people you will meet are a couple who could not in good conscience live in a "Jim Crow" Stuyvesant Town; a painter who swung from a chandelier to trumpet his views on unemployment insurance; and an African American veteran who, with his storytelling wile and the help of his union, broke the color bar in sales positions at Macy's. These extraordinary acts by ordinary people inspired us as we toiled over this project, and will, we hope, similarly inspire our readers.

Debra E. Bernhardt and Rachel Bernstein
Robert F. Wagner Labor Archives
NYU Bobst Library
70 Washington Square South
New York, New York 10012

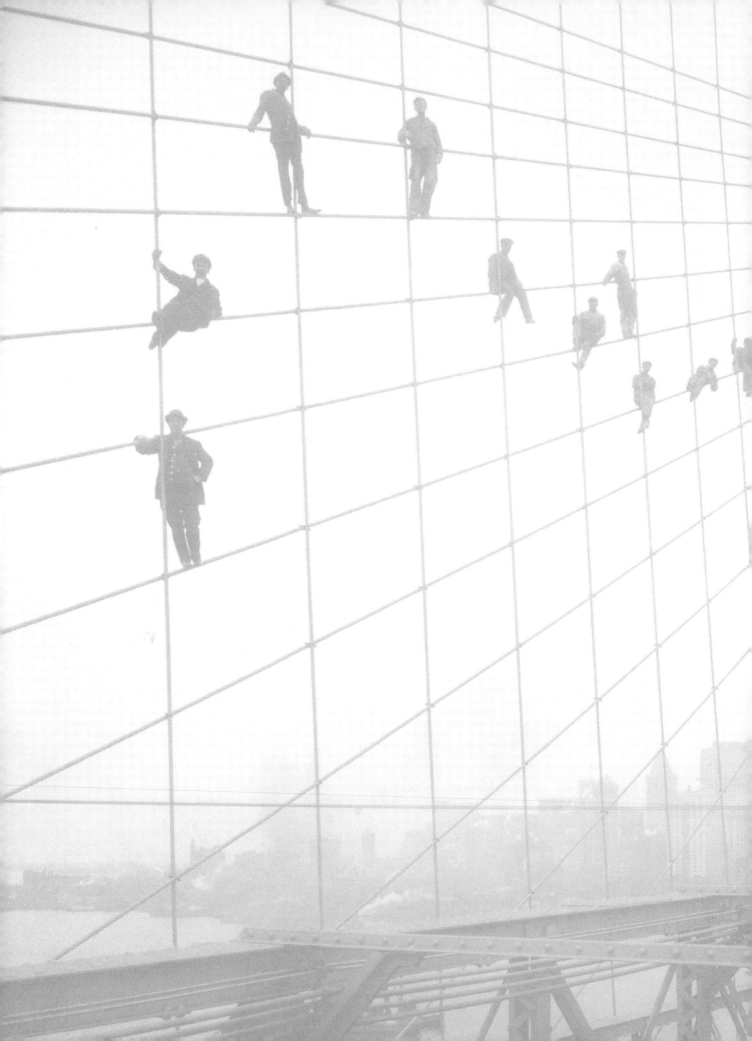

NEW YORKERS AT WORK

Building the City

1

The men and women who built New York City's subways, sewers, bridges, and buildings were a constantly changing mix. Early in the twentieth century carpenters, ironworkers, plumbers, bricklayers, electricians, and sandhogs were often Irish and German Americans. More recently, immigrants from Italy and Eastern Europe found work as unskilled laborers on enormous public works projects. From the most to the least skilled, from the best to the worst paid, from the most to the least organized, from all over the world, these workers built the city.

At the beginning of the twenty-first century New Yorkers still live and work with the infrastructure built a century or more ago. The subways and bridges and water systems were intended to outlast their builders by many generations, and they have.

In 1881 Samuel Gompers and representatives of trades unions of skilled workers founded a labor federation to protect the work traditions and living standards of craftsmen; in 1886 it became the American Federation of Labor. Committed to collective action, solidarity, brotherhood, mutual aid, and support, the AF of L gradually achieved a high standard of living for many skilled workers. But even this success did not spare craftsmen from the boom and bust of industry, seasonal unemployment, and the highest accident and mortality rate of any occupational sector.

Early emblem from the American Federation of Labor Building Trades Department. *(1906, George Meany Memorial Archives, Building and Construction Trades Department Collection)*

SAMUEL GOMPERS, 1850–1924

Shown near the end of life, receiving a Red Cross award. Gompers, of Dutch Jewish origins, came to New York at the age of thirteen and soon began working as a cigar maker. He organized his fellow workers in the 1860s, became president of the New York City Cigar Makers' local in 1875, and went on to build a national Cigar Makers' Union that by 1881 was the strongest union in the country. Gompers helped to found the American Federation of Labor and served as its president for nearly thirty-seven years, exerting a powerful influence as he emphasized solidarity, collective bargaining, and the autonomy of each trade.

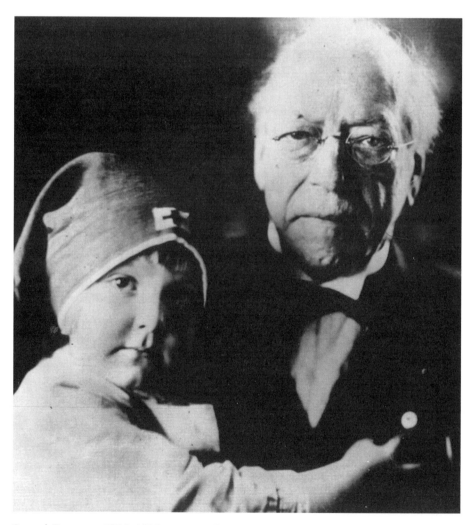

Samuel Gompers, 1850–1924. *(1924, Robert F. Wagner Labor Archives)*

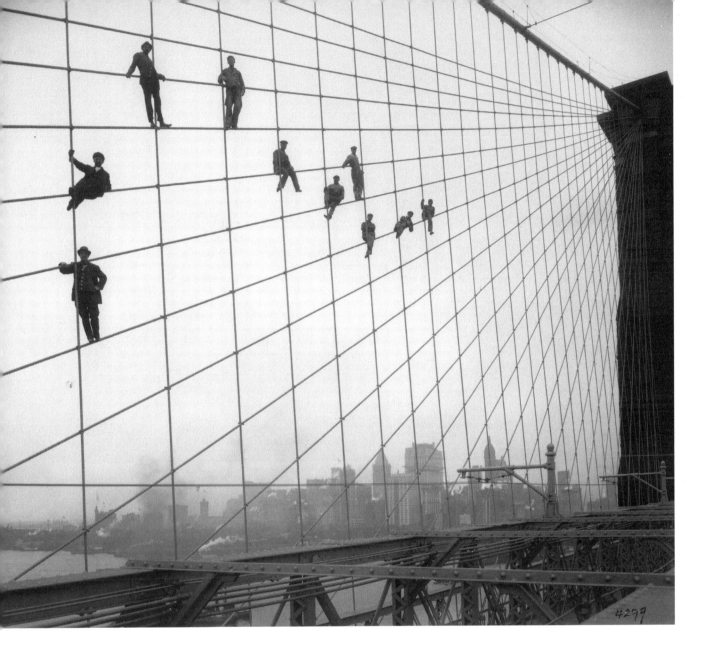

HARRY BELKIN (1912–), painter:

"We learned how to grain, decorate, stripe, gilt—probably forty or fifty operations involved in our trade, see? And when you know them all and when you are not afraid of your tools, and you make every move count, you have become a mechanic. An artisan. A craftsman."

Archivist Katie Kirwan discovered this extraordinary photograph among thousands of routine images taken to document the completion of municipal contracts. She believes it depicts a genial crew—one that was likely to have worked on the bridge year round for the City Department of Bridges, Plants and Structures—showing off for the photographer, a fellow municipal employee.

Brooklyn Bridge, showing painters on suspenders. *(1914, New York City Municipal Archives)*

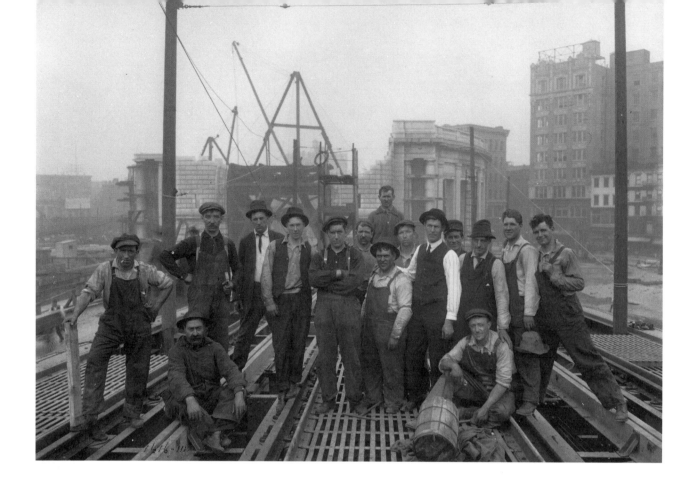

Above. Manhattan Bridge, "Emergency force employed on completing elevated structure for trolley operation." *(May 22, 1915, New York City Municipal Archives)*

Opposite. The cutting edge of the shield used by sandhogs constructing a subway tunnel under the East River. *(1918, Robert F. Wagner Labor Archives, Civil Service Technical Guild Collection)*

The building of the Brooklyn Bridge (1869–1883) employed hundreds of day laborers, men paid 12.5¢ per hour for a twelve-hour day, and scores of skilled tradesmen, principally masons and bricklayers, who received more than twice that amount. The overwhelming majority of these builders were of Irish descent, as were many of the workers who did maintenance work in subsequent decades.

Sandhogs, the miners who work on underground or underwater tunnels, trace their union back to the first strike against dangerous conditions during the building of Brooklyn Bridge, May 8, 1872.

The first city subway, opened October 27, 1904, ran from City Hall to 145th Street in less than half an hour and attracted over one hundred million riders during the first year of operation. The original five-cent fare held steady until 1948, during which time New York developed one of the most complete urban transportation networks in the world. Built with a combination of city funds and corporate investments, the subway system was designed by competing private companies that invested in and then operated the different lines. After reaping considerable profits, but failing to invest in maintenance, these private companies sold their lines to the city in 1940. The city alternately invested in the system and neglected it, all along confronting the expectations of working (and voting) New Yorkers that the five-cent fare was eternal.

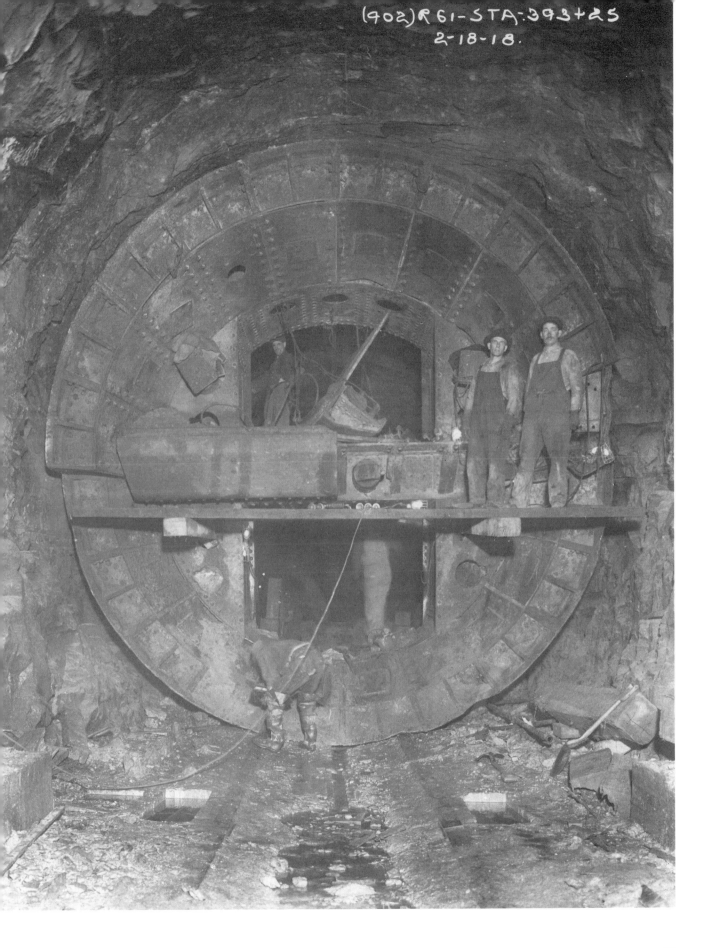

(402)R 61-STA-393+25
2-18-18.

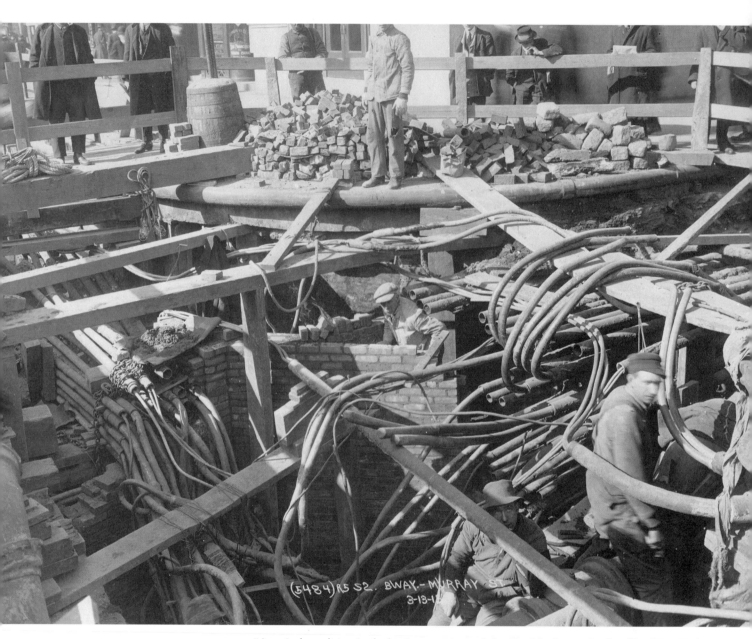

"A typical condition in the business sections of the City" is the caption on this glimpse of Manhattan underground. *(1918, Robert F. Wagner Labor Archives, Civil Service Technical Guild Collection)*

EDWARD J. CLEARY, SR. (1900–1986), electrician, International Brotherhood of Electrical Workers (IBEW) Local 3:

"I started out as a gas fitter for Standard Gaslight Company. People still used gas for light then. The average person in the poorer neighborhoods didn't really start to get electricity until about 1923 or 1924. In 1923 I took my examination to become a journeyman electrician. I worked two years with Comstock—he done the telephone work in New York. Them days we used to pull the lead-covered wire in from the manholes in the street into the building. After that I went to Movietone—that's installing sound work in the theaters when the talkies came in. I done the first theater in New York, a little theater down on Clinton Street. From there on, we done all of Loew's theaters, all the big show houses in New York. We done all them. I was on that for about two years.

"After that we went into the Empire State Building, about 1931. We got the job of running four-inch pipe from the 85th floor up the 102nd, and from there on, we worked on the antenna. For a publicity stunt, they used to come around with the blimps and drop the morning newspapers off in bundles onto the observation deck. They used to have daredevils down there to reach out and clip the thing. They couldn't reach one day so Bill, from the top, pulled out his pliers and clipped it. The funniest thing up there, I'm swinging a hammer one day and a bee bit me right on the top of the knuckle here. A bumblebee. They're blown over from Jersey with the winds. It was beautiful up there. Nothing like drilling holes in the sunshine. There was just the two of us who put up that antenna, Bill O'Keefe and myself. I put my son's name and the day he was born up there, carved in the top of the antenna."

EDWARD J. CLEARY, JR., electrician, former president of the city and state Building and Construction Trades Councils and retired president, New York State AFL-CIO:

"I come out of high school and was married, you know, right out of high school. And I needed a job. And I was going to be a lifeguard in Rockaway, which I had been for two previous years, in the summer, you know, the glorious life. My father told me, 'You just don't marry someone and then all of a sudden decide that you're going to go out and live in this fantasy world. You've got a responsibility now and you better take care of it.' And I said, 'Well, what do I do?' He says, 'You go down to the local. Go down and see Mr. D'Angelo'—he was the assistant business manager for manufacturing. He said, 'Maybe he can get you something.'"

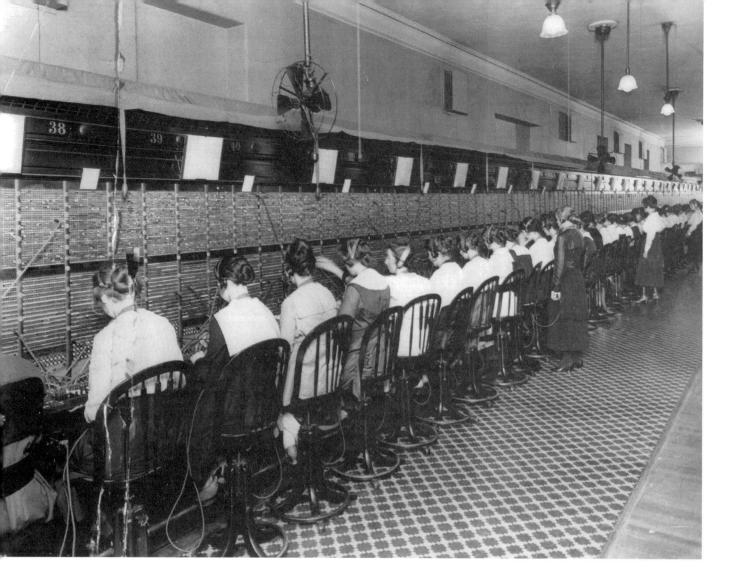

AT&T–Long Lines operators with supervisors standing nearby. *(1906, AT&T Archives)*

The wires and cables that made up the city's communications network were laid by men; direct customer contact work in the communications industry was deemed appropriate only for women. They were often subjected to demeaning treatment—for example, an operator could not "unplug" for a "run-out" or restroom break without permission. Only through unionization and collective bargaining after World War II were these women able to earn a wage that could support a household.

PATRICIA MECKLE, retired telephone operator and Communications Workers of America Local 1150 officer, speaking of the 1940s:
"The supervision was always there, but among the women who worked in the traffic department there developed an incredible camaraderie. An awful lot of families were raised by operators who had a lot of flexibility in which tour of duty they wanted to schedule—and co-workers were always willing to switch hours to help out. We organized the 'Sunshine Club' to respond to the hard times and joyous occasions."

In the early decades of the century very few black workers were hired for municipal jobs, except for those involving unskilled day labor. This photograph was labeled "RC Pipers," but the explanation for that is a mystery (as are the origins of many historical photos).

African American workers laying water or sewer pipe in Queens. *(1920, New York City Municipal Archives)*

At the beginning of the century indoor plumbing was a luxury. About half of New York families had access only to an outdoor privy, and water was often carried from an outdoor tap. By the 1920s these arrangements posed serious health hazards; indoor plumbing became a necessity. Water and sewer pipes were laid rapidly during this period, with wealthier and newly planned neighborhoods usually being connected first.

Laying pipes in Manhattan. (*Undated, New York City Municipal Archives*)

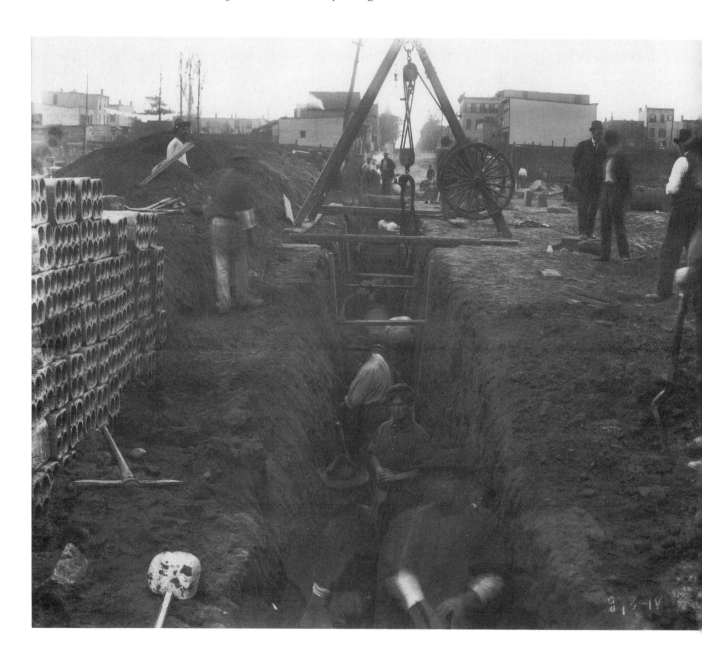

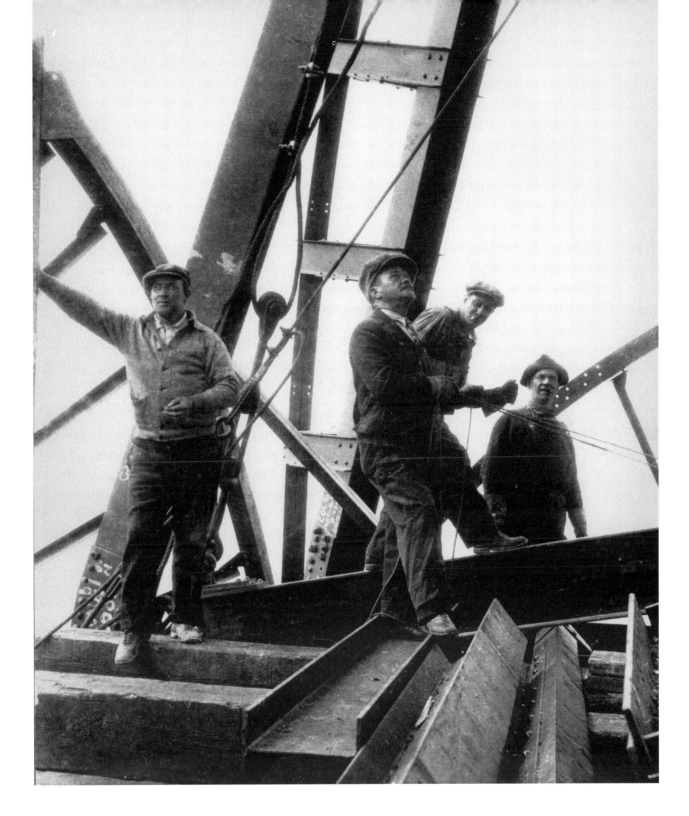

Born Constantinos Kapornaros in Mani, Greece, Charlie Rivers (1905–1993), looking for a job as an ironworker, changed his name to resemble those of the Mohawk Indians working on the high steel of New York City's skyscrapers and bridges. Rivers, an amateur photographer, worked steadily through the early days of the Depression on the Chrysler and Empire State buildings.

A derrick bellman (center, holding bell rope) working on the Chrysler Building. *(1929, Robert F. Wagner Labor Archives, Charles Rivers Collection)*

MARTIN KEANE, Iron Workers Union, Local 40:

"Every man's got his job. You got one pusher in each gang. And a foreman and a super. The superintendent is in charge of everybody. And then we had, he had three foremen. Each one of them had their own gang to handle that steel and set it. And to look out for each other. After they're around doing that for a few years, they do it just like clockwork, if they're good men. Most of them them days were the best kind of men. They come from all over the world there."

VICTOR A. CLEMENT, bricklayer, ninety-four at the time of his interview:

"I look at every building that I ever built if I'm anywheres in the neighborhood. I never had a failure."

• • •

Federal programs established to provide work during the Great Depression were pioneered in New York City, and two-thirds of the jobs were on construction and engineering projects. During the seven and a half years the Works Progress Administration existed, over a quarter of the city's residents were WPA workers or members of their families. This army of workers rehabilitated every playground and park in the city, and built hundreds more. Federal relief funds from many agencies went into the city's playgrounds, parks, and swimming pools, as well as into highways and the four bridges that together form the Triborough Bridge.

ANNE LEVINE FILARDO, wife and daughter of carpenters:

"Al [her husband] mentions how it felt to come home from a job after you've been laid off. The other side of the coin is how the family felt. I remember as a child the gloom that used to fall on the house when my father would come in with his tool box. I went through some of that [as an adult], too. Fortunately, once the children were a little bit older, I went to work. But during the period when I wasn't working, gloom really settled on the house because you never knew how soon you'd be working again.

"People who were outside the field would look to the hourly wage and in that sense it was an aristocracy of labor. But in terms of the annual earnings and the insecurity of never knowing what you were going to earn in any one year or in any one week or any one month, that affected not only the way you lived in terms of economics, but it affected your attitude and your psychology toward life. You were afraid to take a chance, afraid to plan, afraid to buy a house, afraid to buy a car."

The Price of a Pair of Hands: Prevailing Wages

In 1931 Congress, virtually without debate, enacted the Davis-Bacon Act, which required bidders on federal construction projects to maintain "prevailing wages"—the same wages paid to private sector workers on similar projects in the same area. Long a legislative goal of the AF of L, the law originated when Republican congressman Robert Bacon won approval for the construction of a new veterans' hospital in his upstate New York district. He was dismayed to find that, instead of providing employment for his jobless constituents, the contract was awarded to an Alabama contractor who undercut local bidders. The contractor brought with him thousands of workers from the South, who "were herded onto the job, housed in shacks, and paid a very low wage." The Davis-Bacon Act was passed to protect construction workers from the unregulated wage-cutting that occurred during the competitive bidding process.

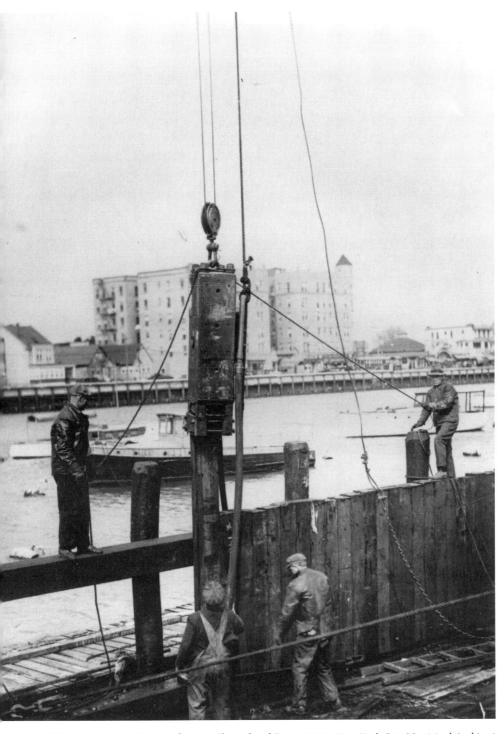

WPA workers on the waterfront at Sheepshead Bay. *(1930s, New York City Municipal Archives)*

Works Progress Administration strikers gather outside the Astor low-cost housing project at First Street and Avenue A. *(1935, Schomburg Center for Research in Black Culture, NYPL, Corbis/Bettmann)*

When the Roosevelt administration attempted to impose a wage of half the prevailing rate on building tradesmen employed on WPA projects, New York's George Meany, at that time president of the New York State Federation of Labor, put his foot down. On August 8, 1935, the New York City Central Trades and Labor Council voted to strike all WPA projects. Only a small percentage struck, but because these skilled workers supervised unskilled crews, the projects could not continue without them. By early September, the WPA conceded to the building trades unions' prevailing wage demands. Meany's New York victory set the pattern for union scale on WPA projects throughout the country, and the linking of public to private construction trades pay rates enabled significant numbers of skilled tradespeople to achieve middle-class life styles.

GEORGE MEANY, 1894–1980

Elected business agent of the New York City plumbers local, Meany went on to become a vice president of the New York State Federation of Labor, where he successfully pushed for federal work relief programs, unemployment insurance, and workers' compensation. Elected secretary-treasurer of the American Federation of Labor in 1939, he served as a labor delegate to federal war boards before he became AF of L president in 1952. Meany negotiated the merger of the AF of L and the Congress of Industrial Organizations (CIO) and became its first president in 1955. An outspoken and active anti-Communist, he led the federation until 1979, becoming the country's most important and visible trade unionist.

George Meany, speaking at the National Press Club, during the Watergate hearings, July 15, 1974

President of the National Press Club: "Mr. Meany, those White House plumbers, do they belong to your union or are they part of another outfit?"

Meany: "No, they don't belong to our union, and if they try to get in, I'd block them, I'll tell you that. Because there's one thing about a plumber—he makes a contribution to society. And you can't say that of these fellows. They were all lawyers. [Laughter] And I contend a plumber is much more important to humanity, to civilization than any lawyer. You take these great cities—London, New York, Washington—people all crowded together. Can you imagine those cities without plumbing? I can imagine them without lawyers, but not without plumbing." [Laughter and applause] *(George Meany Memorial Archives)*

George Meany, 1894–1980. *(Undated, Robert F. Wagner Labor Archives, Central Labor Council Collection)*

ED CROSS (1916–1987), son of an African American father and a Danish American mother, worked as a sandhog in the 1940s, and was later elected secretary-treasurer of Tunnel Workers Local 147:

"I got involved with the Brooklyn Battery Tunnel. It was a union job and naturally you joined the union. It wasn't the best union in the world. Back in those days we had segregated work gangs. The skilled jobs—shield driver, electrician, pipe-fitter, and maintenance men—all went to whites. And I didn't think much of that idea. I never shaped a white gang. I got in with an Irish gang, John Gilmore. He seemed a little different—all he wanted was a good workman. I got in with Gilmore's gang and I stayed. One day, we had a collapse in the heading. When the heading comes in, there's always a chance that the air is going to rush out. If enough air rushes out, the water comes in and the place floods. Jimmy and I were in the side pocket. We couldn't get out. You know, it's funny. We knew we were going to die, but nobody panicked, and really we were disgusted. Jimmy said the same as I felt: 'You get a job and make a few bucks, and then we're going to get killed.' The sand was coming down on top of us. But there were some planks 'cause apparently the weight finally broke it. I was shot out into the center of the shield and I got out. Jimmy was shot out, too, and he came back up the other side. Then I could hear the iron boss, Charlie Sweeney, 'Come back! Come back!' There was about forty-six men in the gang, and I guess you can't blame them, a lot of them were relatively new. When the heading started to collapse they ran for the lock. We both went back in the heading. There were only six men there. I guess I'll never forget those six men. We secured the heading. The water never came in. But I guess that's probably the start of my Irish support."

DAVID JACOBSON, civil engineer, Civil Service Technical Guild, Local 375, AFSCME:

"In those days, civil service employees [designed] most of the structures, like the water system, the water supply system, the transit system, the bridges, tunnels, and all that. All that, under the guidance of the civil service engineers, that was all done without any scandal about it. Most of the large construction projects were handled by civil service. Then later on, quite a bit of that was farmed out; it became very profitable for consultants to handle these projects."

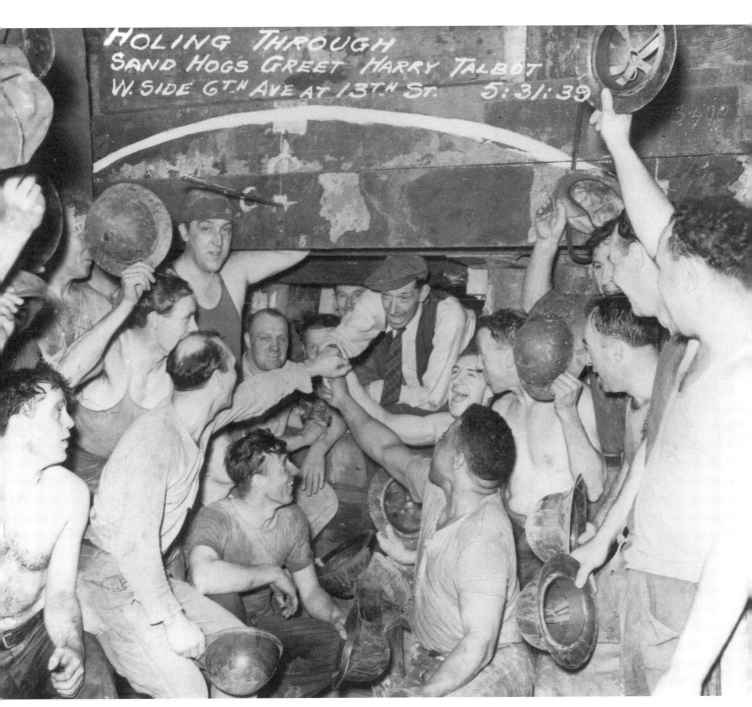

"Holing Through. Sand hogs greet Harry Talbot at 6th Ave at 13th street." Who was
Harry Talbot? We don't know. *(May 1939, New York City Municipal Archives)*

SONNY HALL, former bus driver and international president, Transport Workers Union:

"Cleaning buses and driving them through the streets of New York City, as my dad did before me for thirty years, has also been an education and life experience for me. Our tens of thousands of members working seven days a week, twenty-four hours a day, make a miracle out of a less than perfect system. Mass transit workers move millions of people. Life in this great city would be impossible without us."

• • •

Affordable, habitable housing was in short supply throughout the twentieth century, a problem addressed by both middle-class reformers and working-class activists and their unions. The early housing reform movement succeeded in getting pioneering building codes enacted, but enforcement of those and later laws was a continual hurdle. During Mayor Fiorello LaGuardia's term, municipal socialists successfully pressured for the formation of a housing authority, which built what remain some of the most successful public housing units in the country. Unions representing electrical workers, typographers, and garment workers built affordable housing for their members, and other unions invested pension funds in housing projects through the United Housing Foundation.

Led by Robert F. Wagner when he was a state senator and Alfred E. Smith when he was speaker of the state assembly, the Factory Investigating Commission was formed in the public outcry after the Triangle Shirtwaist Fire in 1911. The commission held three years of hearings and investigations, and compiled extraordinarily detailed evidence about working and living conditions in New York. The leaders and members of the Commission, including the AF of L's Samuel Gompers and the Women Trade Union League's Mary E. Dreier, together with volunteers such as Frances Perkins, went on to influence legislation about housing and working conditions on both the state and the national level.

NATALIE ZUCKERMAN, daughter of Jewish immigrants from Austria-Hungary, was born in 1915 and grew up on the Lower East Side:

"All the other apartments, prior to that one, the toilet was out in the hall, and when you wanted to take a bath, the sink in the kitchen served as a washtub. But then, we got rich. My father got a raise, so we moved to Eldridge Street and we had our own bathroom.

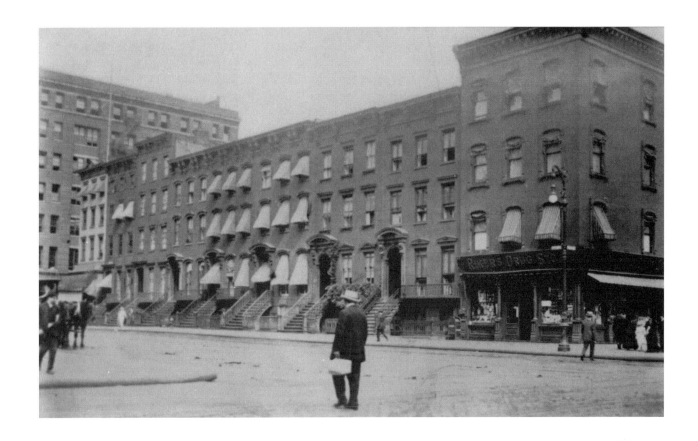

"We always had boarders. We could never never afford to pay the rent, so we always had boarders. We had no trouble. All you had to do was put a sign downstairs on the door, and we got Jewish, Irish, Italian . . . always men . . . their wives were in Europe. I'd have to sleep with my little brothers in the kitchen."

RUTH VOGEL, a Bloomingdale's storeworker when she moved into the newly opened Penn South complex in 1963:

"My husband and I would come down to Chelsea on our lunch hours to watch the progress on the building. Before we moved here we had organized the small building that we lived in to protect our rent, but this idea of cooperative housing for workers was a big thing in our lives. We moved in, a floor at a time. Most of our neighbors were garment workers, teachers, and fur workers because the idea was "walk to work" housing. We had all been active as union members in our workplaces, so of course, we organized our housing, too. We owned our apartments jointly as shareholders and elected house committees to represent us. We had to learn to be our own landlords. But we went one better. We organized ourselves to meet all of our needs as a community—a coop food market, childcare, recreation, and social committees."

"Typical workers housing. A row of furnished-room houses. North side of Seventh Avenue, Fourteenth to Fifteenth Streets, New York City. Every house in this block advertises furnished rooms. This and the preceding photographs show typical glimpses of the west side of New York, from Eleventh Street to Twenty-second Street. Splendid old residences have been given over to roomers. Many of the buildings are sadly decadent." *(1911–1914, New York State Factory Investigating Commission, New York State Archives)*

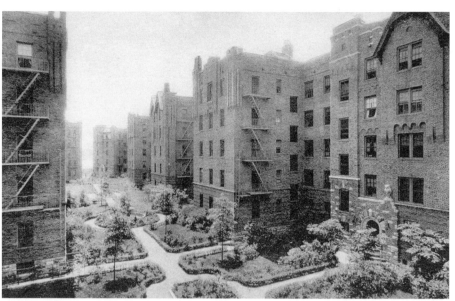

Postcards of Amalgamated Cooperative Apartments. *(1927, Robert F. Wagner Labor Archives)*

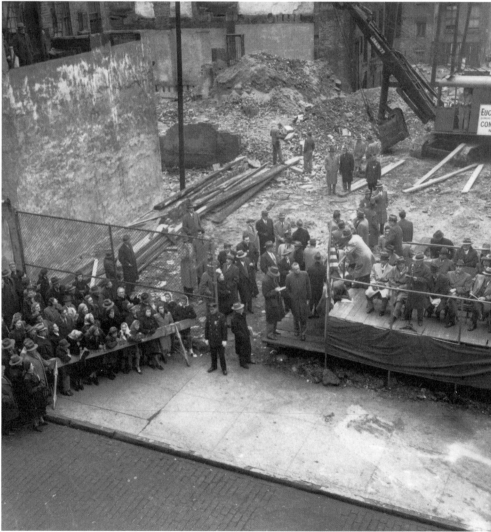

Groundbreaking at the Hillman houses, another Amalgamated Housing Corporation project, on Grand Street. *(1947, ILGWU Archives, Kheel Center, Cornell University)*

Built by the Amalgamated Housing Corporation on a site close to a subway line in the Bronx, these buildings *(opposite)* were cooperatively owned and operated. Cooperative medical and dental services, a newspaper, and cultural programs were also part of the initial vision, though those programs did not last. The Housing Corporation, formed by the Amalgamated Clothing Workers union together with other groups, went on to build low-cost housing in the Bronx and on the Lower East Side. By the 1990s it operated over fourteen hundred apartments.

HARRY VAN ARSDALE, JR., 1905–1986

Van Arsdale, whose father was an electrician, joined Local 3 of the International Brotherhood of Electrical Workers in 1925 and served his apprenticeship to become a journeyman electrician. Elected business manager in 1933, in this leadership role he introduced a number of innovations that became models for other unions. He negotiated shorter hours for construction electricians, which by 1965 were reduced to thirty-five per week. Local 3 also negotiated the first pension plan in the construction industry. Health and welfare benefits jointly administered with employers were expanded to include educational benefits for members, spouses, and children. After World War II, responding to the post-war housing shortage and high unemployment among members, he led Local 3 into a joint venture with construction industry employers. Together they built Electchester, a seventy-five-acre cooperative apartment complex for moderate income families in Flushing.

After the merger of the AF of L and the CIO, Van Arsdale was elected president of the New York City Central Labor Council, where he mobilized affiliated unions to work together in organizing the unorganized and strengthening links between unions and government. Under his leadership the CLC played a decisive role in organizing taxi drivers, hospital workers, and teachers and in achieving legally protected collective bargaining for municipal employees. He helped to shape state and city policies as a confidant and advisor to Mayor Robert F. Wagner and Governor Nelson Rockefeller. On the national scene, Van Arsdale was elected treasurer of the IBEW. He lived modestly. As shown in this picture, he rode to meetings on a motor scooter driven by Arnold Beichman, editor of *Electrical Union World.*

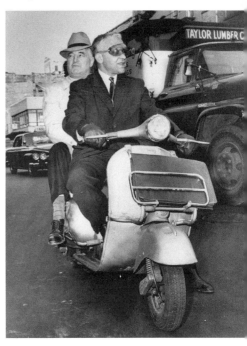

Harry Van Arsdale, Jr., 1905–1986. *(Joint Electrical Industry Board Archives)*

The construction industry has always been an economic ladder for newcomers to the city. The dirtiest and most dangerous work—from ditchdigging to demolition—has long been a vital source of employment for immigrants and minorities. Some of these groups, with strong union contracts, were able to create a subculture in the trades, passing the skills and the jobs on to family members and landsmen. The construction unions have been a stabilizing force in the industry, have won high wages for skilled workers, and have fought hard to improve the construction and maintenance of the city's infrastructure.

EDWIN LOPEZ, construction electrician and business representative, IBEW
 Local 3:

"My father, Jose Lopez (1932–1985), was born in Cayey, Puerto Rico, and after graduating from high school in 1947, moved to New York where he started working as a lamp assembler in a factory organized by the Lamp and Shade Division of Local 3, IBEW. When the Korean War broke out, he volunteered—he was eighteen years old. He rose to the rank of master sergeant and received a Purple Heart. When he returned to his old job, he became very active in the union. He served as shop steward and on various committees, and in 1958, he, Harry Van Arsdale, Jr., and others founded the Santiago Iglesias Educational Society within Local 3, named for the father of the Puerto Rican labor movement. Recognizing his leadership and organizational skills, AFL-CIO president George Meany appointed him a national field organizer. His first assignment was to work with Cesar Chavez and the United Farm Workers Organizing Committee. He worked with distinction and dignity until his death on October 18, 1985. My dad triumphed over discrimination and adversity to be in the position to fight—through the union he loved—for all working men and women, especially the Puerto Rican/Latino community. He paved the way for generations to come."

GILBERT BANKS, African American construction worker and Korean War
 veteran:

"When I was discharged from the army, I wanted to get a job as a diesel mechanic. No way, no way. I walked up and down all the major construction in Brooklyn—I'd worked on graders, I'd worked on shovels, I'd

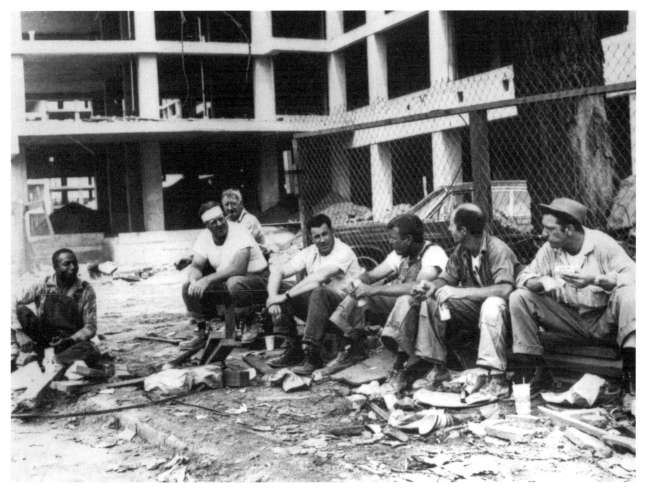

Workers' lunch break at the Warbasse Houses, United Housing Foundation, Manhattan.
(1963, Robert F. Wagner Labor Archives, Sam Reiss Collection)

worked on cranes. And I also knew some hydraulics. But no way could I go to work as a diesel mechanic. What they'd tell me is that you got to get a [union membership] book. And when I'd go to the union to get a book, they'd say, 'You gotta get a job.' I used to sleep on the subways because I wasn't making money and I couldn't pay my room rent and all that. That was in 1961 or 1962. I joined Brooklyn CORE [Congress of Racial Equality] and I began to deal with some of my frustrations that I had accumulated all those years."

Climbing Jacob's Ladder

In May 1963, a coalition of civil rights and labor organizations, including A. Philip Randolph's Negro American Labor Council, the Association of Catholic Trade Unionists, and the Workers Defense League, mounted a campaign against discriminatory hiring. They targeted federally funded construction projects in New York City with the demand that minorities comprise 25 percent of the work crews. Hundreds of black and white demonstrators conducted daily occupations of Mayor Wagner's office and civil disobedience at construction sites, the largest of them at Harlem Hospital and Downstate Medical Center in Brooklyn. The passage of the Civil Rights Act in 1964 initiated a decade and more of struggle over access to high-paying skilled jobs. Some building trades voluntarily opened their doors to minorities, while others were forced to do so under court order. The New York Plan for Training, established through labor and management cooperation, contributed a penny per hour worked to increase minority participation. More than three decades later, the New York State Department of Labor reported that 42 percent of New York City apprentices and an estimated 35 percent of journeymen were minorities or women. Still, the swings of the building industry cycle, the season, and a worker's skill, reputation, blood relationships, skin color, and gender continue to dictate how many days a year a tradesperson can expect to work.

PETER BRENNAN, 1918–1996

A house painter from Hell's Kitchen, Peter Brennan returned from World War II and began a meteoric rise to the presidency of the New York City Building and Construction Trades Council in 1957. He was instrumental in creating training programs aimed at increasing minority opportunities in the construction industry. Brennan gained national attention by leading a 1970 march of 100,000 hardhats and longshoremen in support of U.S. troops in Vietnam, days after a smaller group of construction workers had clashed with anti-war protesters. Brennan gained the admiration of President Richard Nixon, who appointed him U.S. Secretary of Labor, a post he held 1973–1975.

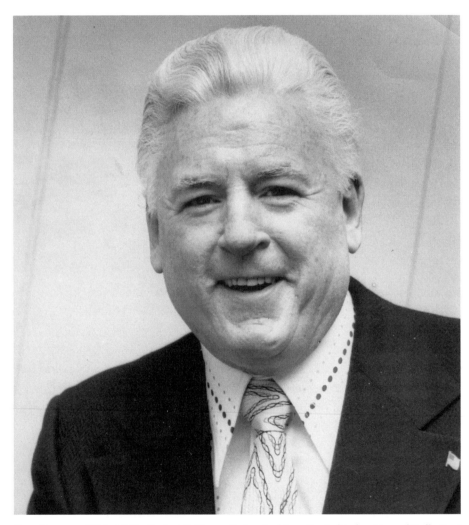

Peter Brennan, 1918–1996. *(Robert F. Wagner Labor Archives, Central Labor Council Collection)*

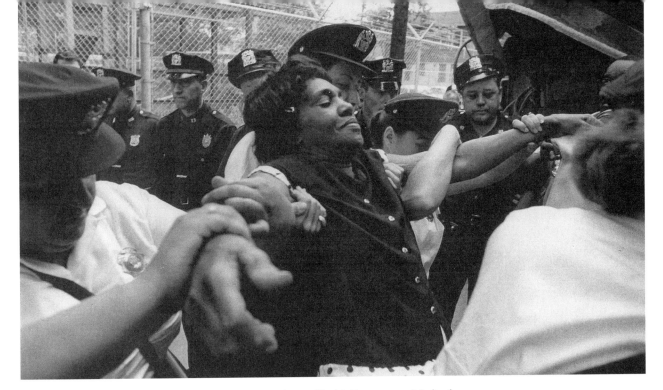

Above. Civil disobedience at the State University of New York's Downstate Medical Center in Brooklyn. *(1963, photograph by Bob Adelman); Below.* Cynthia Long working in an electrical closet, tightening a coupling on a pipe elbow. *(Early 1980s, Robert F. Wagner Labor Archives, New Yorkers at Work Collection)*

CYNTHIA LONG, electrician, IBEW Local 3:

"I had worked in offices; I had done those traditional female roles and I didn't like them for all the—what I consider—garbage that you have to put up with. It was extremely low-paying, because you'd be spending your money to buy clothing to look attractive for the office. So I came to the conclusion that with a skilled trade, I would have mobility. I would also have a skill that could command a good price. I was informed by the Women in Apprenticeship Project that the electricians' union was opening up in June of 1978. We organized a sleep-out on the streets of Flushing, outside the Joint Industry Board, for six nights and five days, just to get the applications. We were part of the first hundred people on that line so we attracted a lot of media attention, as well as attention from electricians who would come by, kind of checking us out.

"Most of the electricians would say to us, 'This is men's work, heavy work.' And we would say, 'I don't think it would be that much heavier than carrying a sleepy five- or seven-year-old child, or carrying wet laundry, or carrying two full bags of groceries up a six-floor walk-up. We have done these things.' It's very hard for them to conceptualize somebody wanting to do this work. So I turn it around and say, 'Well, why do you want to do this work?' And they say, 'Because it pays well.' I say, 'Precisely. That's what it's about.'"

In the last quarter of the twentieth century, privatization, contracting out, and new technologies undermined skilled workers' efforts to maintain unionized jobs. At the same time, neither the city nor the federal government invested in the infrastructure. The consequences of decades of deferred maintenance have forced New Yorkers to deal with water main breaks, bridge closures, and subway disruptions. Unions and the building industry have banded together to respond to this problem.

IBEW Local 3 electrician Evan Ruderman (woman in bucket) and others working on the computerization of traffic signals in Manhattan. *(Early 1990s, Joint Electrical Industry Board Archives)*

Father Philip A. Carey (1908–1989) was a popular Jesuit priest and director of the Xavier Institute of Industrial Relations, a labor school founded in 1936 and attended by many of the city's Catholic trade unionists. Here he blesses the shaft of the Hudson Avenue Tunnel. *(1962, Fordham University Archives, Xavier Labor School Collection)*

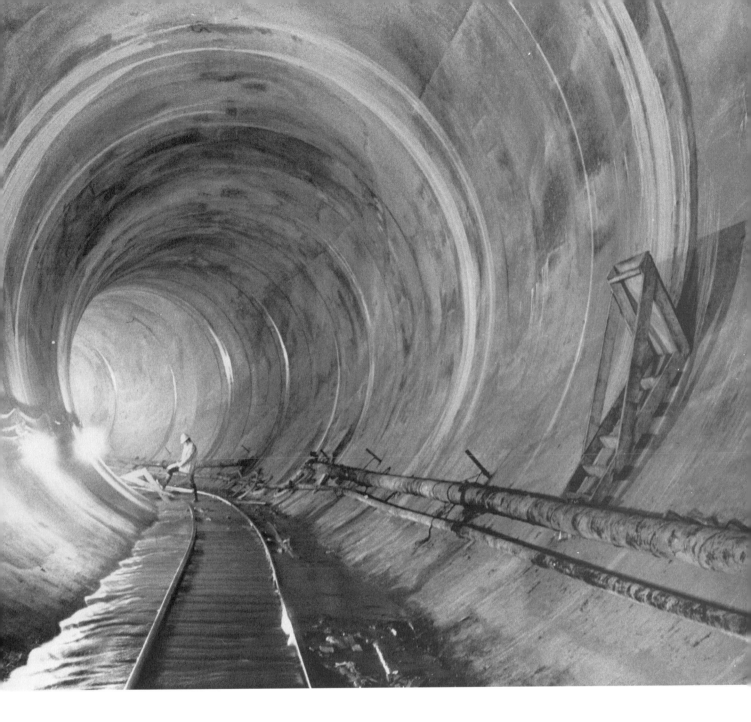

The largest peacetime public works project ever built, Water Tunnel #3 was begun in 1970 and will not be completed until 2025. Serving as a back-up tunnel for Tunnel #1 (completed 1917) and Tunnel #2 (completed 1936), Tunnel #3 will allow the city to shut down these primary tunnels for repairs. Without it, a problem in either of the two interconnected older tunnels would most likely result in the shutdown of the entire city water system. By 1998 twenty-four workers had lost their lives in the construction of the tunnel.

City Water Tunnel #3. *(Circa 1980, Robert F. Wagner Labor Archives, Civil Service Technical Guild Collection)*

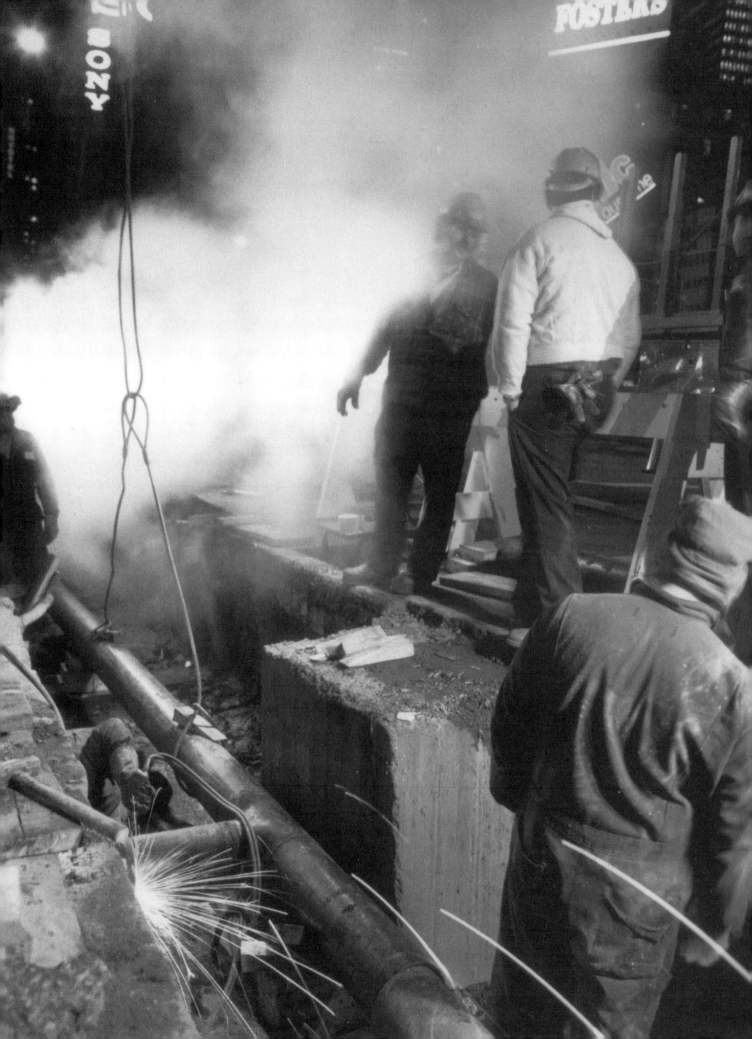

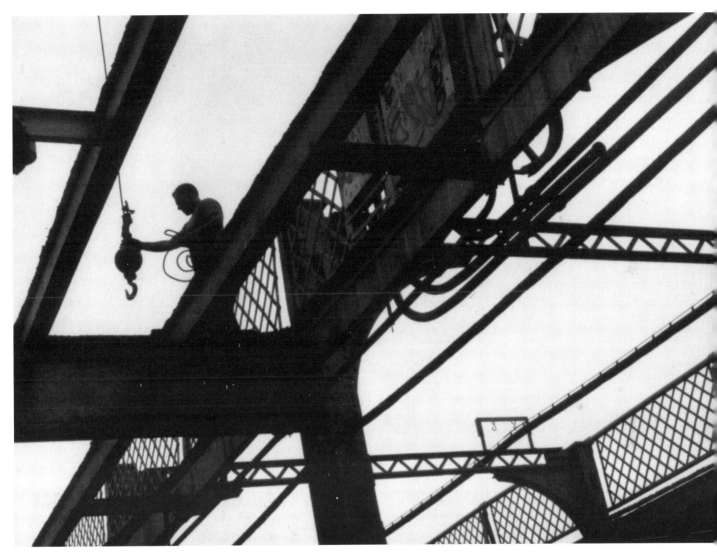

Above. Laborers dismantle Williamsburg Bridge walkway for repairs. *(1991, International Brotherhood of Teamsters, Local 237, photograph by Donna Ristorucci)*

Opposite. Replacing a steam main in midtown Manhattan. Note the welder connecting the service pipe to the main line. *(1987, Robert F. Wagner Labor Archives, Utility Workers Local 1-2 Collection)*

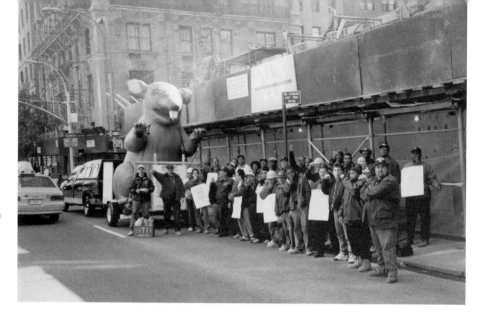

Laborers protesting a non-union job on Park Avenue.
(1998, Laborers' Union Local 79)

Recent flamboyant organizing drives among asbestos removers and demolition workers have brought hundreds of workers into the Laborers' Union. The union uses large inflatable rats to represent "scab" (non-union) employers or employees, and conducts meetings in several languages—Polish, Spanish Creole, and English.

EDWARD J. MALLOY, President, New York City Building and Construction Trades Council:

"We need the same vision that the builders of New York City showed a century ago and in the 1930s. They laid the foundation for a century of unprecedented growth and prosperity. We need to make a commitment to the future to rebuild the metropolis. This is broader than just jobs for the building trades. We're talking about a safe and pleasant environment for our children and our children's children."

LOIS GRAY, labor relations specialist:

"New York is still the most highly organized city in the United States. Collective bargaining agreements apply to approximately one-third of its work force, twice the national average. Some of these contracts (apparel, maritime, and entertainment) dominate national markets; others (newspapers, hotels, hospitals, construction and public workers) greatly influence bargaining elsewhere; the remainder concentrate on local considerations and have little effect outside of the city.

"New York labor relations are characterized by a high degree of union organization and a lesser degree of management organization, a multiplicity of organizational structures on both the union and management sides, a system of disputes settlement in which third parties play a decisive role and in which mutual support is the motivating factor, and finally, the settlement of critical disputes in the political arena."

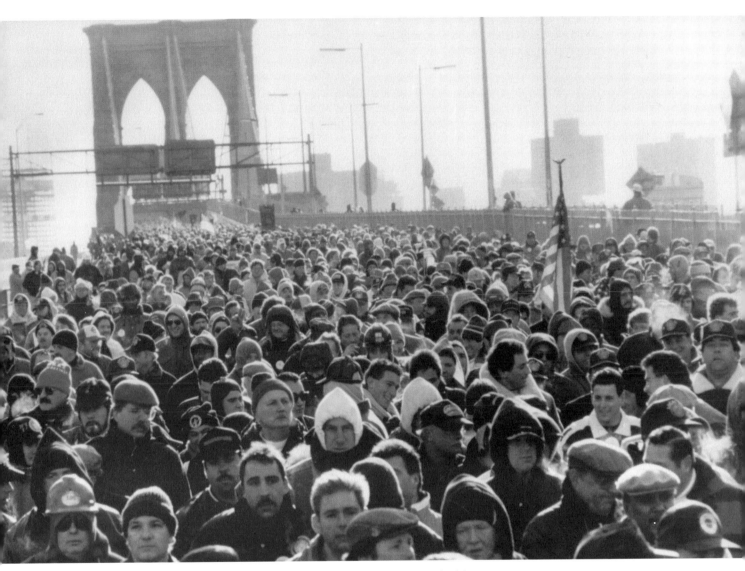

More than 50,000 construction workers demonstrated to protest delays in city building projects in this 1991 Rebuild America demonstration. *(New York Building Congress)*

NEW YORKERS AT WORK

Faces of a Changing Economy

New York City, the nation's largest and most varied workplace, defies generalization. At different moments in the city's history, it has been the largest manufacturing center in the country, its busiest port, the point of entry for the largest number of immigrants, the largest population center in the country, and the most densely settled city in the world.

The character of its workforce has gradually changed from skill-based to knowledge-based; from an economy dominated by blue-collar work to one where a majority of the jobs are in the white-collar service sector. Throughout, the working people who filled these jobs not only physically built the city's infrastructure, but also provided the brains and muscle for the city's extraordinary economy.

In 1900, 10 percent of all goods produced in the entire United States were made in the city's 36,000 factories. New York's ready market, transportation links, and the continual flood of immigrant workers made it a prime center for light manufacturing. Nearly 40 percent of city workers found employment in those factories, half of them in three industries: garment, printing and publishing, and iron products.

Manhattan's last cargo pier, Pier 42 on the East River, was vacated by the Dole Fruit Company in the late 1980s. During the 1950s New York's waterfront docks handled over 32 million tons of fruit shipments per year.

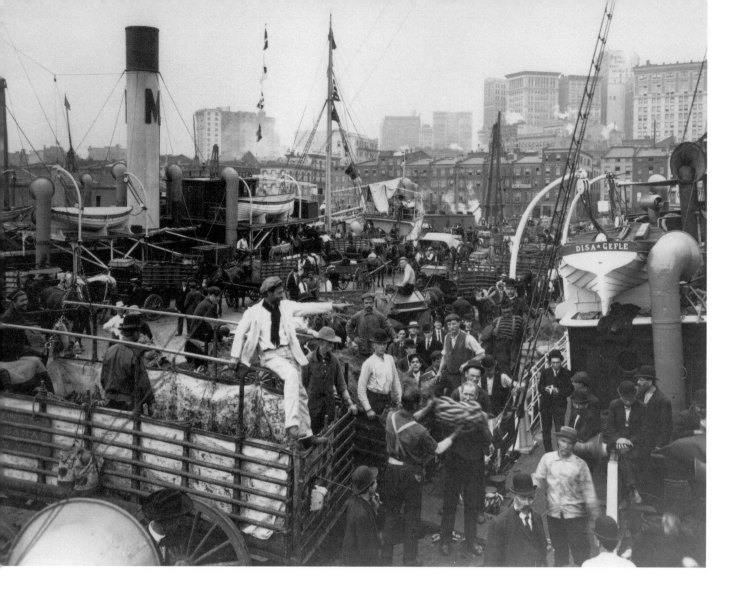

Bananas being unloaded on a New York City dock. *(1906, Library of Congress)*

FRANK BARBARO, New York State Supreme Court Judge and former long-shoreman:

"I never worked the banana docks. Even in the 1950s, banana ships were unloaded in the most primitive, back-breaking manner—literally. It was one of few docks where black longshoremen were able to find work."

Traditionally, domestic work was the unpaid labor of wives and daughters, and without it their families could often not survive on the low wages of the household head. Women did the same kind of labor outside their homes as well, for wages that were most often very meager. As early as 1900, one in four New Yorkers earned their living as barbers, bartenders, boarding-house keepers, bootblacks, janitors, laundresses, servants, restaurant workers, cooks, and the like. Immigrants, minorities, and women worked at low-wage service jobs at the turn of the century, and a hundred years later this sector still provides an often tenuous existence in an underground economy for undocumented newcomers to the city.

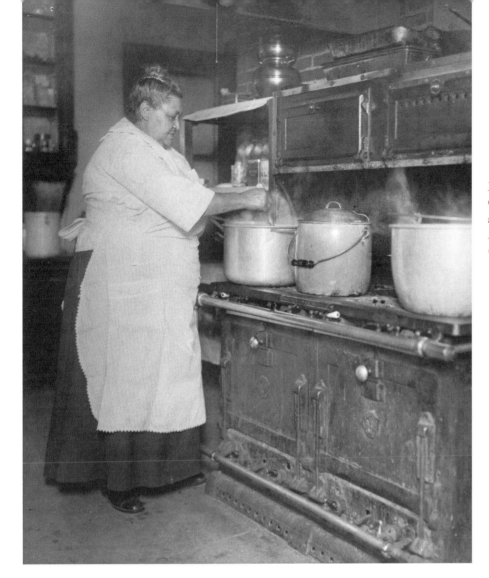

Mrs. Kitty Hoge cooking at Greenwich House. *(1928, Tamiment Institute Library, Greenwich House Collection, photograph by Carl Klein)*

MARY CONDON, housemaid who came to New York from County Roscommon, Ireland, in 1930:

"Mary Handlin had been to America and she influenced me. 'You must go and do domestic work, in that it's much safer. You mustn't live out in a furnished room.' That was impressed on me for many years. You'd get about thirty dollars a month and a place to sleep. The place you slept generally was a bed you'd put in the hall. I was used to being out in the air, and being enclosed all the time, except when you went out with the babies, was very hard.

"We used to go over to the East Side. There were agencies [for domestic employment] on Madison Avenue in the seventies and we would go there looking for jobs. They would come, mostly ladies that had estates and kept many people in help, possibly six or eight. They would sort of look you over with the lorgnette and ask you if you wanted to go to church. [You] wondered; if she had other people going to church it wasn't so bad, but if it was only you, she wouldn't want that time allotted. So during that time I got work with Louis Comfort Tiffany and I spent a summer out there."

A worker at the Wo Sing Shirt Press in Chinatown. *(1983, Museum of Chinese in the Americas, photograph by Paul Calhoun)*

The series of legislative restrictions on Chinese immigration known as the Chinese Exclusion Acts (1882–1965) had severe consequences for Chinese immigrants. Craft unions supported these laws, which had occupational restrictions as severe as the immigration restrictions. As a result the vast majority of Chinese workers had to work in either restaurants or laundries. In 1930, 84 percent of Chinese workers in New York City were found in these two sectors. The Chinese Hand-Laundry Alliance, founded in 1933, became one of the foremost organizations working to improve conditions for Chinese workers.

WING HAY LOUIS, laundry worker:
"Back then to make a few tens of dollars of business, one had to work night and day. Oh, it was very miserable. Back during my father's laundry days there was not even time to sleep. He said the bowl he was holding during the meal would drop and broke. He was so sleepy he broke all the dishes while eating." (Museum of Chinese in the Americas)

Reformers helped legislate increasingly strict limits on children's work, and helped build social pressure against child labor. But violations of child-labor laws persist. Today many of the children employed are undocumented immigrants; now, as a century ago, their small wages help their families survive.

RITA PALTER, retired handbag maker, Leather Workers Local 1:
"A woman I worked with first worked for her father, who was a small contractor. He took work home and made his family work for him. If she didn't want to, he would slap her. I always took a principled stand against home work. It made a difference to work in the shop—the conditions were better."

ETHEL KOKAFSKY KAHN's parents were Jewish immigrants from Poland and Galicia; born in 1914, she grew up on the Lower East Side:
"We had a neighbor on my floor who had a husband who was a gambler. . . . She had lots of trouble . . . and because she needed extra money, she worked at home. One season she had tie, neck ties, and she would be

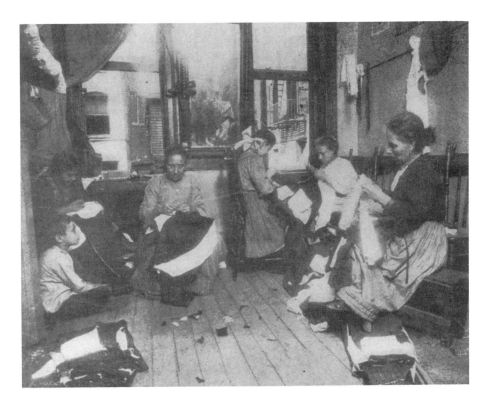

Child Labor in tenements.
(1911, New York Child Labor Committee pamphlet, Tamiment Institute Library)

Garment shop on Bond Street. The "No Smoking" sign is possibly posted in response to awareness of fire hazards after the recent Triangle Shirtwaist Factory fire. Note the most skilled worker, a cutter, is wearing a tie. *(1913, ILGWU Archives, Kheel Center, Cornell University)*

turning these ties. Another season she had the garters that men wore on their shirts.

"We had no such thing as after school activities, and when I got home from school it was three o'clock, I had many hours to do a little home-work, and the rest of the time I had nothing to do. My mother would say, 'Go into Mrs. Rifler's apartment and help her make those bows.' I might have been ten years old. When I went into her apartment and she taught me how to turn over the tie, I had a trade. Beautiful silk ties, lovely ties the men wore in those days, and I did that with the elastic. She had her own children help too. Now they would call it child labor abuse. But we loved it. We had something to do. We were helping this lady." (Lower East Side Tenement Museum)

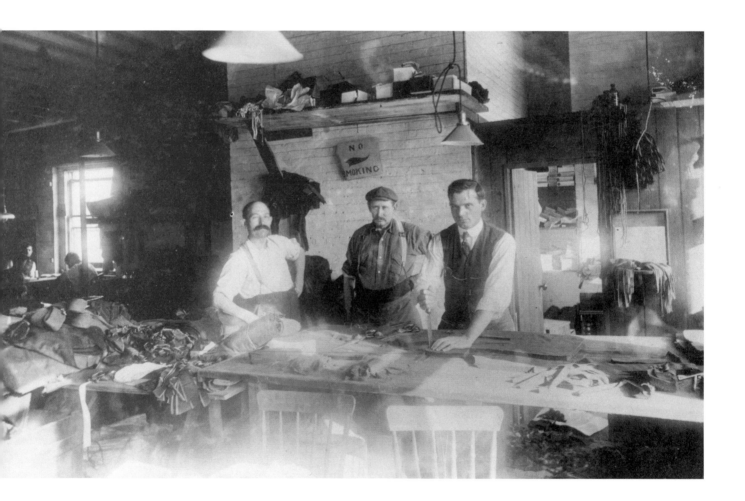

LA NOSTRA DIVISA

LOCAL LXXXIX

I·L·G·W·U·
A·F·oF·L·

PANE E ROSE

Fifteenth anniversary book for the Italian Dressmakers' Union, Local 89, International Ladies' Garment Workers Union: *Ultra: strenna commemorativa del XV anniversario della Foundazione della Italian Dressmakers Union, Locale 89. (1934, Tamiment Institute Library)*

In 1900, 40,000 New York City garment workers produced 37 percent of the nation's ready-to-wear clothing, mostly in small shops like the one on the facing page. For much of the century, the garment industry provided jobs for immigrants—from Eastern European Jews and Italians, many of whom arrived with tailoring skills, to the more recent waves of Asian and Hispanic workers.

JULIA BENICCI, garment worker:
"She took a bundle and she cut the string. And when you open the bundle, it is a thousand pieces. And all these pieces, you put them to-gether and you make a beautiful dress. The operator on dresses is an engineer."

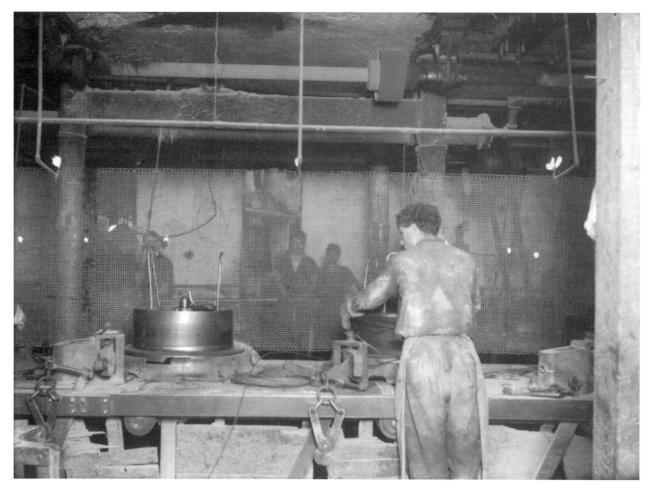

Unsafe working conditions at the Wire Cable Company in Brooklyn, "showing wire-drawing machines unprotected. On the machine to the left the operator was recently caught and wound around the drums, sustaining frightful injuries." Note the open flames—gas jets—used for lighting. *(New York State Factory Investigating Commission, 1911–1914, New York State Archives and Records Administration)*

New York City's iron products factories produced consumer items such as typewriters, stoves, iceboxes, and cutlery, as well as building materials for the city's rising skyline. Machine-tooling shops produced the machinery for the city's expanding manufacturing sector, and as the century progressed, its electronics sector provided lighting, switchboards, and circuitry for the city's communications infrastructure.

As a youth in Budapest, David Jacobowitz studied to be a rabbi. This photograph was taken soon after he arrived in this country, by an itinerant photographer who made a print of it for anyone in the shop who could afford the steep purchase price.

The city specialized in making finished goods for consumers. The cigar industry was one place where Cuban and Puerto Rican immigrants were welcome, and where men and women often worked side by side.

Cigar workers in a factory loft, Lower Manhattan, David Isaac Jacobowitz, center. *(1918, Private collection of Mel and Shirley Small [Jacobowitz's daughter])*

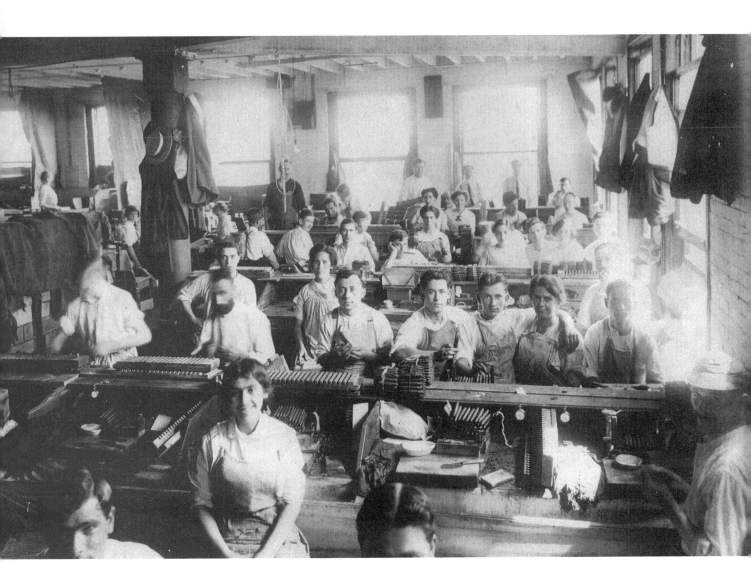

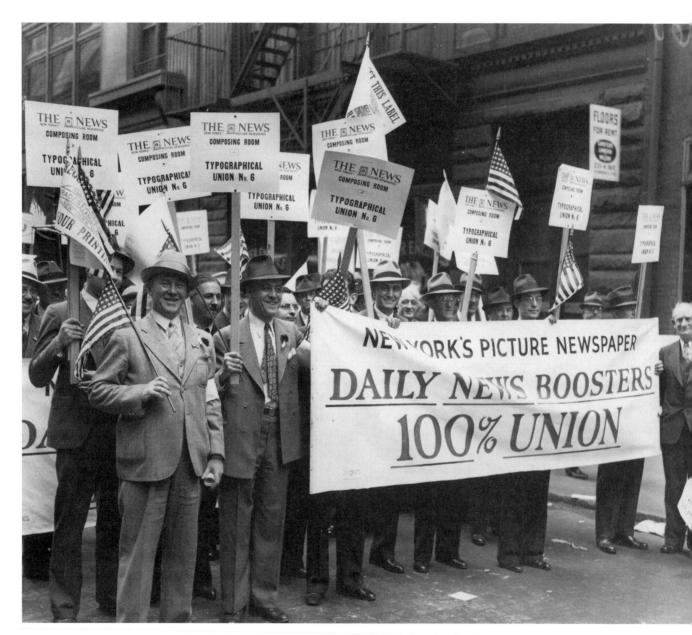

Printers from the *Daily News* composing room, marching in the May 1938 Union Label parade, American Federation of Labor. *(Robert F. Wagner Labor Archives, Union Label Collection)*

BERTRAM POWERS, printer:

"The way of doing the work was still pretty much as it had been with Gutenberg; with the exception of the linotype machine, everything else was hand work. The Typographical Union was very old and had a lot of tradition, and as a result, a union composing room was a much different place than a non-union composing room—much more orderly, much better atmosphere, freer. There was no oppression, no dictatorship in a union composing room because, among other things, the foreman had to be a member of the union chapel [chapter]. He was to direct the work, but at no time would he be abusive in his function as a foreman. Before the advent of the Taft-Hartley Act, if a foreman was abusive, he could be brought up on charges within the union and fined.

"We didn't have a history of strikes, but one of craft pride and identity as union men who were loyal to the union. You did not cross a picket line and you did not work with non-union people. They weren't opposed to non-union people but they were opposed to rats. A rat would be one who was a member, and when a strike had been called, he didn't come out, or he later went back and crossed his own union's lines. That would be a rat. They felt so strongly about that, that if later a rat were in a non-union shop that became organized, they'd have to take him and he'd now be a member again. But they would call him a whitewashed rat. He would always be a rat."

BETTY BOYD CAROLI, historian:

"Gotham has always been among the most 'foreign' of American cities, and for much of the twentieth century new ethnics appeared to come in pairs to New York. In 1900 Germans and Irish led in numbers, but before either could win a majority they were both displaced by huge numbers of 'new immigrants' from southern and eastern Europe. Italians led in numbers, although their impact was lessened by the fact that so many of them came with the express purpose of earning a few dollars and then returning to Italy. Eastern European Jews claimed second place in number of immigrants after 1900, as many of them fled the limitations and persecution of Romania and Russia. By 1920 they accounted for about one in every four New Yorkers, and their concentration in a few neighborhoods, such as the Lower East Side where more than half a million lived in 1910, increased their visibility."

Unemployment was a part of workers' lives throughout the twentieth century, although it reached the national consciousness most during depressions. For some occupations, especially day labor, whether it be domestic or outdoor, the possibility of no work is a daily occurrence.

The African American women who stood on these street corners looking for work were among the city's most exploited workers, earning ten to fifty cents an hour in the 1930s.

GERALDINE MILLER, domestic:
"There used to be the market where the household workers came. The corner where they used to stand was Burnside and Walton. It would be just loaded full of women waiting. If you stood there and watched, you would see the big cars drive up and the white women would go out, look, and say, 'Come, I want you for the day.' And what they looked for is the ones with the most scarred knees, you know, because they felt as though they would be good workers to crawl around on their knees some more."

ANNE LEVINE FILARDO, whose husband and father were carpenters:
"In Brownsville on Stone and Pitkin Avenues, actually for four different corners, the carpenters would stand on one corner and the bricklayers and other trades on the others. The one in Brooklyn was the one I was familiar with, but they were in other boroughs. And on each corner was a different trade. By tradition the carpenters stood on the same corner every Sunday. They would go there early Sunday morning and be there till well into the afternoon even if they weren't looking for work. If the job was going to be coming to an end, they would be nosing around to see, just keeping in touch with the bosses. Now, it wasn't the big bosses. Morse Diesel superintendent wasn't coming to the beerzha [Yiddish for "slave market"]. It was mainly the small homes trade or storefronts where the Jewish bosses were. As a matter of fact, I'm sure that my house wasn't the only house where the wife went crazy on Sunday. The husband would disappear and he would come home late, everybody would be waiting to have lunch or dinner. My mother used to say that my father's funeral would be postponed because the cortege would have to go by the beerzha before it went to the cemetery. But it was a social as well as a job-getting situation. It was also a place where you talked union business."

Unemployed women waiting to be hired as day workers at what they referred to as the Bronx "slave market." *(1939, Schomburg Center for Research in Black Culture, New York Public Library)*

Shape-up at Pier 92. *(1948, Library of Congress, New York World-Telegram and Sun photo-graph by Al Ravena)*

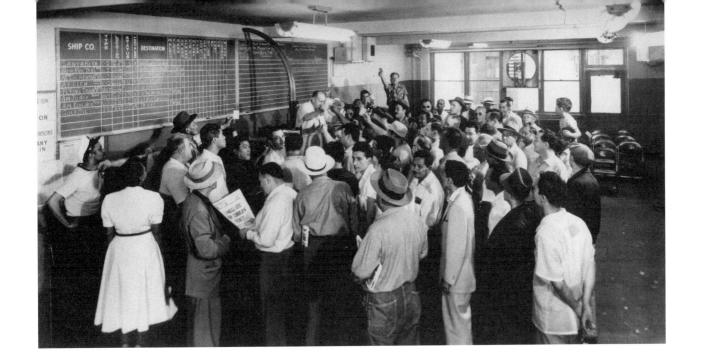

The busiest port in the world for the first half of the twentieth century, New York's docks were well known as corrupt and exploitative places to work. Attempts to organize by rank-and-file workers were crushed time and time again.

SAM MADEL, longshoreman and waterfront organizer, recalling the shape-up at
The Normandie's first crossing:

"So many longshoremen appeared at that shape-up looking to get a day's work on that ship that it made it almost impossible for the stevedore to make the selection. He took a handful of checks and he threw them out amongst the crowd. The longshoremen were pushing each other around and fighting with each other to pick up a check."

AL ROBBINS, merchant seaman in the 1930s:

"There was a great mass of seamen, only a small percentage of which was employed at any given time because there was no hiring hall. Jobs were either obtained by making 'pierhead jumps'—in other words you'd apply right at the pierhead, or through crimps. A crimp was a real bastard organization, men who owned boarding houses and had connections in the shipping line. They got you a ship and they had a lien on your pay. That meant you sailed and came out with very little. It was almost a form of serfdom."

JULIUS MARGOLIN, merchant seaman:

"I've done both—shaped up on the pier, when we were treated like slaves, and lined up in the union hall to ship out. The difference was amazing—in the union everything was democratic."

National Maritime Union hiring hall. The rotary hiring system at the union hiring hall gave first pick of a job to the seamen who had been out of work the longest. *(Circa 1946, Robert F. Wagner Labor Archives, National Maritime Union Collection)*

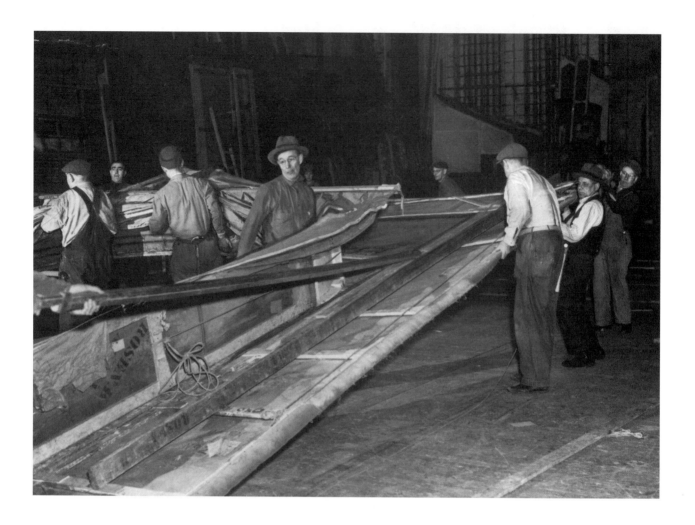

Stagehands "shaped" to work moving sets, here for a Metropolitan Opera production of *Der Rosenkavalier. (1940s, Library of Congress, New York World-Telegram and Sun Collection)*

SAUL "SOLLY" PERNICK (1898–1990), stagehand:

"On 137th Street near Alexander Avenue [in the Bronx], we used to play ball. So what happened was one of our boys hit the ball into the stage doors of a stock house there, the Metropolis Theater. They called them stock houses—stock companies played week in and week out. And I went in to retrieve the ball. There was a man there, whose name I can't ever forget—he used to work in the old Hippodrome Theater. His name was Pinky Morrisey. And he said, 'What are you doing in here?' I said, 'My ball is in here.' He said, 'Well come on, find the ball.' So I found the ball and as I went to go out, he said, 'Foot this piece of scenery while I stand it up.' They used to build the scenery in the theater from nothing. Every week you had a different show and every week you had to rebuild the scenery and repaint the scenery.

Now a piece of scenery is fourteen by five-foot-nine, canvas and wood, and as he went to stand it up, instead of keeping my foot on the bottom of the rail, I picked my foot up and my foot went right through the scene. Well, he ran me around the stage. He would have killed me. To make the long

story short, he said, 'Now you've got to help me fix it.' So we became
friendly and they used to give me a half dollar a week. I was what they call
a gopher. When I was about sixteen and I had worked around the theater
about three or four years, they sent me down to see the business agent in the
Clearers Local 390 that took care of properties. And I was initiated as a
clearer. We got seventy-five cents a show."

Two-thirds of Works Projects Administration employment in the city was on construction and engineering projects, and the remaining third in white-collar and professional jobs, many of which provided social services, especially in education and health fields. The most visible, though, were the arts projects. Home to more artists, writers, musicians, and actors than any other

Raphael Soyer and others at work on *Children,* a mural in the Children's Surgical Ward, Greenpoint Hospital, Brooklyn. *(1930s, New York City Municipal Archives, Federal Arts Project WPA Collection)*

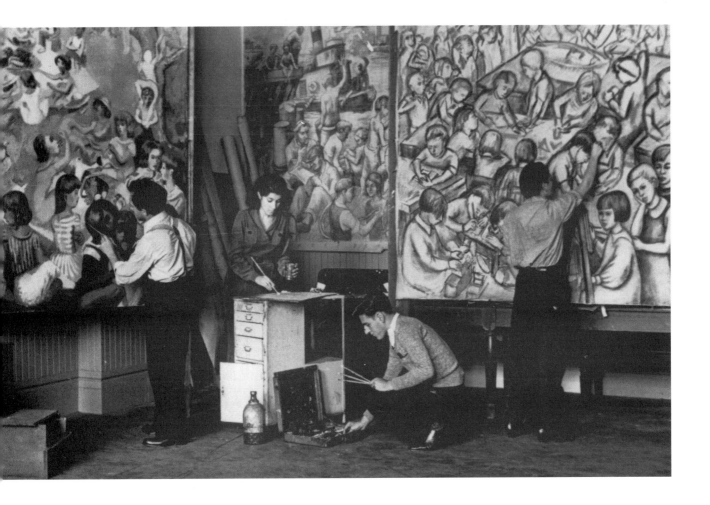

city in the country, New York landed nearly half of the federal funding for the arts. Painters such as Raphael Soyer, Stuart Davis, and Jackson Pollock and the photographer Berenice Abbot worked on city projects funded by the Federal Arts Project.

JOHN DEWEY, pro-union philosopher, giving a speech at a May 1934 rally supporting the Artists' Committee of Action (later Artists' Union) proposal for a city-run cooperative, non-profit gallery. The grassroots ACA Gallery, the first New York gallery to exhibit labor and social realist art, was an offshoot of this campaign:

"Artists have no organized, protected and insured place in community life . . . and it is because I believe that not only does the artist need the community but the community even more needs the artist (that) providing a center in which artists can meet and interchange, where they can get the sense of solidarity and inspiration and the new courage that comes when people feel that they are not alone and a solitary outcast in the community. It is not simply then in the name of the artists but for the use of the community, and this particular community, the City of New York, that I believe that this plan may be carried through." (Handwritten draft of speech discovered by art historian Francine Tyler in the papers of artist Hugo Gellert)

• • •

World War II resulted in a boom in shipping and manufacturing with unprecedented job opportunities for women and minorities. At the war's end 1.7 million New Yorkers were employed in factories.

LUCILLE GEWIRTZ KOLKIN (1918–1997), shipfitter, *U.S.S. Missouri:*
"Before becoming a shipfitter, I was a clerk for the Department of Welfare and that was a secure civil service job. I had read in The Leader *that they were giving an exam for shipyard work. It was hard to think of giving up a secure job so soon after living through the Depression of the thirties. I was about twenty-four at the time. I guess I was instilled with the spirit of helping to win the war against fascism. Perhaps I also romanticized the idea of working in a shop and wearing work pants. You know, women didn't wear pants in those days. It was really an unusual thing and it seemed very romantic."* (South Street Seaport Museum)

Opposite. Souvenir of the launching of the *U.S.S. Missouri* at the Brooklyn Navy Yard. *(1943, Private collection of Al Kolkin)*

Below. Four "Rosies" (as in Rosie the Riveter) before their shift at the Brooklyn Navy Yard. Lucille Gewirtz is on the right in the front row. *(Circa 1944, collection of Al Kolkin)*

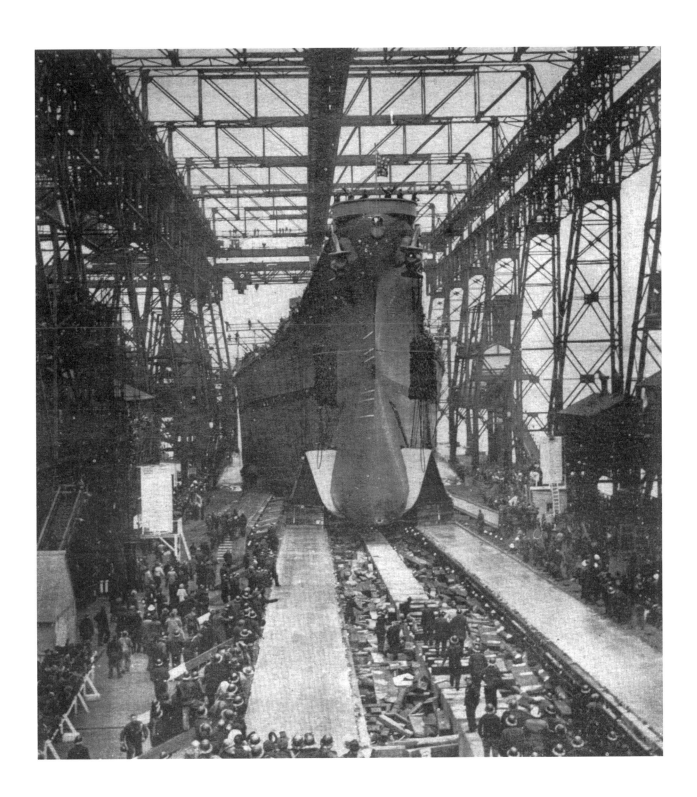

The largest naval construction facility in the country during the war, the Navy Yard employed men and women around the clock. For three weeks in the summer of 1941, IBEW Local 3 conducted a general strike of New York construction sites including the Navy Yard. The Local's goals were two-fold: to force the Navy to bring Navy Yard wages up to those in private shipyards (as mandated by the 1931 Davis-Bacon Act) and to gain recognition from a recalcitrant Con Edison. The day after this photo was taken, Navy Yard electricians returned to work at the request of Sidney Hillman, president of the Amalgamated Clothing Workers and co-director of the Office of Production Management.

International Brotherhood of Electrical Workers Local 3 electricians at the Brooklyn Navy Yard. *(1941, Library of Congress,* New York World-Telegram and Sun *photograph by Al Ravena)*

Sorting laundry, New York Hospital, 1945. The municipal hospital system was expanded and renovated during the war. Professionalism increased, and many jobs were brought under civil service rules. *(Kheel Center, Cornell University, Local 1199 Collection)*

JOHN BOER, former hospital worker and organizer, District Council 37, AFSCME:
"I found myself working, there being no other jobs [in 1935], in a city hospi-tal. It was the Cancer and Neurological Hospital on Welfare Island. I was a hospital helper, a job that covered a multitude of sins—you could work in the kitchen or in the wards carrying ice or dead bodies, sorting laundry, being a yard man or porter. At that time the pay for workers 'living out' in my grade was forty-five dollars a month. If you 'lived in,' it was thirty dollars. I lived in. We lived in a dormitory that was considered no longer fit for the old people who lived in one of the city's two homes for the aged there on the island. It was a very active lesson in being underpaid, overworked, and generally having your dignity destroyed. I immediately began to think of trade unionism for hospital workers. That was not an accepted or popular cause in those days."

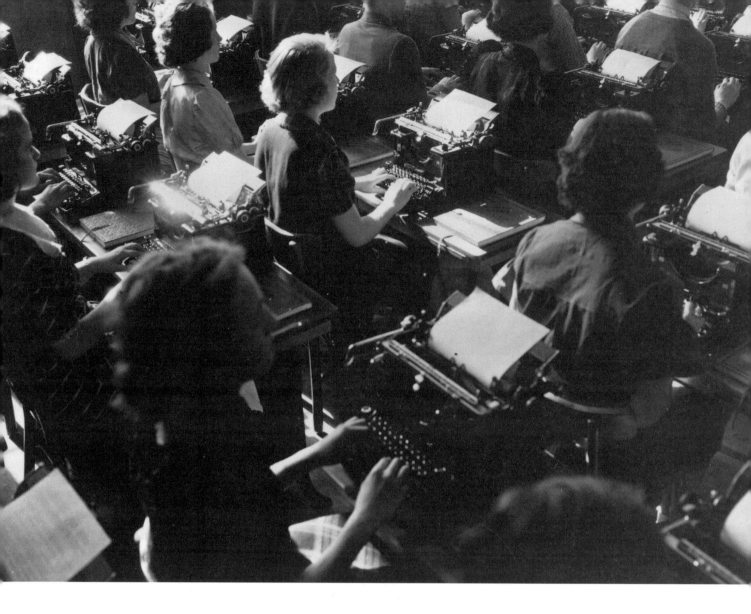

High school typing class. Clerical work was predominantly women's work for most of the twentieth century, holding a special place as a "respectable" but usually very poorly paid occupation. *(1936, New York City Municipal Archives, Board of Education photographer)*

In the years after the war, manufacturing declined more rapidly in New York than elsewhere, but its economy remained one of the most diversified in the nation. Service industries, from retail and food service to business services such as banking, law, and advertising, grew apace.

MARGE ALBERT (1928–1982), clerical worker and organizer, District 65:

"In my day, lower-middle-class Jewish girls became secretaries, and I was literally tracked into becoming a secretary. My two sisters and I had never really questioned the fact that we didn't go to college. We just accepted that if anybody goes to college, it would be my brother. And he did, and he became an engineer, and my two sisters and I became secretaries.

"I never stayed on a job more than two years. I almost always left over money, and got more money by switching around. They'd say, 'Well, we're already paying you the top secretary's salary, and there's a limit to what we pay secretaries.' And so, I'd just move on to some other place."

Cab driving is the quintessential New York occupation. The several attempts to organize drivers had some successes, followed by the reorganization of the industry and recurring difficult conditions for cabbies.

TONY ALLEYNE, cab driver who emigrated from Barbados in 1967:

"Most of the people who drive for the company are people who are on their way to something else: students, potential actors like myself, musicians, people who have a business that is not exactly thriving yet, but do this as lucrative, instant money. If you like people it can be fun. A cab driver is pretty much like a psychiatrist and bartender at times. New York City can be one big lonely town. I had a man who had a hundred dollars in his pocket and no friend, and all he did was to sit in the back seat of that car and ride all around until that hundred dollars was up."

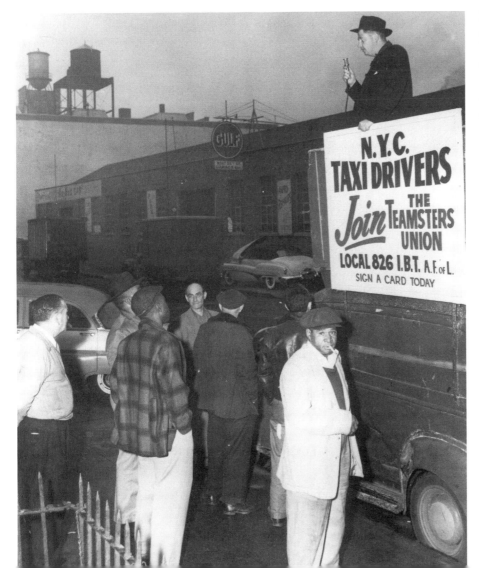

Bill Nuchow (speaker), president of New York Taxi Drivers Union Local 826, led a strike of cab drivers in 1956. *(Undated, George Meany Memorial Archives, photograph by Harry Rubenstein)*

The hotel and restaurant industry continues to provide entry-level jobs to newcomers. In unionized workplaces like this one, these relatively low-paying jobs can provide benefits and a livable wage.

CLARENCE REED, son of a union waiter at Luchow's in the 1910s:
"My father was an artisan of a craft that today isn't recognized anymore. As a youth, he served an apprenticeship as a waiter, and that is a very honorable degree in Germany and throughout Europe. He made very good money for a while, but then, because his arches broke down, we went through poverty of the worst sort that ever was."

Puerto Rican waiters at the Waldorf Astoria Hotel. *(Circa 1950, Centro de Estudios Puertorriqueños, Hunter College, CUNY, Justo A. Martí Collection)*

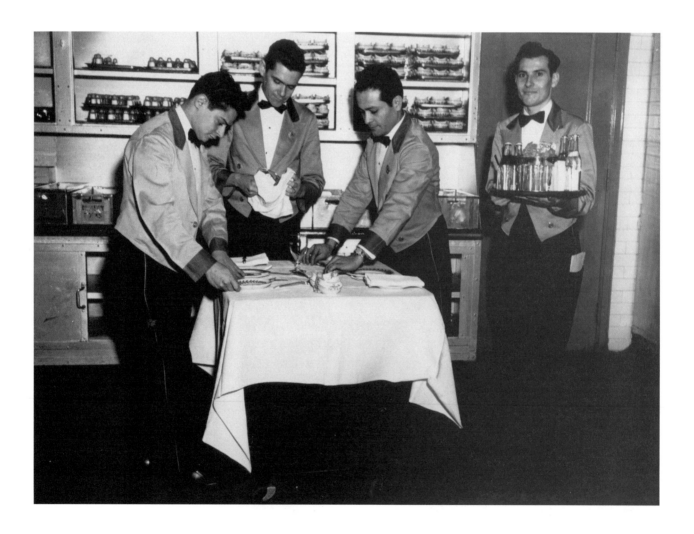

LORETTA SZELIGA POSTEK, cafeteria worker:

"It was a bitch. They could do whatever they wanted to you. They could tell you to come in and then you go there, they could tell you to go home. I became a carver. I had to stand up on a box because I was so short. You'd carve those big roasts. And they paid me much less than the man carver got. That was one thing that burnt my fanny. And we had more women in that industry because they paid them less. If they didn't like the way you looked, or you didn't go to bed with the boss, OUT! If you didn't let somebody feel you up, OUT! During the Depression, you'd go for a job. They'd say, 'With pleasure'—whatever it was—'ten dollars a week.' [Interviewer: And without pleasure?] You didn't get the job. Period. [Laughs] This happened more to office workers, that 'with or without pleasure,' than it did to unskilled workers. And in factories it happened. A lot of girls were scared. They were frightened. They were afraid to talk back to the boss. They were afraid. That was one thing I remember saying: 'If you join the union, you don't have to be afraid. You're not alone because there're other people with you.'"

Irish waitresses in the kitchen of Stouffer's Pershing Square (Manhattan) restaurant, Joan Dineen (front), from County Kerry, and Kathleen Moriarty (behind her) from County Cork. (Circa 1957, Private collection of Marion Casey, Actuality photograph by Charles Harbutt)

Eighth-floor sales at Gimbel's department store. About a quarter of the city's workforce was employed in the retail and wholesale trades at midcentury, and that figure held steady throughout the century. *(1957, Robert F. Wagner Labor Archives, District 65 Collection)*

WILLIAM ATKINSON, one of the first four blacks to break the color bar in sales positions at Macy's through the help of his union, Local 1-S, Retail, Wholesale and Department Store Workers:

"The places where blacks could work at Macy's was in the food department as cooks, the receiving department, and the elevator department. And that was all. No selling positions. After my service [in World War II], I looked around all of New York to find a job and I couldn't. I didn't want to operate elevators. Finally I went back, with my monkey suit on and my ruptured duck [uniform and honorable discharge insignia]. I had my discharge papers right under my arm. I put my papers on her desk. She says, 'Oh, Mr. Atkinson, we're so happy to have you back and we know you'd like to have your old job.' I said, 'Look, I fought a war for democracy. I was promised a better world. Now I want a better job.' She says, 'Well, what would you like?'

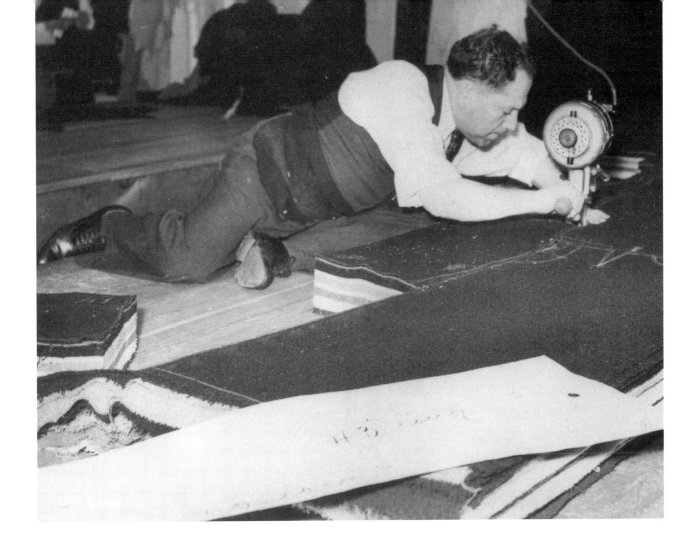

Cutters were—and still are—
among the most skilled workers
in the garment industry. (1956,
ILGWU Archives, Kheel Center,
Cornell University, photograph by
Harry Rubenstein)

*Now, I knew what the jobs were and what the salaries were. The highest-
paying job at that time was furniture, as a salesman. So I said, 'Furniture.'
She says, 'Oh, no. You have to have selling experience.' I said, 'Uh-huh.
Next one, rugs.' She says, 'Oh, that's the same thing.' I said, 'Radios.' She
said, 'Radios? No, because you see, you have to have experience.' That's
what I was waiting for. I said, 'Now Miss Hyde, be my guest. Turn over my
discharge and look at my rating—Radioman First Class. Three and a half
year's experience.' And she said, 'Well, there's no opening right now.'"*

LENORE MILLER, past president of Retail, Wholesale and Department Store Union:
*"When I entered the trade, you thought you were starting a lifetime career.
These days 80 percent of store workers are part-time."*

KATHY ANDRADE, former garment worker and labor educator:
*"The work is still the same except cutters are now Hispanic and black in-
stead of Jewish and Italian. There are even a few women, but you need a lot
of strength to be a cutter. Patterns are computer-generated now, but cutters
still use round and straight knives."*

In 1962 Judy Bond, a New York manufacturer of women's blouses, locked out its workers and shifted production to a plant in Brewton, Alabama. The International Ladies' Garment Workers' Union (ILGWU) waged a fierce campaign against the company—which included, many New Yorkers will remember, the distribution of 3 million "Don't Buy Judy Bond" shopping bags in the first twelve months of the protracted struggle. But these efforts did not stem the tide of runaway shops, first to "right to work" states in the South, and later, abroad.

Although manufacturing has declined dramatically, especially in the garment industry, New York remains one of the fashion capitals of the world.

Opposite. Judy Bond boycott. *(1962, ILGWU Archives, Kheel Center, Cornell University)*

Below. Rockefeller Center fashion show, ILGWU. *(Circa 1965, ILGWU Archives, Kheel Center, Cornell University)*

BRENDA BERKMAN, lieutenant, Ladder 12, Manhattan, whose class action case forced the Fire Department to change, if briefly, its entrance procedures. Berkman was among forty women who graduated from the Training Academy in 1982 to become New York's first women firefighters. In 1999, thirty-five women worked as New York City firefighters.

"People really admire firefighters. People look up to us. They want their kids to talk to us. We're the ones who help everyone. It doesn't matter what time of the day or night, how rich or poor they are, what color they are. We go into their houses and risk our lives to save them. The poorest people are the happiest to see us because they know what we do. It's a very nice feeling. We just go out there and do what we are supposed to do. When you finish up, you know you have helped people."

The number of hospital beds in New York fell by almost half between 1968 and 1998; the sense of urgency captured in this photograph from the 1965 blackout remains the same.

Opposite. Firefighters fighting a fire in a ruptured gas line. *(Early 1960s, New York City Fire Department Photo Unit)*

Below. Emergency room at Columbia Presbyterian Medical Center. *(1965, Columbia University Health Sciences Library, photograph by Elizabeth Wilcox)*

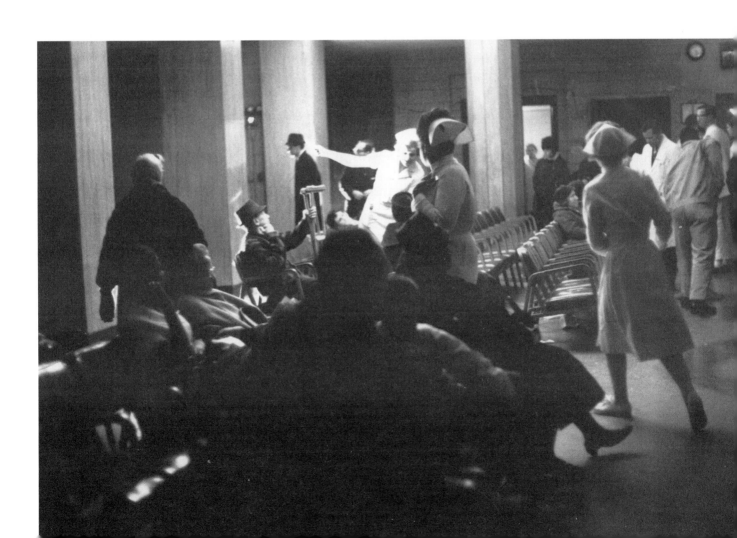

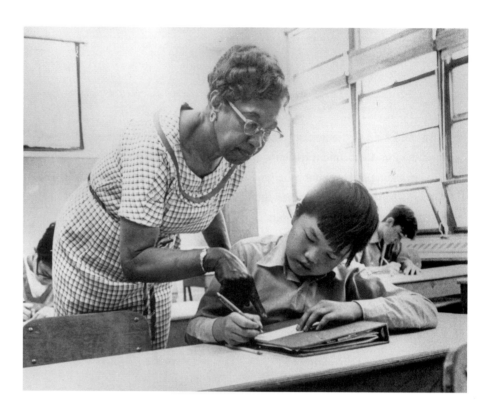

Public school teacher. *(Circa 1968, Robert F. Wagner Labor Archives, Sam Reiss Collection)*

BEN OCCHIOGROSSO, high school teacher, United Federation of Teachers, interviewed in 1981:

"It was odd being a teacher having had this image of what a teacher is visited on you by years of being a student yourself, and being in the professions—you know, the white collar, the tie, the jacket which male teachers wore in those days. We dressed like professionals. We certainly weren't salaried as professionals. I started in 1956 at $4,000 a year. And my mother wanted to know if this was why I had gone to college. My first paycheck broke down to something like sixty-nine dollars for a week's work. Teachers still had a status. It wasn't being a doctor or a wealthy businessman, but it meant something because there were very few young people going to college in those days, certainly from our background. After the initial shock of my salary wore off, even my parents were somewhat impressed."

"There is such a thing as burn-out. And the majority of teachers in my age group—I'm in my forties and I've been teaching twenty-five years—it's been an emotional drain. It's been in many ways a very satisfying job because, I felt, we were giving something valuable and getting satisfaction out of teaching. But it becomes harder and harder as the years go by. And certainly with large classes—it's not uncommon in a school the size of ours to have thirty-seven, thirty-eight, and in some classes, forty students. That can be very unmanageable. If you have the threat of violence always present, it creates

many more tensions than used to exist in teaching. Supplies of books are di-
minishing, and this term, it was hysterical—I shared an eraser with my
friend in the room next door."

Containerized shipping would eliminate many of the hazards of the occupa-
tion, but it also reduced the number of longshoremen in New York harbor
from nearly 50,000 in 1950 to less than 10,000 in the 1990s.

Longshoremen loading cargo at
Pier 2, Furman Street, Brooklyn.
(1967, Library of Congress, New
York World-Telegram and Sun
photograph by Matthew Black)

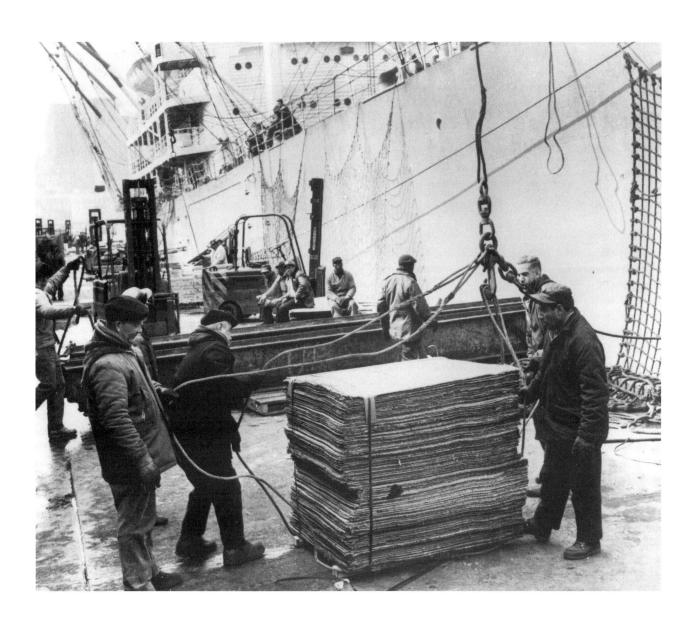

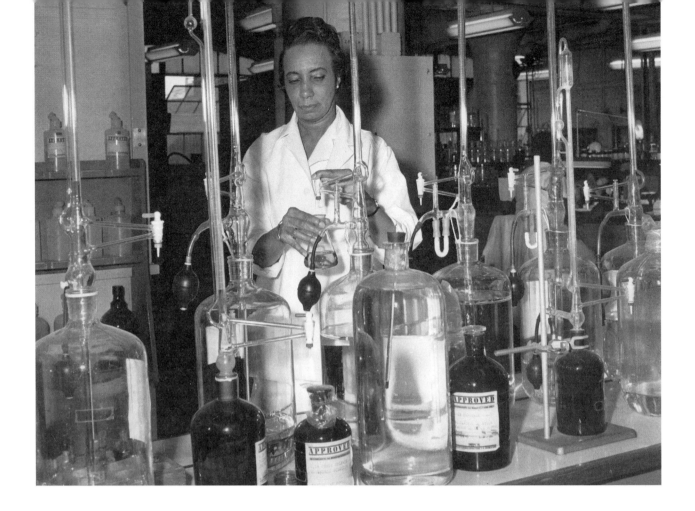

Chemist Annie B. Martin analyzing a drug in the Squibb laboratory. This photograph was taken by the Squibb Company photographer for the company newsletter after Martin's return from the Rev. Martin Luther King, Jr.'s funeral, which she attended as the company's representative. *(1968, Private collection of Martin, an Oil, Chemical and Atomic Workers Local 8-138 chemist)*

Squibb left the city for New Jersey soon after this picture was taken, seeking room for expansion that its Brooklyn location could not provide. It was one of many companies to leave the city in this period.

In the early 1950s employers introduced new equipment that linked typewriter keyboards to linotype machines; printers could be replaced by typists—generally women—who could be hired at cheaper rates. The International Typographical Union fought these changes by negotiating a contract requiring that all work within the union's jurisdiction remain in the hands of printers. But new technologies continued to displace skilled workers, and printers no longer exert control over the printing process.

BERTRAM POWERS, former president, Typographical Union Local 6, responsible with arbitrator Theodore Kheel for bargaining the landmark 1974 agreement providing job protection for printers as the city's daily newspapers introduced cold-type:

"I was present as a child, twelve years old or younger, when two uncles who were pressmen were talking about their union. And they said, one to the other, 'The Typographical Union, that's a union!' The other one says, 'Why do you say that?' He says, 'Because they're very strong. You know there's an

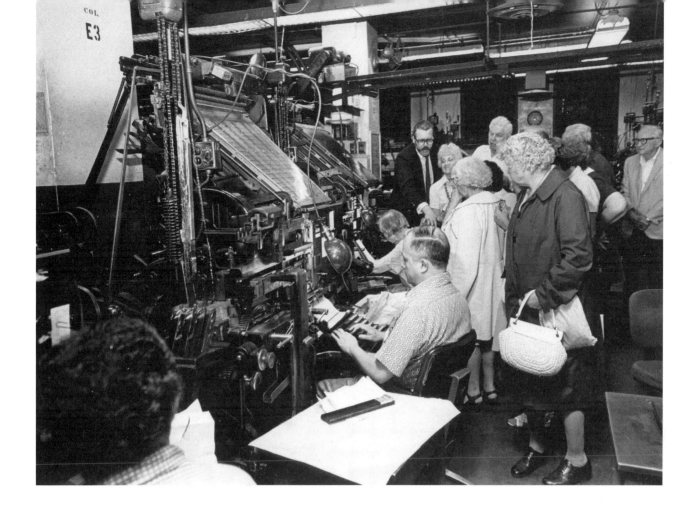

invitation for setting type without the need of typographers or printers. And the union bought the invention, bought the patent, and they keep it in their safe and won't let anybody use it.' And the other one said, 'Well that is very good.' And I thought to myself, that sounds very good to me. I later became a printer and did join the Typographical Union, but that was my first introduction to the word 'typographical.' By the way, they didn't have any such patent. I wish they had. Now [1996] we're down to about four hundred working members, down from ninety-five hundred in 1974."

Printer working on linotype machine as visitors look on. *(1975, Robert F. Wagner Labor Archives, Reiss Collection, photograph by Sam Reiss)*

HELEN ZALPH, a proofreader at a major city newspaper and member of Typographical Local 6:

"The old-time print shop was vastly different. It was one huge room and you could stand up on one end and see everybody working. We're very separated from each other now and you don't have the same sense of being one union and one group of people. It's the people in the laser room and the people in the computer room and the VDT operators. Everybody's separated from everybody else. They have largely destroyed the pride of craft. You let the computer do it all. You don't have to know typeface, you don't have to know a type size, the computer knows it. I think that's kind of sad. I liked the old print shop much better."

A mechanic working in the cab of a car at Manhattan Ford. *(Circa 1981, United Auto Workers Local 259, photograph by Bob Gumpertz)*

In the last third of the twentieth century New York City's economy was restructured by the globalization of capitalism. A revolution in transportation made cheaper labor markets elsewhere more attractive. At the same time the city's central role in media and finance enhanced its value as a corporate headquarters.

JOE CRAVOTTA, president, Local 259 United Auto Workers:
"Since our last contract, we're called technicians, not mechanics anymore. The work is now highly technical, not mechanical. Our members are the most highly trained technicians in the industry—80 percent of New York City and Long Island auto dealerships are unionized. It's a whole different ball game from when I started as a mechanic as a teenager, at Brooklyn Automotive High School in the early 1950s. I worked in gas stations, repair shops, and in 1964 I went to work in a car dealership. Cars were a lot easier to diagnose and repair than they are now. Technicians now use hand computers to find problems and to learn how to fix them. When I started the pay was $3.03 an hour; now it's anywhere from $22 to $26. You ask how many cars are there in the city? Who can count them? Just don't stall at a traffic light or park in the wrong place!"

The original caption of this photograph reads: "In the dimly lit clutter of the Fable Toy Company in Brooklyn, approximately 50 workers sew and stuff fluffy toys that appear on the shelves of department stores. In an average week the primarily Latin and Black employees spend one or two days without heat in the building. They bring brown bag lunches for their half-hour lunch break, and then go back to jobs that break down along sex-role lines—the men working heavy machinery and the women mostly sewing and stuffing." The photographer recalls the air in this place as being thick with stuffing and seemingly dangerous to breathe. White particles in the air are visible in front of the woman's dark sweater. The factory, founded by the Lower East Side employers who owned it when this photo was taken, was sold to an immigrant family who now manufacture the toys abroad and ship them to New York.

Workers at the Fable Toy Company in Brooklyn. *(1979, Tamiment Institute Library, Liberation News Service Collection, photograph by Laurie Leifer)*

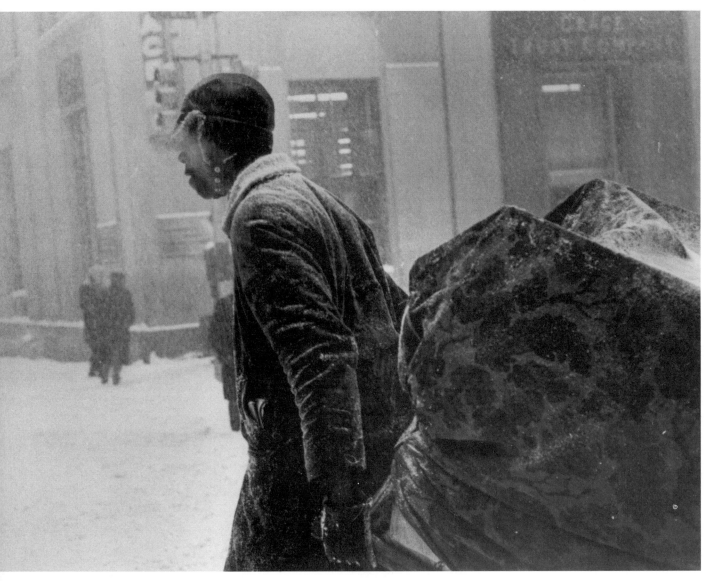

Hauling garments in the snow. *(Undated, ILGWU Archives, Kheel Center, Cornell University, photograph by Jerry Soalt)*

The garment industry in New York peaked in 1947 with 350,000 workers; by 1993 there were only 86,000. In the last two decades, however, there has been a resurgence of sweatshops, many of them employing undocumented immigrants at extremely low wages.

JAY MAZUR, president of the Union of Needletrades, Industrial and Textile Employees (UNITE):

"New York City's apparel industry has been the gateway for new immigrants to our city for over a century. Each new wave of workers, most of them women, found opportunity in the garment shops, but each also struggled with the relentless competition in the industry, which forced down labor standards, pitting workers against each other. The languages and faces have changed as the workforce changes—Jewish, Italian, African American, Latino and Asian—but all have shared a commitment to struggle for better conditions and all have found in the union a vehicle for a better life. Today, the struggle is, if anything, harder than ever, as giant corporations search the globe for low cost labor."

"Sau Kuen Wong, single operator." *(Undated, ILGWU Archives, Kheel Center, Cornell University, photograph by Bob Gumpertz)*

The culture industry in New York employs nearly 150,000 artists, craftspeople, and technicians and attracts some 21 million tourists each year, who stay at hotels, eat in restaurants, shop in stores, and ride in taxis, subways, and buses. Art and entertainment events of the city generate an estimated $13.4 billion in annual revenues. Funds spent on art, culture, and entertainment generate as much as eleven dollars for each dollar directly spent, creating a "ripple effect" because of the affiliated industries that benefit from the activities of the patrons and audiences.

Backstage in the wardrobe room at the Broadway production of *Barnum*. (1981, photograph by Rivka Katvan for the Theatrical Wardrobe Union Local 764, IATSE)

Bronx Bureau of Child Welfare job action protesting excessive case loads. *(1981, Robert F. Wagner Labor Archives, Social Services Employees Union Collection)*

Funds for public assistance were cut during the fiscal crisis of the mid-1970s, and cut further by Mayor Ed Koch beginning in 1978. With the election of President Ronald Reagan in 1980 housing programs, welfare, disability, hot-lunch programs, and food stamps were all dramatically reduced. Welfare workers were left with larger and larger numbers of people in need, fewer and fewer resources, and fewer and fewer workers to deal with the problem.

Union workers from hotels city-wide participate in a bed-making contest. *(1993, Hotel, Restaurant and Club Employees Local 6)*

For two decades the New York Hotel Trades Council and the Hotel Association of New York City jointly sponsored the Hotel Olympics. Events ranged from physical feats to artistic and culinary achievements—waiter/waitress races carrying trays of drinks, food displays, ice sculpture, the best original drink, the perfect martini. More than 50 percent of hotel employees work in the housekeeping department.

This worker is one of a small number of former welfare recipients who landed city jobs; she got hers through a training program run by the American Federation of State, County and Municipal Employees District Council 37. The Work Experience Program requires men and women on assistance to work cleaning streets, raking parks, painting city housing projects, and processing paperwork. The number of hours they work is based on the value of their welfare check and food stamp allotment divided by the $5.15 minimum wage. In mid-1998 the number of New Yorkers on public assistance was nearly one-third fewer than five years earlier, though the number of people living below the federal poverty line was estimated to be at least one in five, as it had been for a decade.

Lola Armond, a Work Experience Program (WEP) participant now employed in a school cafeteria at PS 172 in the Bronx. *(1997, AFSCME DC 37,* Public Employee Press *photograph by George Cohen)*

A Bell Atlantic cable splicer repairing a telephone cable after a 1998 gas main explosion on Fifth Avenue near Eighteenth Street disrupted phone and electrical service. This hole contains fiber optic cables installed during the last decade, plastic-coated copper cables since the early 1960s, and lead cable dating back to the 1920s still in operation. *(1998, Communications Workers of America Local 1101, photograph by Jack DuMars)*

MORTON BAHR, president, Communications Workers of America:

"When I worked as a telegraph operator, we thought of ourselves as indispensable. The human skills required to transcribe Morse Code to English text, reading through sunspots and static, and having the sender resubmit portions of the message that were illegible made us feel that our jobs would always be secure. We were able to do what few others could. We felt certain that we would never be automated out of existence. We were wrong. Fortunately, we were CWA members by then. We negotiated the first automation clause in any industrial service-sector collective bargaining agreement. The contract protected our title, wage rate, and seniority. We kept our jobs while the company had flexibility to assign us to other work. Without the union, we surely would have been out on the street. Today the information industries are converging: the industries of telecommunications, information, media, and entertainment—TIME, for short. And so must their unions."

Like many other immigrant groups, Korean immigrants found an occupational niche that grew as new arrivals were helped by established kin. In 1991 Koreans ran 10,000 small businesses, primarily green groceries, retail fish markets, and dry cleaners. They arrived with considerably more education than most immigrants (74 percent of arriving householders had completed college in Korea), and most often with relatives (close to 90 percent arrived with their spouses), and many set up three-generation households.

Korean greengrocer. *(1998, photograph by Anna Strout)*

New York Stock Exchange trading floor. *(1997, New York Stock Exchange Archives)*

In 1995 two of every three jobs in the city were in finance and service, but the distance between highly paid professional and technical jobs and low-wage service sector jobs increases yearly. A 1999 report on the state of working New York by the Fiscal Policy Institute warned that New York City is far more dependent on the volatile Wall Street sector than previously and could again be subject to a painful contraction should the unparalleled boom come to an end.

DANIEL J. WALKOWITZ, historian:
"As a global city, New York has become more sharply divided between an affluent, technocratic, professional white-collar group managing the financial and commercial life of an international city and an unemployed and under-employed service sector which is substantially black and Hispanic. Earlier divisions in the city were ethnic and economic, today racial and gender divisions and the growing predominance of white collar work on the one hand and worklessness on the other hand have made New York's labor market resemble that of a third world city. Blacks and to a less extent Hispanics have gained employment in government, banking and health services. But a vastly disproportionate share of racial minorities face widespread unemployment, and pervasive underemployment in low-paid work in maintenance and service jobs attending the offices and restaurants where the affluent professionals work and dine."

"Speak up for the voiceless, for the rights of all the unfortunate. Speak up; judge righteously; champion the poor and the needy."
—Old Testament, Proverbs 31:8, 9

"Whatsoever you do to the least of my brothers, that you do unto me."
—New Testament, Matthew 25:40

"We hold these truths to be self-evident: that all men are created equal, that they are endowed by their creator with certain inalienable rights, that among these rights are life, liberty and the pursuit of happiness."
—Declaration of Independence, 1776

"Workers of the world unite! You have nothing to lose but your chains!"
—Karl Marx
The Communist Manifesto, 1848

"An injury to one is the concern of all."
—Knights of Labor, 1869

"Let us help one another while we build a better world for all."
—Arbeiter Ring (Workmen's Circle) Constitution (founded 1897)

CREATING A CULTURE OF SOLIDARITY

The Cradle of the Labor Movement

3

Working people have shaped the face of the city in a myriad ways. They have built its buildings and created its vast wealth. They have established cultural traditions and institutions that give the city its special character. They have struggled for solidarity, a society in which the concerns of the many take precedence over the ambitions of a few. Many of the gains won by New York's workers were firsts, setting precedents for the national labor movement.

For over a century workers, through their labor organizations, have fought for certain basic objectives: full employment, a safe workplace, a living wage, shorter hours, an end to discrimination, the right to organize and bargain collectively, and "economic democracy" for workers at home and abroad. Through many tactics—organizing on the job, lobbying in Albany and Washington, walking a picket line or marching in a demonstration that brings issues to the national consciousness—ordinary New Yorkers have struggled to improve conditions in the workplace and the community.

Early twentieth-century labor activists drew strength from the cultural, intellectual, and ethical traditions of new immigrants and from a strong nineteenth-century tradition of craft unionism in America.

American Federation of Labor banner. *(Circa 1886)*

PETER J. McGUIRE, 1852–1906

Denounced by his father on the steps of the Catholic church for his radicalism, McGuire went on to become one of the best known labor leaders of his era. Samuel Gompers, with whom he helped found the American Federation of Labor, called him one of "our most gifted and devoted trade unionists." Founder of the national United Brotherhood of Carpenters and Joiners, McGuire worked tirelessly until his premature death at age fifty-four to organize every carpenter in the nation and to improve their working conditions. He served as editor of the union's newspaper, and championed the eight-hour work-day as a cure for unemployment. He led nationwide strikes for the eight-hour day in both 1886 and 1890. Under his leadership the Brotherhood became one of the most influential and progressive craft unions in the country. McGuire is remembered in the labor community as a key organizer of a one-day strike in 1882, and of the parade to Union Square that September that eventually led to the establishment of Labor Day as a national holiday. His motto "Organize, Agitate, Educate" still resonates with trade union activists.

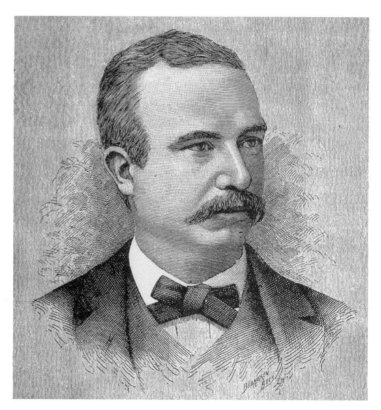

Peter J. McGuire, 1852–1906. *(1880s, Tamiment Institute Library)*

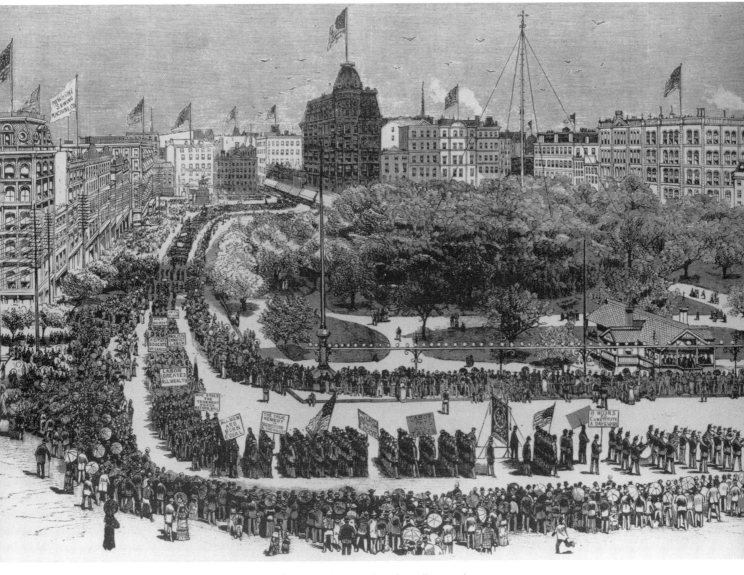

First Labor Day Parade, Union Square, September 5, 1882. *(Frank Leslies' Illustrated, Robert F. Wagner Labor Archives)*

After a decade of oppressive economic and social conditions, New York City's newly formed Central Labor Union called for a public showing of labor's strength. More than 30,000 members of the Knights of Labor and craft unions marched up Broadway and Fifth Avenue demanding an eight-hour workday; at the time, most worked ten hours or more per day. In 1998 the National Park Service designated Union Square a national historical landmark as the site of the first Labor Day observance, as well as a place where workers exercised their rights of free speech and assembly through many years of May Day parades, unemployed demonstrations, and protest rallies.

Above. Russian Labor Association in Labor Parade, May 1909. *(Library of Congress, Bain Collection); Below.* Elizabeth Gurley Flynn, 1890–1964, shown here speaking when she was fifteen years old. *(1905, Tamiment Institute Library, Elizabeth Gurley Flynn Collection)*

ELIZABETH GURLEY FLYNN, 1890–1964

As a teenage organizer for the Industrial Workers of the World (IWW), Flynn was first arrested in 1906 for blocking traffic while addressing a socialist meeting on Broadway. She was a leader in major strikes around the country, including the Lawrence, Massachusetts, textile strike of 1912; the Paterson silk strike of 1913; and the Mesabi Range miners strike of 1916. Flynn fought to save IWW organizer Joe Hill from execution for murder in Utah, and she inspired his labor song "The Rebel Girl." Active in defending those arrested during the post–World War I Red Scare, she was also a founding member of the American Civil Liberties Union (1920) and spent seven years organizing to defend the Italian-born anarchists Sacco and Vanzetti. She joined the Communist Party in 1936, wrote a column for the *Daily Worker,* served three years in prison for her leadership in the Communist Party, and in 1961 was the first woman to chair its National Committee.

Founded in 1903, the Women's Trade Union League was an attempt to forge a cross-class alliance between wealthy and working-class women, with the goals of organizing all workers into trade unions and fighting for equal pay for equal work, an eight-hour workday, a minimum wage scale, and women's suffrage. Women with socialist, trade unionist, and feminist ideals came together in an organization that was very visible and effective in its early years.

Women's Trade Union League Labor Parade, circa 1909. Rose Schneiderman is in the front row, next to last on right. Note the sign "We Condemn Child Labor." *(Robert F. Wagner Labor Archives, Schneiderman Collection)*

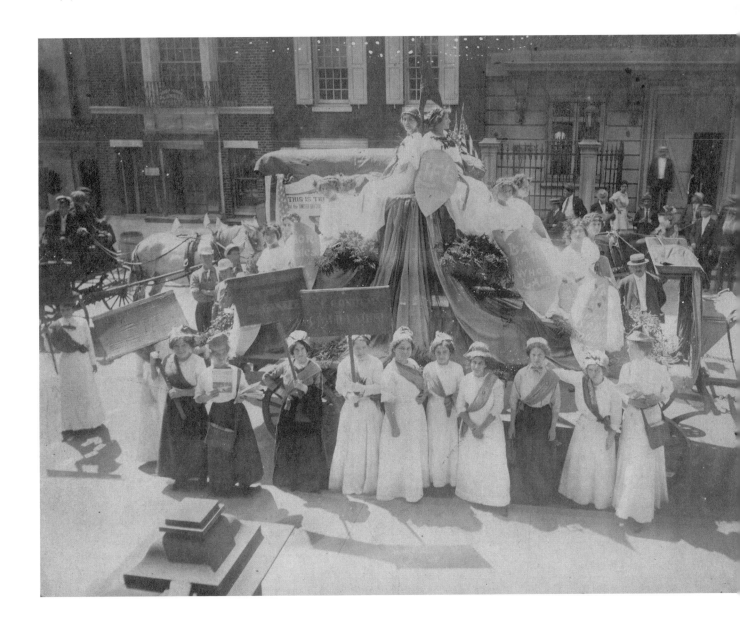

LEONORA O'REILLY, 1870–1927

While working long days as a garment worker, O'Reilly created a Working Women's Society, inspired the formation of the New York Consumers League, and brought her workplace into a local of the United Garment Workers. She was a founder and guiding light of the Women's Trade Union League, playing an important role in the 1909 shirtwaist strike. In 1911–12 she was president of the Wage Earners Suffrage League (later it became part of the Industrial Section of the suffrage association). She was a Socialist, a founding member of the National Association for the Advancement of Colored People, and a compelling speaker who spent her life agitating for the improvement of working women's lives.

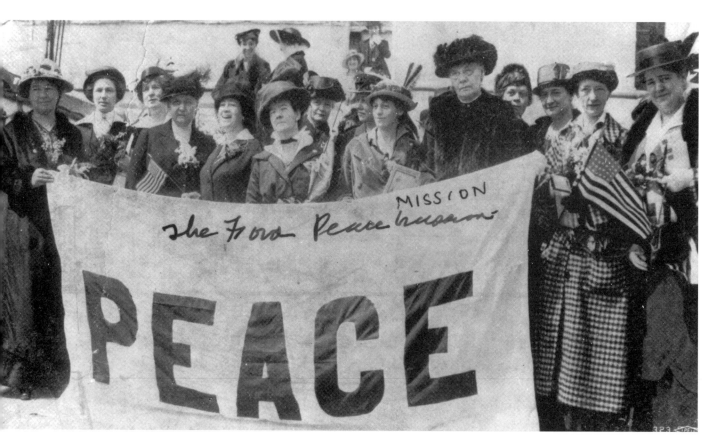

Leonora O'Reilly, 1870–1927, shown here in checked coat holding the American flag. Henry Ford sponsored a "Peace Ship" in December 1915, a delegation of one hundred socialists, feminists, and pacifists aiming for a negotiated peace. *(Undated, Robert F. Wagner Labor Archives, Schneiderman Collection)*

Union Label advertisement.
(Early 1900s, Robert F. Wagner Labor Archives, American Federationist*)*

The Union Label Trades Department of the AF of L encouraged—and still encourages—consumers to buy goods made by unionized workers. They often used images of men as breadwinners and women as helpmates, housewives, and consumers in their campaign literature. Notice the class message implicit in the advertisement. Clothing could assert or mask class differences. Between 1916 and 1947, the Central Union Label Council, the New York affiliate, operated a store at 902–4 Broadway in Brooklyn that sold union-labeled merchandise—clothes made in union shops.

On November 22, 1909, a twenty-three-year-old Jewish immigrant garment worker from Russia named Clara Lemlich sat in the Great Hall at Cooper Union. She listened with hundreds of fellow shirtwaist workers as Samuel Gompers and others debated whether their union, the International Ladies' Garment Workers Union, should call a general strike. Suddenly she raced to the platform and, speaking in Yiddish, she said: "I am a working girl, one of those striking against intolerable conditions. I am tired of listening to speakers who talk in generalities. What we are here for is to decide whether or not to strike. I offer a resolution that a general strike be declared—now!"

The crowd went wild. When the chairman finally restored order, he asked for someone to second the motion. The entire assemblage shouted its response.

For thirteen weeks that winter, 20,000 strikers, most of them young Jewish and Italian women, walked the picket line and beat off employer thugs. The settlement improved working conditions, though the union was only recognized in some shops.

Shirtwaist makers strike, "Uprising of 20,000." *(1909, Tamiment Institute Library)*

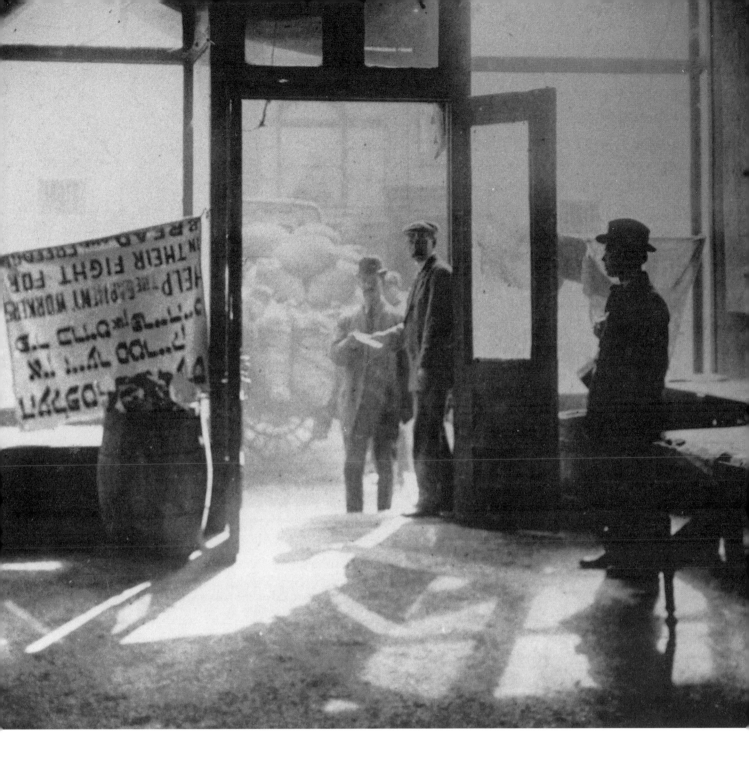

Just five months after the shirtwaist makers strike was settled, 60,000 cloak-makers, most of them men, struck. The employers turned to jurist Louis Brandeis, who helped reach a settlement that became known as the Protocol of Peace. This landmark agreement required employers to give preference to union members if they were equally qualified for a job, abolished home work and inside subcontracting, established a six-day workweek of fifty-four hours, and created the machinery for arbitrating disputes and grievances.

The poster in the window reads "Help the garment workers in their fight for bread and freedom," in English and Yiddish. *(1910, ILGWU Archives, Kheel Center, Cornell University)*

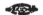

Fellow Workers!

Join in rendering a last sad tribute of sympathy and affection for the victims of the Triangle Fire. THE FUNERAL PROCESSION will take place Wednesday, April 5th, at 1 P.M. Watch the newspapers for the line of march.

צו דער לויה שוועסטער און ברידער !

די לויה פון די היילינע קרבנות פון דעם טריינגעל פיער וועם זיין
סימוואך, דעם לפטען אפריל, 1 אדזר נאכטיטטאג.

קיינער פון אייך מאר ניט פערבלייבען אין די שעפער ! שליסם זיך און אין די רייהען
פון די מאציערנדע ! דריקם אויס אייער סימפּאטיע און פּרטעמט קעגען דעם
נרויסען אומגליק וואס די ארבייטערוועלט האט געהאם
געלימען די קעפ — סיס ציטעטרע הערצער זאלען זיר פיהרען אונזערע מחייערע
מפעערם צו זייער לעצטער רה.
וואמט די צייסונגען דורך וועלכע זיר וועלען לאזען וויסען וואו איהר קענט זיך
צוואמענקלימען.

צו דער לויה פון די היילינע קרבנות,
קומם שוועסטער און ברידער !

Operai Italiani!

Unitevi compatti a rendere l'ultimo tributo d'affetto alle vittime dell'imane sciagura della Triangle Waist Co. IL CORTEO FUNEBRE avrà luogo mercoledi, 5 Aprile, alle ore 1 P.M. Traverete nei giornali l'ordine della marcia.

English, Yiddish, and Italian announcement for Triangle Shirtwaist Fire victims' funeral procession. *(1911, Tamiment Institute Library)*

More than 80,000 mourners marched for hours in a rainstorm to pay tribute to the 146 workers, most of them Jewish and Italian teenage girls, who were killed in the Triangle Shirtwaist Factory on March 25, 1911. That Saturday afternoon, about five hundred employees were at work making the high-necked blouses worn by working women of the day. At 4:30 P.M. there was a muffled explosion. Smoke poured out of the eighth-floor windows. Within minutes flames raged out of control; girls jumped to certain death from windows high above the street; locked exits and a fire escape that buckled under the weight of fleeing workers blocked escape. The fire lasted only eighteen minutes.

The tragedy shocked and outraged the nation. At a memorial meeting in the Metropolitan Opera House, Rose Schneiderman, a young garment

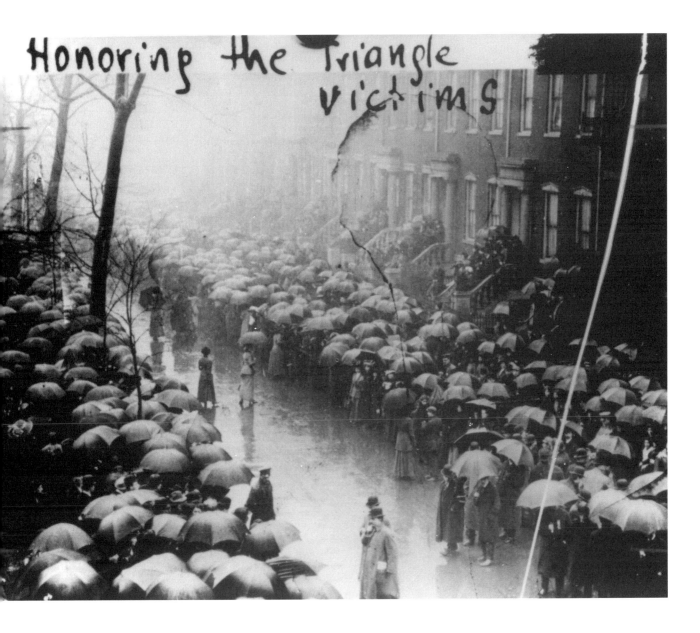

Honoring the Triangle victims

worker and organizer for the New York Women's Trade Union League, spoke: "Every year thousands of us are maimed. The life of men and women is so cheap and property is so sacred! I know from my experience it is up to the working people to save themselves, and the only way is through a strong working-class movement."

Out of the crucible of the Triangle Fire, that movement grew. It pushed politicians to accept a new notion of the responsibilities of government. The extensive work done by the commission set up to investigate the fire—the New York State Factory Investigating Commission—ultimately resulted in passage of thirty-six new labor laws, the foundation of New York State's industrial code, and an industrial safety model for the nation.

Mourning the Triangle Shirt-waist Fire victims in the rain. *(1911, ILGWU Archives, Kheel Center, Cornell University)*

ROSE SCHNEIDERMAN, 1884–1972

Instrumental in getting women admitted to the Hat and Cap Makers' Union, Schneiderman participated in a successful strike and went on to become one of the best known women in the labor movement. She was first an organizer and later an officer of the New York Women's Trade Union League before becoming president of the organization for two decades. She was an official of the National Recovery Administration in the 1930s and served as head of the New York State Department of Labor 1937–1943. Famed as a speaker, she fought for women's suffrage, organized some of the most exploited workers in the city, and trained a new generation of organizers.

Rose Schneiderman, 1884–1972, posing at a sewing machine. *(Undated, Robert F. Wagner Labor Archives, Schneiderman Collection)*

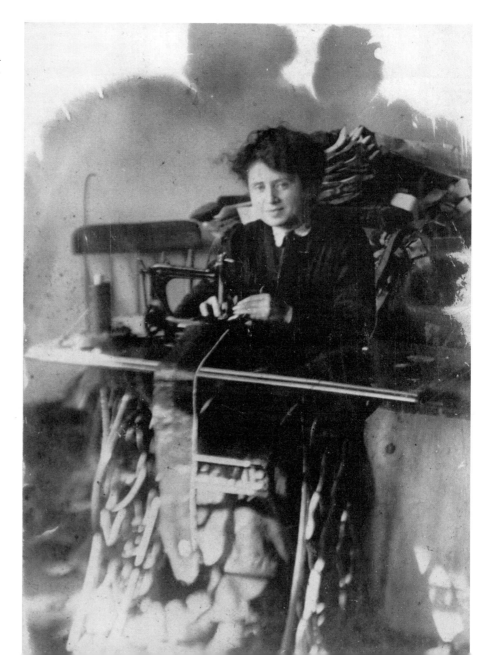

"Your Honor: The information connected with this movement is not for personal gain or profit, but for the education of the working and professional class who harrassed by economic conditions, by the high cost of living, by the terrible congestion of our large cities, cannot decently provide for a large brood of children, as a result of which their children are born weak, are ill cared for and ill nourished."

Emma Goldman Speech in Court.

Birth Control Meeting
Friday, May 5th, 1916
8 P. M.
At CARNEGIE HALL
57th Street and 6th Avenue
TO WELCOME

EMMA GOLDMAN
FROM PRISON

And demonstrate that locking up a propagandist does not prevent the dissemination of Ideas.

We still live in a Country, where it is a crime to teach people that which no one can deny, will make the world a better place in which to live.

SPEAKERS:

ROSE PASTOR STOKES	HARRY WEINBERG
PROMINENT DOCTORS	EMMA GOLDMAN
LEONARD D. ABBOTT	And Others
MUSIC	*THEODORE SCHROEDER, Chairman*

Admission 15, 25 and 50 Cents Boxes $5.00

Tickets on sale at Mother Earth, 20 East 125th St. Tel. Harlem, 6194

If you believe that all serious minded women and men should have the right to learn about Birth Control Methods and any thing else that will better their conditions, then you can not afford to miss this meeting.

Movements challenging exploitation of all kinds were at a high point in the teens, and free access to birth control information was one of their most radical demands. Margaret Sanger and Emma Goldman were the best known advocates, and both made speeches, published widely, and were arrested for their efforts. The birth control movement was initially carried forward by socialists and radical union organizers, though later it became separated from workers' movements and sought the support of medical professionals.

Handbill for a birth control meeting welcoming Emma Goldman from prison. *(1916, Tamiment Institute Library, Rose Pastor Stokes Collection)*

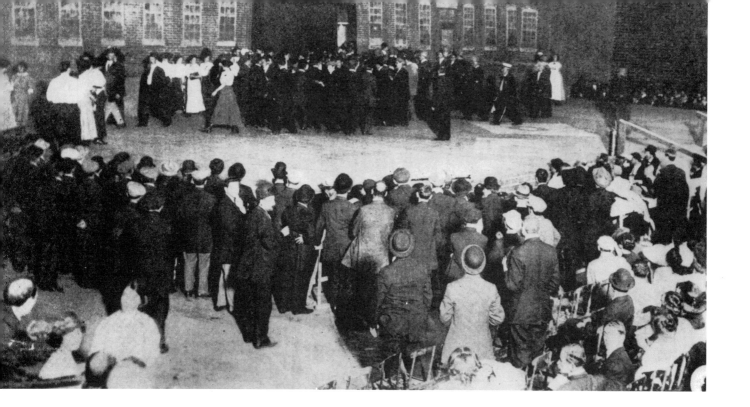

Paterson textile strike pageant, Madison Square Garden. *(1913, Tamiment Institute Library)*

Fifteen thousand workers and their allies crowded into New York's Madison Square Garden to see strikers reenact events from the Paterson, New Jersey, textile strike. Organized in the middle of the strike to benefit the workers, the pageant was staged by journalist John Reed with a set designed by artist John Sloan. The event was a high point in the collaboration between activists and artists in the fight to win better conditions for working people.

ALICE KESSLER-HARRIS AND BEATRIX HOFFMAN, historians:

"New York City workers have created and supported many different kinds of social and political movements throughout the century. From radical endeavors to reform the relationship of property to wage labor, to mainstream attempts to construct 'machine politics' that would make the urban political system work for them, to energetic efforts to promote forms of cooperative living, these have invariably been rooted in the city's ethnic communities.

The unique character of New York City, its dense and cohesive immigrant neighborhoods, have provided New York workers with both a strong sense of cultural identity, and the ability to move beyond their own locales to try and change the world. The tensions between tradition and change, between the desire to retain a sense of solidarity and the temptations fostered by a sense of community with workers nationwide and worldwide, have produced a dynamic and responsive political spirit. Fueled by the ebb and flow of economic cycles and of the shifting character of the urban population, New York has given rise to more than its share of visionary ideas and of leaders capable of articulating and acting on them."

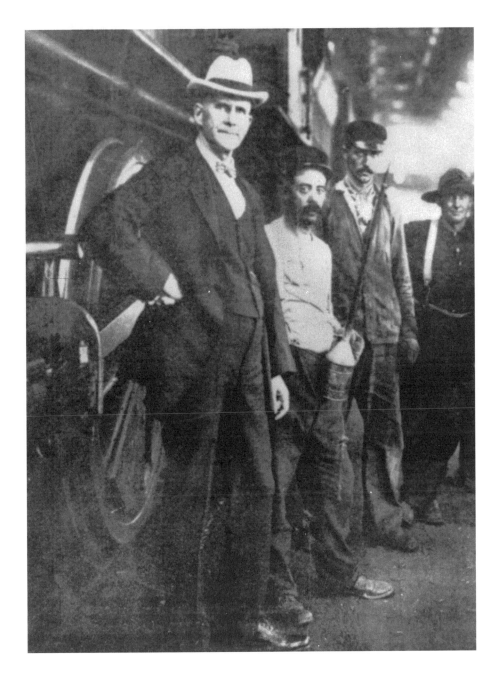

New York City was a national center of socialism from the late nineteenth century through the Depression. In 1912 New Yorkers helped Eugene V. Debs win nearly a million votes in the presidential election (6 percent of the votes cast). Workers on the Lower East Side, many of them from the garment industry, elected Socialist candidate Meyer London to the U.S. House of Representatives three times, and in 1917 the city elected ten Socialists to the State Assembly and five to the city Board of Aldermen. Debs and London both were heroes of the labor movement in the early decades of the century.

Eugene V. Debs with the crew of the "Red Special," the train that transported his campaign for the presidency of the United States. *(1908, Tamiment Institute Library)*

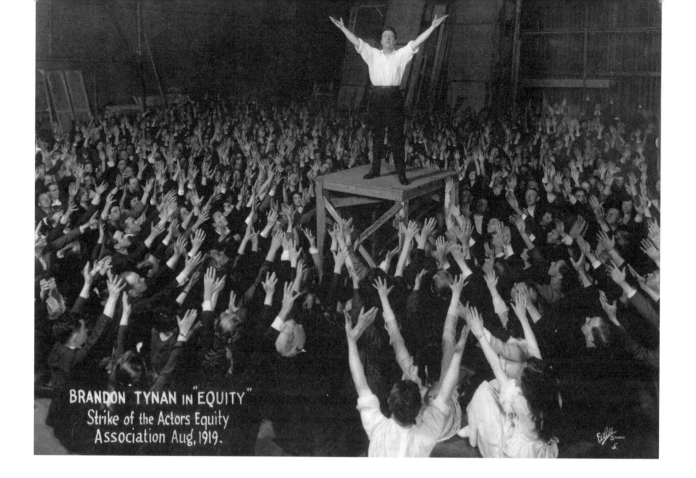

BRANDON TYNAN IN "EQUITY"
Strike of the Actors Equity
Association Aug, 1919.

Actors' Equity strike of 1919, re-created during the strike at the Lexington Avenue Opera House. *(August 1919, Robert F. Wagner Labor Archives, Actors Equity Collection)*

Socialists and immigrants with radical agendas (including Eugene Debs, Emma Goldman, Elizabeth Gurley Flynn, and the Industrial Workers of the World) bore the brunt of the World War I era Red Scare, and repression continued throughout the 1920s. Despite the hostile climate, unions such as Actors' Equity and the Sleeping Car Porters won important contests, and labor schools overcame the attacks to lay important groundwork for the rebuilding of the left and labor that would follow in the 1930s.

Often called the "revolt of the actors," the 1919 strike established the newly formed actors' union as a force in the American theater. Actors' Equity produced shows to raise money for the strike fund, including the one pictured here, with actor Brandon Tynan declaiming a well-adapted version of Marc Antony's address to the Roman citizens at the funeral of Julius Caesar:

"Friends, Brothers, Sisters, Countrymen, lend me your ears. I come not to bury Equity but to praise him. The evil that men do lives after them. The good is oft interred with their bones. Not so with Equity. . . .

"Behind us we have more than five million men and women. The ship of hope—the American Federation of Labor. [The mob cheers.]

"Now, dear public, our great public. You have always stood for justice. You have always been just to us and we have always tried to be just to you. Will you stand up and show that you are with us, and join us in our cry of EQUITY! EQUITY!!, EQUITY!!!"

The crowded house sprang to its feet as the actors onstage threw back their heads, stretched out their arms, and thrilled to their cry of faith, with the audience joining in. (*New York Call*, August, 1919)

A center for socialist and labor education founded in 1906, the Rand School attracted thousands of working-class students annually. In the anti-radical hysteria after World War I, the school, located at 7 East Fifteenth Street, was subjected to a series of police actions and mob attacks. In 1919, New York state senator Clayton Lusk's committee to investigate "subversive activities" raided the school, confiscated its records, and (unsuccessfully) attempted to close it by court-ordered injunction.

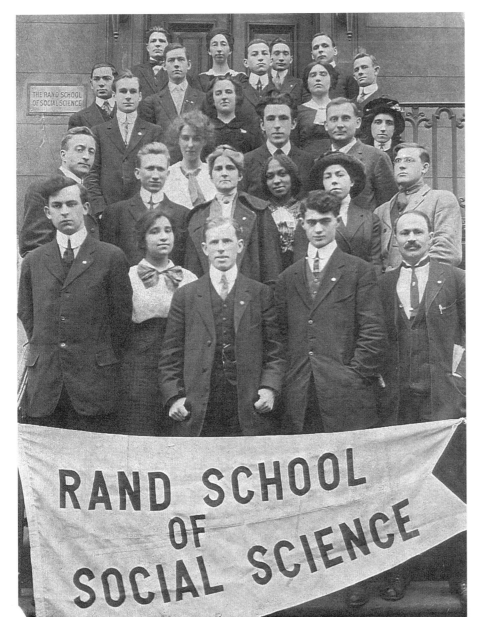

Rand School of Social Science, full-time class of 1914. *(1914, Tamiment Institute Library)*

SAMUEL H. FRIEDMAN, socialist activist:

"I had the job at Fairchild Publications. And the most important thing about Fairchild, unlike most employers of that day [was] he didn't care what you did outside, so long as I was there [made it to work on time]. Several times it got into the newspapers, but he said, 'Sam can do what he likes, as long as he's here.' As it happened, each case, I was able to be bailed out in time.

"I had left home and got myself a little room on Fourteenth Street, see, because the Rand School was in fear of being attacked. At one time it was attacked by soldiers and sailors. The American Legion would attack socialist and labor halls all across the country. If the call came, I would be ready. There was a big room with a little room in the back at 9 West Fourteenth Street, which I rented. And, after a little while, people began coming there. The door was open day and night and there was always something in the little kitchen that I set up. There were books and I bought a phonograph, so that people could come. Because they heard about the place, all across the country, if you have nowhere to go . . . people were so hungry and I was one of the few that had a job.

"The Rand School at that time had a cafeteria in the basement. So I arranged with the manager who was a fellow socialist that when you'd pay at the end of the line, people would say, 'Put it on Friedman's bill.' I would pay at the end of the month. After about two or three months, he said to me, 'You can't afford this! This is running up to one hundred and two hundred dollars!' It was chiefly communists, I was told, who would sit in front of the fire, eating our food, and hold mock trials. And the first ones they would execute would be the social fascists like Hillquit, Dubinsky, and Friedman!" [laughs]

Founded in Katonah, New York, in 1921, by a group of unionists and pro-union educators, Brookwood's residential two-year program provided scores of working-class students education in history, economics, labor journalism, and other subjects. It was the flagship of several dozen "labor colleges" established after World War I, inspired in part by Ruskin College in Oxford, England. These programs included evening classes sponsored by central labor councils and the needle trades, such as the ILGWU's "Workers' University," and summer schools such as the Hudson Shore, Barnard and Bryn Mawr Summer School for Women Workers in Industry.

Brookwood Labor College.
(Circa 1926, Tamiment Institute Library);

Clergyman A. J. Muste, later famous for his leadership in the Vietnam-era peace movement, directed the school from 1921 to 1933. Brookwood's five hundred graduates returned to the labor movement, and many became CIO organizers in the 1930s. The school closed in 1937 as a result of financial difficulties, just as the labor movement was reviving.

Brookwood class on the lawn. *(Late 1920s, private collection of Jon Bloom)*

A. Philip Randolph edited *The Messenger,* Harlem's magazine of socialist politics and culture, and actively supported socialist candidates for office. He went on to found the Brotherhood of Sleeping Car Porters in 1925.

The execution of Italian-born anarchists Nicola Sacco and Bartolomeo Vanzetti in Massachusetts in 1927 seemed to many Americans—from working-class radicals to legal scholars—to be the final blow in a series of attacks on the constitutional rights of dissidents in this country that had begun with the 1919 Red Scare. Accused of murder, and convicted primarily because immigrant witnesses on their behalf spoke halting English, their defense united labor and left organizations across the country and eventually around the world.

Opposite. "The Modern 'Gulliver,'" from an article by A. Philip Randolph in *The Messenger.* (1926, Tamiment Institute Library)

Below. Carlo Tresca speaking in New York City at a Sacco-Vanzetti demonstration in the mid-1920s, possibly in Union Square. *(Tamiment Institute Library, Roberta Bobba–Peter Martin Collection)*

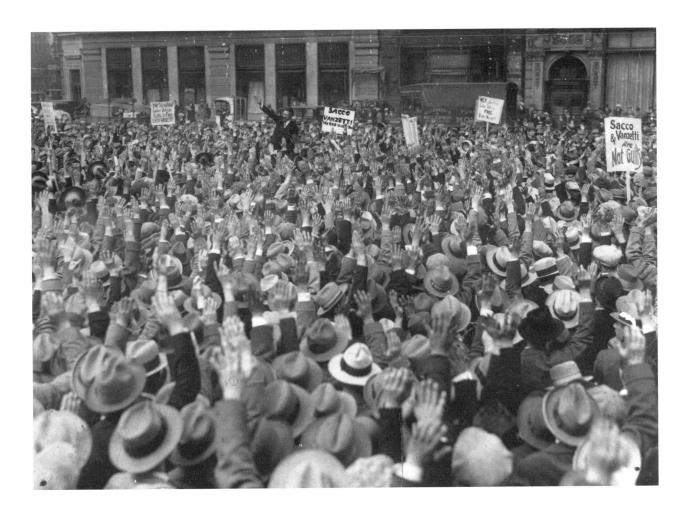

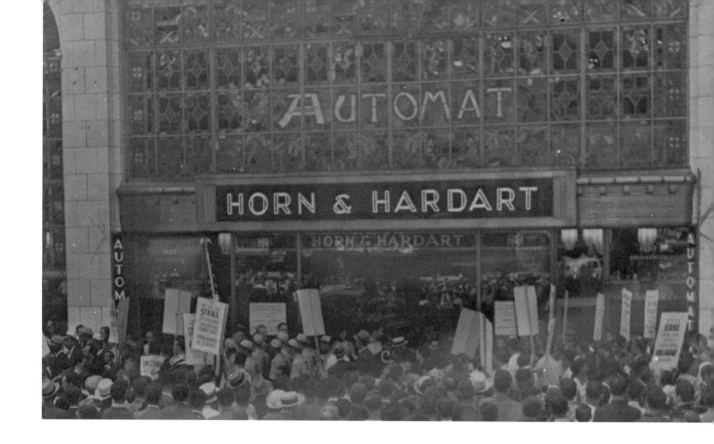

Pickets in front of the Horn and Hardart Automat. *(1934, Robert F. Wagner Labor Archives, Hotel Trades Council Collection)*

JAY RUBIN (1904–1990), founder of the Hotel Trades Council:

"I got involved in the struggle of workers very young. I came to the States in 1921 from Grodno, Poland. When I came from Europe, already I knew the struggle that went on there in a general fashion. I was part of the Bund [General Jewish Workers Union of Russia, Poland, and Lithuania]. I landed up in the Middle West, in Iowa, and I was there working nights in a bakery at forty cents an hour. I didn't like it and I wanted to go back to Europe to my country. I landed up in New York City and got involved as an uphol-sterer and began to like it. I was about eighteen years old. One of my rela-tives owned the factory and I worked for him. I didn't like the conditions and tried to get a union in the shop. I then joined the Upholsterer's Union and became the vice-president of Local 76. It was an AF of L union. I be-came very active in the union—and very much interested in the left-wing movement. The reason was very obvious. The AF of L in those days was not interested in organizing the unskilled workers. They basically organized craft unions, and the craft unions established certain principles and condi-tions. If the worker worked in a place where the conditions does not exist, they refused to take him in.

"Naturally, being interested in the lower paid, in the masses, in the work-ers that are not in craft unions, I became very much interested and organ-ized the Food Workers Industrial Union and became secretary of that partic-ular union. You have the bakers, you see, which was the original craft that I was forced to accept, and for that reason I was very much interested in get-

ting a position in the hotels as a baker. I didn't enjoy it, but it was a neces-
sity. It was not easy any place to get a job in those days. I became the secre-
tary of the Food Workers Industrial Union and we tried to organize the un-
skilled workers that the AF of L refused to take in.

"*In 1934 the AF of L union called a strike at the Waldorf which was*
their mainstay. They rushed too fast and based themselves only on the sec-
tion which you can reach easier, the waiters. The waiters were a radical
breed, basically Germans and Italians. I think because of their freer time,
they read, they philosophized. The strike was lost.

"*We decided among ourselves in the Food Workers Industrial Union to*
join the Hotel and Restaurant international union (AF of L) and liquidated
the Food Workers. We then insisted, as part of our joining, that they should
give us money and permit us to organize New York City. They agreed and es-
tablished an organizing committee and gave us twenty-four thousand dollars.

"*We didn't concentrate on the hotels yet. We concentrated on restaurants.*
Child's in those days had forty or forty-five restaurants. We concentrated on
Child's and were successful. At that time the AF of L unions were under in-
vestigation for racketeering and Thomas Dewey was the prosecutor. But he
didn't want to be known as anti-union, so as a matter of fact, he was a great
help to us to be able, at least, to talk to the management. By making a state-
ment that he believes that we have nothing to do with the corruption in the
other unions, he had a tremendous effect. We had an election and we won.
This was the first success that we got. In the Automat, we struck. We lost it.
We then tried to organize the Tiptoe Inn which also had about forty or fifty
restaurants throughout the city.

"*We tried to work out unity between the craft union and ourselves, and*
we were agreed that if we organized it, that they will get the waiters and
waitresses, and we will get the other workers. They put obstacles not only
there, but in many other places. Even in the hotels, they tried to prevent us
from succeeding to organize. They were afraid of our growth and influence.
They didn't work with us honestly. While we tried to organize from below
the workers, they tried to work out deals on the top with the employer.

"*We learned a few things from organizing Child's and the losing of the Au-*
tomat. We learned, first of all, that we have to establish an organization
bringing the craft unions together. And there the Council came into existence.
We have to bring the major crafts together first and see if we can't agree to
work jointly. For that reason, we concentrated in getting the electricians, the

firemen and oilers, the stationary engineers. The only one in those days that really opened the door was Harry Van Arsdale, the president of the electrical union. They were not big in numbers in the hotels, but they're very important.

"At that time the hotels were basically controlled, the majority of them, by the New York Central and Pennsylvania Railroad. Hotel workers were considered, prior to the organization, like servants, not like workers. As a matter of fact, in many of the hotels, the maid had to sleep in to be available twenty-four hours a day. It was only when we came in that this was broken down. We were able to organize a hundred percent in the hotels finally."

<p style="text-align:center">• • •</p>

Conditions during the Depression spurred a revival of activism and union organizing. Led nationally by United Mine Workers president John L. Lewis and other labor leaders who broke away from the American Federation of Labor, the new Committee for Industrial Organization, later renamed the Congress of Industrial Organizations (CIO), advocated organizing workers on an industrial basis rather than into the traditional small craft unions of skilled workers. Workers in auto, steel, textile, and other industries flocked into the new industrial unions. In New York City, young, left-leaning, first- and second-generation immigrant CIO organizers built unions in retail, maritime, transport, journalism, and education; others worked to rebuild existing unions.

John L. Lewis was quoted as saying, "Who gets the bird, the hunter or the dog?" He used Communists to help organize the CIO, which he then controlled. The period of the Depression represented the heyday of American Communism—close to a million people supported the Communist Party's militant stands for home relief, unemployment insurance, social security, and other reforms, though the number who actually joined the party was 100,000 or less.

IZZIE AXELROD, Brooklyn house painter, Alteration Painters Local 1:
"I was walking down Fourth Street and there was all kinds of crowds of people and hordes of police. The cops start pushing me and it winded up they pushed me into the heart of the demonstration on Fourteenth Street. So that was the first time I had contact with masses of workers and, of course, with the left. I remember I was very—oh!—enthusiastic about this demonstration, and I thought that this was the opportunity, being a worker and coming from a working-class community, there was a way out."

ROBERT McELROY, merchant seaman, National Maritime Union:

"I'm on Whitehall Street and South Street and there is a soap box, and on that soap box is a [waterfront labor organizer] man by the name of Norman Talentyre and he's describing the ordinary life of a seagoing being. He's talking about the necessity of organizing. And he recited the poem:

> *What is freedom?*
> *Ye can tell that which slavery is too well*
> *Tis' to work and have such pay*
> *As just keeps life from day to day*
> *In your soul as in a cell*
> *For the tyrant's use to dwell*
> *Rise like lions after slumber*
> *In unvanquishable number*
> *Shake your chains to earth like dew*
> *For ye are many and they are few.*

Ha, that grabbed me like nothing else has ever grabbed me!"

EDITOR'S NOTE: Percy Bysshe Shelley would recognize the lines, lifted and rearranged from his "The Mask of Anarchy: Written on the Occasion of the Massacre at Manchester."

Demonstration by unemployed workers in Union Square, in front of Communist Party Headquarters. *(1934, Robert F. Wagner Labor Archives, Charles Rivers Collection)*

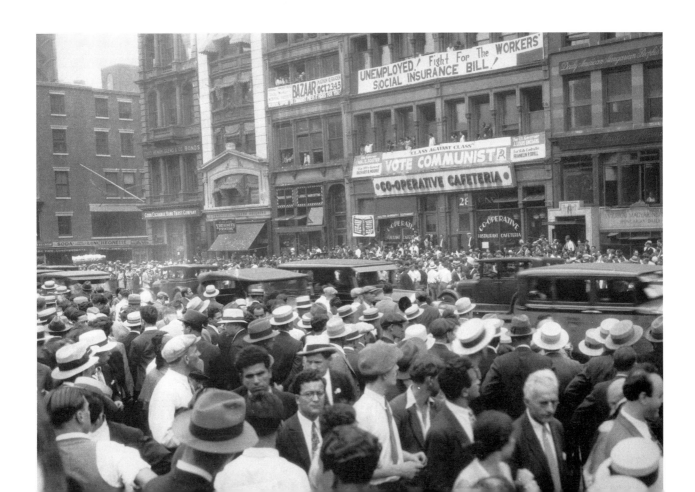

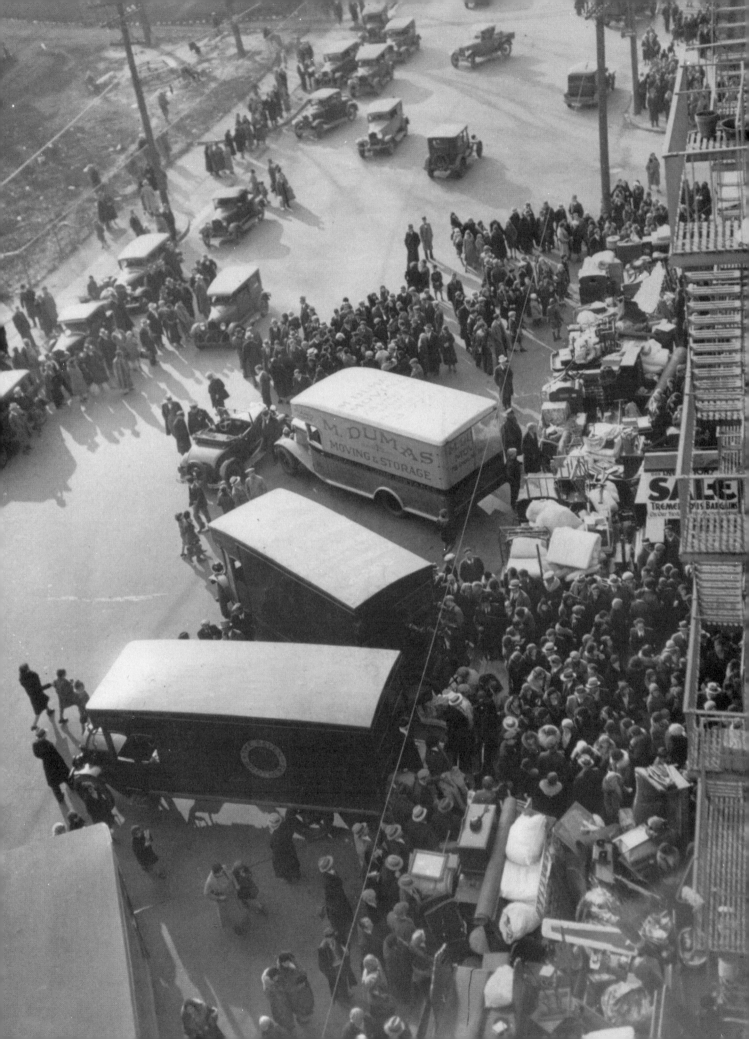

Left. Evicted family—Esther Hochberg with her children in Brooklyn. *(Circa 1934, Schomburg Center for Research in Black Culture, NYPL, International Labor Defense Collection)*

Opposite. Eviction with moving vans. *(1930s, Schomburg Center for Research in Black Culture, NYPL, International Labor Defense Collection, Corbis/Bettmann)*

Communists and socialists boldly stopped evictions during the Depression, helping families like this one move back into apartments from which they had been evicted, and organizing massive demonstrations demanding government relief programs.

SYLVIA ARONOV (1922–1998), grew up in East New York:

"During the Depression, tomato herring came in a big can and it cost a nickel. And sometimes we didn't even have a nickel, but the grocery man would let us have it and keep a list of what we owed. I was pretty young, coming home from school one day for lunch. And what did we have for lunch? Tomato herring. And I said, 'I don't want it. I don't want tomato herring any more.' Whereupon, my mother burst into tears and walked away. My oldest sister bent down and said, 'Sylvie, nobody in the family ate last night, and we were saving this last piece of tomato herring for you for lunch.' Because I was malnourished. And in my childlike way, I ran out to my mother, 'Mommy, Mommy, don't cry. I love tomato herring! I love it!' And I remember having difficulty swallowing it, knowing that nobody else ate.

"Once I was on a stage as an example for the Communist Party. My father enrolled me—a doctor was there talking about children being malnourished 'cause there's not enough to eat. There was an auditorium full of people and one by one the kids went. Papa said go, so I went."

Bonus marchers commandeer the New York–New Jersey ferry. *(1932, Schomburg Center for Research in Black Culture, NYPL, International Labor Defense Collection, Corbis/Bettmann)*

Veterans of World War I came to Washington, D.C., in the summer of 1932 to demand bonuses scheduled to be paid in 1945, but which many unemployed veterans and their hungry families needed immediately. Black and white veterans camped out in vacant lots and empty buildings as President Herbert Hoover lobbied against the Bonus bill, which failed. Many of them went home, but those who remained were eventually attacked by the Army led by General Douglas MacArthur, in a scene that shocked the country and helped elect Franklin D. Roosevelt to his first term in office.

ABRAM FLAXER (1904–1989), social worker and a founder of the CIO's State, County and Municipal Workers union:

"A person like myself had gone through the 1929 Crash, the Hoovervilles, the apple sellers, the veterans' march on Washington, the expulsion of the veterans by General MacArthur from the Anacostia Flats, the farmers' penny sales to save their farms from being auctioned off because they couldn't pay their taxes. There were these rockbound Americans talking wilder than I ever dreamed of talking—because they were pinched. I wanted to see a greater distribution of wealth for these hard-working people."

These office workers had only recently won legal protections for their right to organize, with the passage of Roosevelt's National Industrial Recovery Act in 1933. The Act's famous Section 7(a) recognized for the first time the right of workers to organize into unions of their own choosing to represent their interests.

After a flurry of bitter strikes in 1934, New York's Senator Robert F. Wagner drafted legislation that set up a federal agency, the National Labor Relations Board, to conduct representation elections, hear cases involving unfair labor practices, and encourage industrial peace. The CIO's organizing campaigns benefited greatly from these new legal protections.

The Bookkeepers, Stenographers, and Accountants' Union, an affiliate of the AF of L, attempted to organize office workers. Harry Avrutin (1916–1988), who would serve as secretary of the New York City Central Labor Council four decades later, is second from left with mustache. *(Circa 1935, Robert F. Wagner Labor Archives, Union Label Collection)*

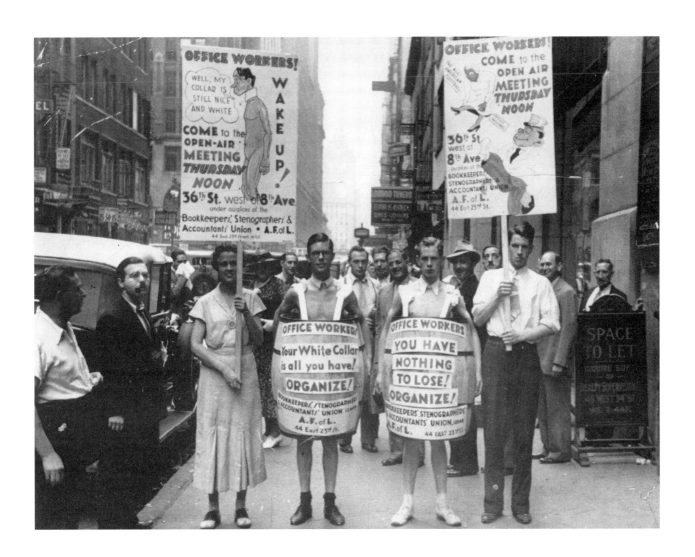

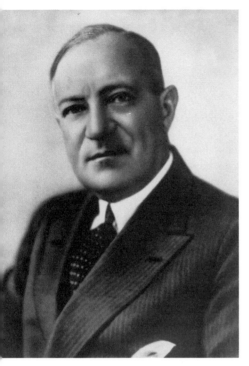

Robert F. Wagner, 1877–1953.
*(Undated, Robert F. Wagner
Labor Archives)*

ROBERT F. WAGNER, 1877–1953

Arriving in New York City as a nine-year-old immigrant from Germany, Wagner and his family suffered privation in the "land of opportunity." His mother took in washing and his father could only find work as a janitor of the tenement where the family lived rent-free in the basement. With his family's backing, Robert was able to take advantage of free public education, attending the tuition-free "people's university"—City College—graduating with honors and passing the bar to launch a brilliant career as a legislator. Called the "Father of urban liberalism," he believed all Americans should live with "social security"—old age pensions, universal health care, full employment, unemployment insurance, and affordable housing. In the New York State Senate he investigated factory conditions after the Triangle Shirtwaist Fire, and on the state Supreme Court he did much to protect the rights of labor. As a U.S. Senator (1927–1949), he was a leader in legislating the New Deal. His National Labor Relations Act, passed in 1935, was called labor's *Magna Carta*. Remembering his boyhood, Wagner would say, "I came through it, yes. But that was luck, luck, luck! Think of the others!"

LOUIS WEINSTOCK (1903–1994), Hungarian immigrant and president of the New York Painters District 9, had led a delegation to the 1932 AF of L convention in support of unemployment insurance:

"The sargent-at-arms took the credential to Bill Green [president of the AF of L] but sixteen policemen came back and said, 'You can't come in.' But the balcony was open for the public and we went up to the balcony and there was a huge chandelier somewhat close to the balcony. I climbed on that chandelier and I started to yell, 'Mr. Chairman! The convention must think of the twelve million unemployed and you must legislate and change the position of the executive council and support unemployment insurance!' This came through clear. And I got my five minutes—until they brought in the firemen and got me out, because I couldn't get back!"

ETHEL BLOCH LOBMAN (1924–1999), Red Falcon, Norman Thomas Flight 22:
"There was the rechts *and the* links—*the right and the left within the radical movement. Most of the unions in the city of New York were either lined up with the Socialist Party or the Communist Party and usually they didn't march together or hold meetings together, because their differences appeared to be greater to them than what they had in common. But for two years, 1936 and 1937, they joined together to march in a United May Day parade,*

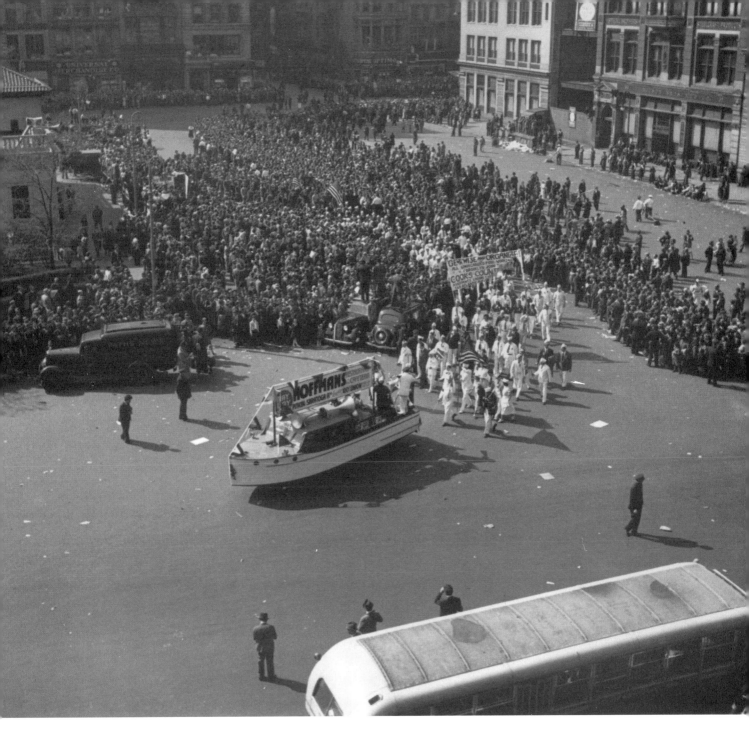

probably the largest May Day parades. All the workers in the unions, all the members of these two parties, most of whom were workers, marched together. We started way uptown near Central Park and marched all the way down to Union Square, where we circled the Square and where speakers spoke from the various trade unions and organizations.

"I was at that time about eleven years old. I had been a member of the Red Falcons of America, which was the youth group of the Socialist Party, since the age of seven. It was modeled to a large extent after the Boy Scouts,

Union Square May Day demonstration. Tens of thousands of people marched in the annual May Day parades in Union Square during the 1930s. *(1937, Tamiment Institute Library, John Albok Collection)*

which, in those days in New York, were considered fascists. We learned how to tie knots. We wore uniforms—blue shirts and red bandannas which you learned how to use as tourniquets. Falcons had a whole list of things which they were supposed to do: a Falcon was a friend and defender of nature; a Falcon was a defender of the working class. We sang all the radical songs, we gave out leaflets, we went on hikes. We took boat trips up to Bear Mountain. I still remember doing the Big Apple on the boat. It was an international organization. Our main headquarters was in the Karl Marx Houses in Vienna. And we had penpals. We wrote a lot to them. And when they were annihilated, when the fascist dictator of Austria moved against the Karl Marx Houses [in 1934] and they were all slaughtered, it was a personal tragedy. There were sixty or seventy boys and girls in our Flight.

"So May Day. It was celebrated on May 1 by all the hundreds of thousands of the city's political people. We all stayed home from school on May Day. I mean, it never occurred to us to go to school, but it was very anxiety-provoking because they took the opportunity to give tests and all that. And the next day, you had to come to school with your mother, which was always a trauma to me, because my mother spoke with an accent. But my mother was a fighter and she would just go in and blast the principal. She'd say, 'This is our holiday. It's a workers' holiday.' She'd give a whole lecture. She'd explain the class struggle. All these unions had to fight to accomplish things. She'd even say, 'Listen, all the things that you got, you got because somebody fought for them.' Oh, she'd really blast them, which was very embarrassing for me, but [laughs] I realized she was absolutely right."

After Akron rubberworkers and Flint autoworkers successfully used the tactic in 1937, the sit-down strike became widely used, until ruled illegal by the Supreme Court in 1939. In mid-March 1937, the employees of five H. L. Green chain stores, virtually all young women, staged a sit-down strike demanding the forty-hour week, a twenty-dollar minimum weekly wage, and union recognition. Four days later the employees of Woolworth's at Union Square also sat down. The occupation of the stores continued for ten days until Mayor Fiorello LaGuardia intervened, forcing a settlement providing union recognition, an eight-hour day, a six-day week, and a minimum wage of 32.5 cents per hour. Other stores followed suit, though Abraham and Straus in Brooklyn proved unorganizable and the sales employees at Macy's had to be painstakingly won department by department throughout most of

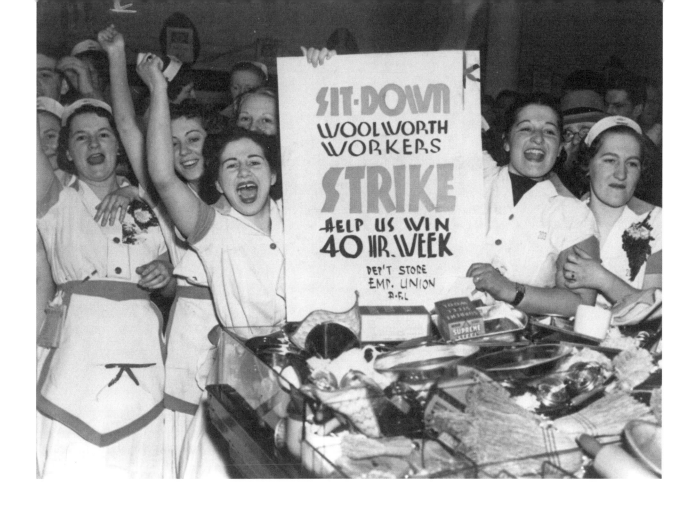

the war. The CIO made an indelible imprint on labor relations in the city's retail industry.

A sit-down strike at Woolworth's. Note the crop marks made by the editor of the newspaper and how different the cropped and uncropped photos are. *(1937, Library of Congress, New York World-Telegram and Sun Collection)*

GEORGE MEISLER, organizer, Store Workers Local 1250:

"I got fired from Hearn's at the end of 1935. I was openly organizing and I was really signing up people. There was no such thing as a salary—you just worked. We were very successful in organizing about seven H. L. Green stores. We set up this procedure for how to pull a sit-down strike. We first had contacts in the store and they knew what to do. When we blew the whistle, everybody would fold their arms and wouldn't work. Then we'd go around the store and say, 'Customers, will you please leave? This store's on strike.' And we'd get them out. . . . One morning I came in and we'd had a call from a girl at Ninety-ninth Street and Columbus Avenue. . . . Okay, I got my assignment and I went up there. One stock boy was in there and sixteen girls. Apparently the manager decided to keep the store closed to keep the union out. . . . And I says, 'Tell me what happened? The important principle is that you people have a right to be here. You have property rights to this job.' The one girl said, 'This morning they held a meeting and they called the superintendent in. He said that the union is coming in to call a strike and I want to be sure you girls are not going to strike. After all, I

know that those girls at Fourteenth Street are not like you. You shouldn't do what they did. They're the scum of the earth.' And then Mr. Kinsberg who was the manager said, 'Girls, I want you to tell me now what you're going to do. I don't want to go through this business of whistle blowing and folding your arms and pushing the customers out. So tell me what you're going to do.' So this girl spoke up, and she said, 'Look, when that supervisor called those girls at Fourteenth Street the scum of the earth he was calling us the scum of the earth. Because what they're fighting for is what we want. And Mr. Kinsberg, if the union comes in here, we're going to strike.'"

Left. Saul Mills (1910–1988) was a reporter at the *Brooklyn Eagle* when noted columnist Heywood Broun called for the establishment of a union among newspaper employees. Mills became a charter member of the Newspaper Guild and was promptly dismissed from the *Eagle* for union activity. Volunteering his talents as a publicist to CIO unions, Mills, at the request of John L. Lewis, assumed the position of secretary-treasurer of the Greater New York Industrial Union Council when it was founded in 1940. *(Circa 1935, Robert F. Wagner Labor Archives, Saul Mills Collection); Below.* A "flying squadron" of National Biscuit Company strikers, members of Inside Bakery Workers Local 1585, arrive at Ogden Mills's home to picket. Mills, a prominent New York politician who had earlier been appointed by President Hoover to serve as Secretary of the Treasury, was a major shareholder. *(1935, Schomburg Center for Research in Black Culture, NYPL, Corbis/Bettmann)*

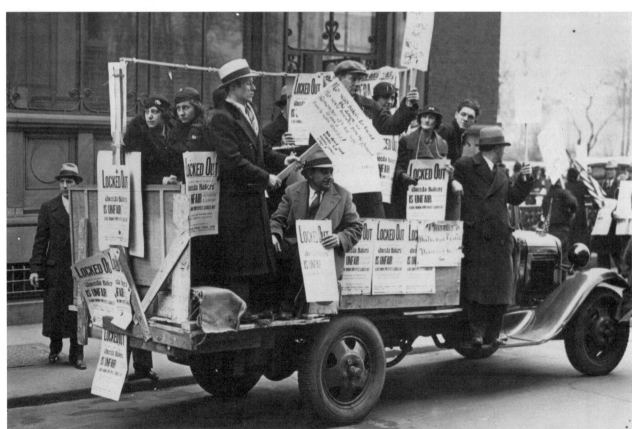

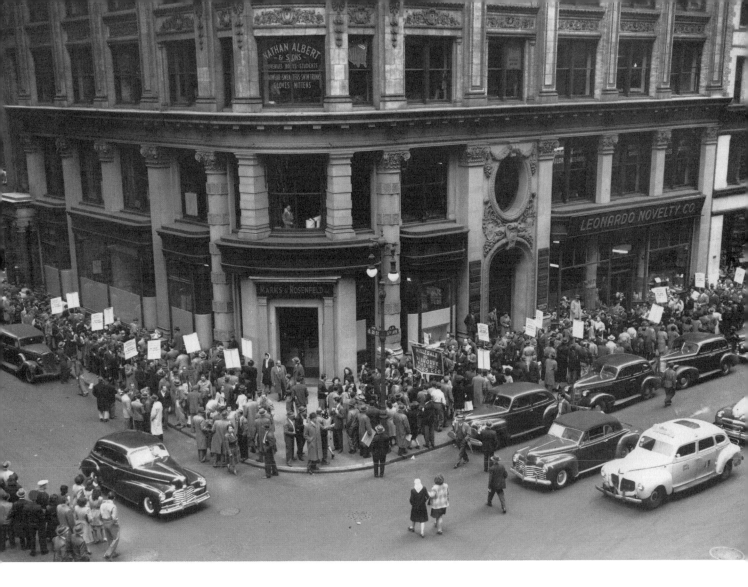

AL BERKNOPF, District 65 organizer:

"Knowing that my father was a religious man, a rabbi, they went even so far as calling my father down. They said, 'You know your son is very active trying to form a union here? Do you know that the union is not going to succeed? He'll be blacklisted in the whole industry. Nobody will hire him because he'll be a troublemaker.' And my father said to Mr. Breiter, 'I'm a shochet *and that's how I make my living. At six o'clock I'm in the chicken market and I perform the ritual slaughtering of chickens'—that's what's called a* shochet. *'And for years we were at the mercy of the owners of these chicken markets who were illiterate and disrespectful human beings, even to me, a man of the cloth. In the winter time, on the coldest days, we were standing in the open air market with filth and dirt and barely making a living. Until we, the ritualistic chicken killers, formed a union. The union sees to it that the place is clean, that I get a reasonable fair wage, and I walk around with my head up in the air. So, if the union has this done for me, why shouldn't it do something for my son?'"*

Local 65, first organized among Lower East Side Jewish workers in the wholesale dry goods industry, grew rapidly by using such tactics as lunchtime mass picket lines. "Be a good neighbor—organize the store next door" was the slogan. *(1946, Robert F. Wagner Labor Archives, District 65 Collection)*

American Labor Party convention. *(Circa 1940, ILGWU Archives, Kheel Center, Cornell University)*

In 1936 labor leaders David Dubinsky and Sidney Hillman founded the American Labor Party (ALP) as a mechanism for Franklin Roosevelt supporters who were disenchanted with New York City's corruption-tainted Democratic machine. The ALP was left-leaning and pro-labor, using the slogan "Don't Scab at the Ballot Box." In 1937 Mayor LaGuardia polled nearly half a million ALP votes, 21 percent of his total. The party built strong grassroots organizations, particularly in Jewish, black, and Puerto Rican working-class neighborhoods. Among those whom ALP members helped to elect were staunchly pro-labor Congressman Vito Marcantonio; State Assemblyman Oscar Garcia Rivera, the first Puerto Rican officeholder in the continental United States; and the first black City Council member, Adam Clayton Powell, Jr., who later won a congressional seat.

DAVID DUBINSKY, 1892–1982

Arrested as a labor agitator in Lodz, Poland, then exiled to Siberia, Dubinsky came to New York City in 1911 and began working as a garment cutter. Active in ILGWU Local 10, he became president of the national union in 1932. Under his leadership, ILGWU members won a thirty-five-hour week and established health centers, retirement pensions, and cooperative housing. Dubinsky was a founder of the Jewish Labor Committee and an AF of L vice president. He moved the ILGWU out of the AF of L when the latter first expelled the unions that became the CIO, and he kept the union independent until 1940, when it rejoined the AF of L. He helped found the American Labor Party. When he believed that the ALP had become too Communist-dominated, he helped found the Liberal Party as an alternative. His long campaign against labor racketeering bore some fruit when the AFL-CIO established a code of ethics in 1957.

David Dubinsky, 1892–1982. *(ILGWU Archives, Kheel Center, Cornell University)*

Right. The ILGWU's Broadway musical revue *Pins and Needles*, with words and music by Harold Rome, ran for four years, including a command performance for President Franklin D. Roosevelt in the White House. The original cast was made up of cutters, basters, and sewing machine operators who played their parts on weekends and went back to the shops Monday morning. *(Circa 1938, ILGWU Archives, Kheel Center, Cornell University)*

Below. Pins and Needles cast with President Roosevelt. *(March 3, 1938, ILGWU Archives, Kheel Center, Cornell University)*

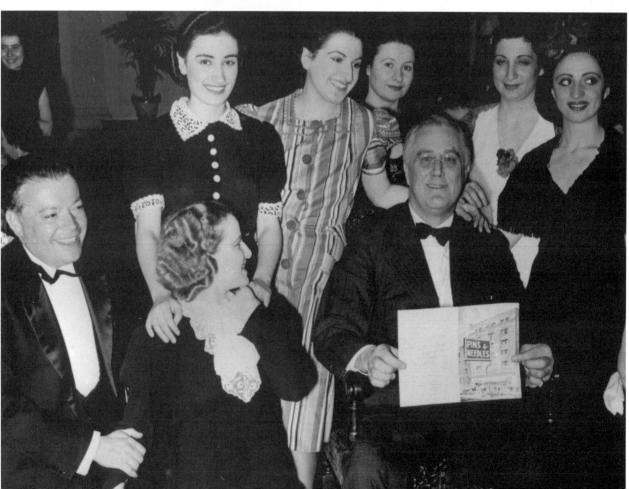

Merchant seamen at the onset of the New Deal had inherited an aged, inept, weak, and in places corrupt AF of L craft union, the International Seamen's Union. A group of young radicals organizing as the Marine Workers Industrial Union, an affiliate of the Communist Party's Trade Union Unity League, sparked organization on the waterfronts of New York, Philadelphia, and Baltimore. They demanded, among other things, emergency relief for destitute seamen "beached" by the Depression shipping slump and a union-controlled rotary hiring hall. Borrowing direct action techniques from the Industrial Workers of the World, the MWIU staged a number of job actions and quickie strikes to improve ship-board conditions. In February 1935, when the Communist Party ended its policy of dual unions, the MWIU disbanded and its members joined the ISU as the Rank-and-File Committee,

Organizers for the National Maritime Union using launches in their campaign to win harbor boatmen away from the International Longshoremen's Association, affiliated with the AF of L. Their principal selling point was that they insisted on gangplanks from barge to shore so boatmen would not have to rely on pails for their drinking water. *(1937, Library of Congress,* New York World-Telegram and Sun *Collection)*

publishing their own newspaper, the *ISU Pilot,* and agitating for union democracy.

On New Year's Day 1936, without first referring the matter to a vote by the membership, the ISU accepted a contract renewal with the shipowners that left unchanged the differential between East and West Coast wages and conditions. Protesting what they called the ISU's sell-out, 300 men in the crew of the intercoastal liner *SS Pennsylvania* went on strike January 4. In March, Joe Curran, a New York–born boatswain, who at thirty years of age was a veteran of sixteen years at sea and whose six-foot-two-inch, 220-pound frame, craggy profile, and guts propelled him to leadership, initiated a sit-down strike on the *SS California.* Docked at San Pedro, California, the ship was ready for the return voyage to New York. Using the new sit-down tactic discovered by Akron rubber workers a few weeks earlier, the crew would neither leave the ship nor work until they received the West Coast rate of pay. Company representatives termed the action a mutiny, and the ISU condemned the strike, but Curran and the strikers held firm for two days until Secretary of Labor Frances Perkins herself intervened. Phoning Curran in a San Pedro butcher market, she promised to use her influence to get them the additional five dollars a month and see to it that there were no recriminations against the crew. Curran conceded and the ship cast off, but upon arrival in New York, the shipowner fired and blacklisted Curran and sixty-four other strikers.

With the growing support of seamen angered by what they saw as betrayal by employers, union, and government, Curran called a wildcat strike in the New York harbor to prevent the next sailing of the *California.* Twenty other intercoastal vessels were detained and, by Curran's estimates, some 4,500 seamen in the port jointed the strike. The strikers demanded an industry-wide contract, West Coast wages and overtime, union control of hiring, and reinstatement of the California crew. The strike strained internal union politics to a breaking point. The ISU expelled Curran, not himself a Communist, accusing him of being a "tool of the Communists." The action only increased his prestige as a rebel leader, but he was unable to withstand the ISU's efforts to undermine the "Spring Strike" and was forced to call it off after nine weeks.

Waterfront warfare erupted in November when Curran and the ISU Rank-and-File Committee called a strike in sympathy with Pacific Coast seamen and longshoremen who were fighting to keep gains they had made after

a general maritime strike in 1934. Some 30,000 sailors, the Masters, Mates and Pilots, and the Marine Engineers and Radio Telegraphists answered Curran's call to sit-down on all ships sailing out of the port of New York. The entire American maritime industry came to a standstill. The ISU rightly regarded the "Fall Strike" as a full-scale rebellion and not only acceded to the shipowners' announcement that striking seamen would be replaced, but promised to find replacements for them and give the strikebreakers protection. "Protection" came from disreputable longshoremen's locals that refused to honor the rebels' picket lines. Curran's group claimed that as many as twenty-seven striking seamen fell to goon violence.

AL ROBBINS, seaman and waterfront organizer:
"We kept saying, 'If we could [just] get somebody to strike.' And that's where Joe Curran and his ship comes in. That ship was the strike that we were looking for. Boom! The whole waterfront just simply exploded. Curran came to New York and, by virtue of the fact that he was the ship's delegate, he became the leader of the strike. And overnight, as the strike progressed to different ports, strike committees were organized, people were assigned to various activities, supporting citizens' committees were organized that helped us to get food, and so on. We had one in New York. It was no great big thing, but it helped to keep us alive, to provide enough food and clothing. If a seaman got ill, we had doctors and dentists who would provide treatment without charge. Guys slept in the Union Hall and the dog house—the Seamen's Church Institute. Some found sympathetic citizens to accommodate them and some guys went home to their home towns.

"The Journal of Commerce had all the ships' arrival and departure times, so we would go down and greet these ships to bring it out on strike by talking to the seamen as they came off. And then, in those cases where ships were being manned, despite our efforts, our job was to go down and try to dissuade the scabs from boarding the ships and getting her out of port. Sometimes we succeeded, sometimes we didn't. But we stopped enough ships to make the strike effective. The strike was not easy. It went on a long time."

The "Fall Strike" lasted eighty-six days before it, too, was broken. But the ISU had won a battle in a losing war. Each setback made Curran more of a hero in the eyes of the seamen. In a coast-wide meeting in mid-December,

rank-and-file delegates from the ISU sailors and cooks and stewards divisions defiantly voted to expel the union's leaders. They constituted themselves as the ISU District Committee and elected trustees to conduct their affairs until the next union election. Then they brazenly approached the shipowners to ask them for recognition. They were refused, but the AF of L, alarmed, called a hearing of the Executive Council to try to patch up differences within the ISU. The gesture was futile.

In the spring of 1937 Curran and the ISU Rank-and-File conducted a series of job actions on the vessels of the International Mercantile Marine. After a sit-down in late April on the IMM's *President Roosevelt*, docked in New York, the IMM agreed to hire its crewmen from the new Rank-and-File hiring hall on Eleventh Avenue. At a mass rally to celebrate this victory, the Rank-and-File seamen declared their independence from the ISU by forming the National Maritime Union. By its founding convention in July, the NMU had enrolled over 35,000 members. Shortly after its formation it voted to affiliate with the CIO.

The National Maritime Union exemplified industrial unionism in its attempt to organize all seamen working together on a ship into one union. Its uncompromising stand on race broke down the practice of "checker-boarding"—confining black and Hispanic seamen to the least desirable jobs as stewards and engine room men. The Cold War and decline of the American fleet would decimate this boisterous child of the CIO.

"OPERATOR," anonymous letter to the editor of the *TWU Express,* August 1934: *"Unbelievable conditions of work exist for the men who have the 'pleasure' of working on the Third Avenue Railway System trolley lines. The trolley-car workers are actually slaves. Even the slaves in early civilization had a few hours for recreation, but for us it is work, sleep and a few hurried meals.*

"First, the average week for trolley-car operators is from 65 to 70 hours, which means seven days a week of about 10 hours a day. Most of the runs have long swings, amounting in many cases to as many as four hours. If a run starts at 6 a.m., the operator works till about 9, he swings until 1 p.m. and finishes at 7 or 8 p.m. The three or four hours' swing cannot be used for anything. After traveling back and forth to the barn and home, you are just about ready to grab a bite, go to sleep and wake up for a new day's work. With seven days of this a week, year in and year out, holiday or no holiday,

BUILD AND
UNITED INVINCIBLE
CONSOLIDATE

INTERNATIONAL EXECUTIVE BOARD
TRANSPORT WORKERS UNION OF AMERICA
1941 --- 1943

is it any wonder that most of the men become nervous, chronically sick and broken after a few years' service.

"A couple of years ago, the Third Avenue Railway System laid off almost half the force. Men who had been slaving for as long as 20 years were ditched when all the two-men cars were turned into one-man cars. Those who were kept became operators at 5 cents an hour raise. For this 'raise' the operators have to keep the day-cards, make change, collect transfers, switch, open and close the doors, issue transfers, and at the end of the line adjust the trolley poles, fix the signs, turn the clock, take the readings, fix the doors, carry the fare box, in addition to answering questions of passengers and driving the car, trying to avoid accidents in crowded traffic like New York's.

"We can put a stop to all this by joining the Transport Workers Union and, together with the workers of the I.R.T., B.M.T., Independent System, buses, procure better conditions for all and two men on all cars."

Transport Workers Union Executive Board. The Transport Workers Union was one of the most powerful of New York City's CIO unions. It was founded in 1934 by Irish nationalists among subway workers and led by the flamboyant Michael J. Quill. *(1943, Robert F. Wagner Labor Archives, Transport Workers Union Collection)*

Father and child at a May Day parade en route to Union Square. *(1936, Tamiment Institute Library, John Albok Collection)*

ADELE ARICO HECTOR, Communications Workers of America Local 1150:

"As a child in the 1930s I learned from my father the saying, 'La Vita è un Battaglia,' he'd raise his fist, 'e Viva la Battaglia!' Which means in Italian 'Life is a struggle' and 'Long live the struggle.' In my own life I chose to fight injustice—in the workplace, on the picket line, in the civil rights movement—and it is still my greatest joy when there is a victory for the workers."

• • •

As fascists seized power in Europe, New York City unionists mobilized against them on the home front.

The Jewish Labor Committee, founded in 1934 by the needle trades unions, the Arbeiter Ring (Workmen's Circle) fraternal organization, and the *Jewish Daily Forward,* worked tirelessly to educate Americans about the dangers of Nazi power and to save the lives of its intended victims.

Opposite. The World Labor Athletic Carnival was organized by the Jewish Labor Committee to counter the World Olympics Nazi Germany hosted in Berlin as a show-case of fascist strength. *(1936, Robert F. Wagner Labor Archives, Jewish Labor Committee Collection)*

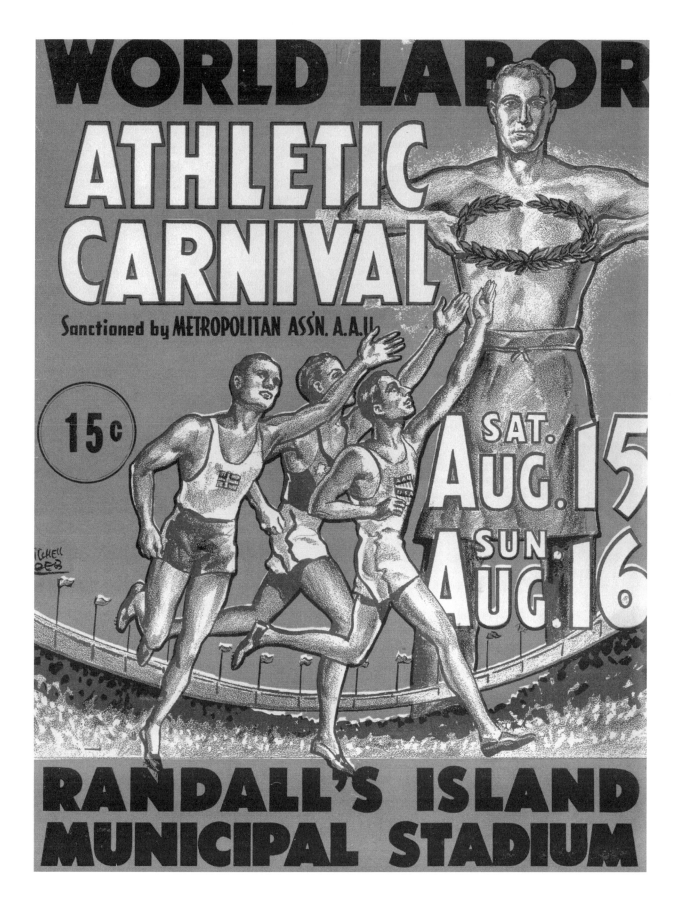

Garment center rally in support of President Roosevelt. For many years Democratic presidential campaigns would end with a massive political meeting of New York unions on Seventh Avenue. Photo editors have always cropped and retouched photographs for publication, and new technology makes the possibilities virtually limitless. Here we used digital means to remove crop marks from the body of the photo—duplicating a small part of the crowd. (*1940, ILGWU Archives, Kheel Center, Cornell University*)

SIDNEY HILLMAN, 1887–1946

As president of the Amalgamated Clothing Workers of America from its inception in 1914 until his death in 1946, Hillman gained national recognition. He introduced new methods of collective bargaining and advocated labor-management cooperation. He broadened the union's scope by establishing union insurance plans, banks that provided low-interest loans to union members, and low-cost housing cooperatives. One of the original leaders of the CIO and a strong Roosevelt supporter, he helped found the American Labor Party and was a labor advisor to President Roosevelt during World War II, leading to the phrase, "Clear it with Sidney." His initiatives continue to be models for the labor movement.

Above. Sidney Hillman, 1887–1946. *(Undated, Robert F. Wagner Labor Archives)*

Left. Shortly after the United States entered the war, leaders of the labor movement vowed not to strike for the duration. Here AF of L president William Green and secretary-treasurer George Meany affirm the AF of L's no-strike pledge to President Roosevelt. Employment and union membership grew rapidly during the war. Through the cooperation of the War Labor Board, unions negotiated vast improvements in pay and other benefits. *(1941, George Meany Memorial Archives)*

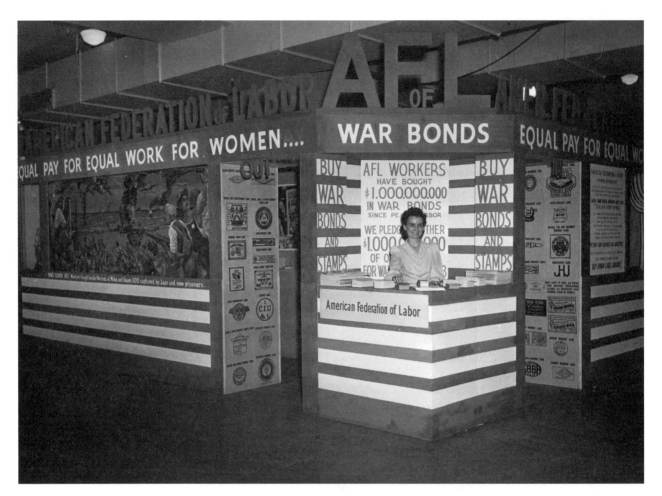

Above. AF of L booth, woman selling war bonds. *(Robert F. Wagner Labor Archives, Union Label Collection, photograph by Alexander Archer Studio)*

Right. Spirit of the Central Trades airplane paid for with war bonds purchased by affiliates of the Central Trades' Unions (AF of L predecessor to the Central Labor Council). Unionists gave generously to the war effort, buying large numbers of war bonds for ambulances, ships, and aircraft. This photograph of a Boeing B-17 Flying-Fortress, presumably issued by the Office of War Information, shows definite signs of doctoring—the donor's name was etched in. *(Undated, Robert F. Wagner Labor Archives, Union Label Collection)*

The black community understood the war and the economic boom as an opportunity to fight for "the double V"—victory over racism at home as well as fascism abroad. In January 1941, A. Philip Randolph called for a Negro March on Washington to demand jobs in war production and to end segregation in the armed forces. Organizing for the march was successful: in order to avoid the embarrassing prospect of 100,000 black people converging on the nation's capital, still beset by Jim Crow practices,

> 50,000 NEGROES MUST ATTEND
> # MADISON SQUARE GARDEN RALLY
> ## JUNE 16, 1942
> RADIO, SCREEN, THEATRE, SPEAKERS
> ## March - On - Washington Movement
> *"Winning Democracy for the Negro Is Winning the War for Democracy"*

President Roosevelt issued an executive order establishing the Fair Employment Practices Commission. The order banned job bias against blacks and other minorities in defense industries. Not until 1963 would Randolph lead a march on Washington, this time of both blacks and whites, for civil rights, jobs, and freedom.

Bumper sticker (with glue still intact) from the March-on-Washington Movement: "Winning Democracy for the Negro Is Winning the War for Democracy." *(1941, Tamiment Institute Library)*

A. PHILIP RANDOLPH, 1889–1979

Co-founder of *The Messenger,* a militant, socialist monthly magazine, Randolph first attracted attention in New York for his eloquent speeches urging blacks not to fight in World War I. He organized elevator operators, and then Pullman porters—all black Americans—and became the first president of the Brotherhood of Sleeping Car Porters. After ten years of agitation and negotiation, the union finally negotiated a contract with the Pullman Company—the first contract between an American corporation and a black union. Randolph went on to become an important spokesman for African Americans in the civil rights movement and labor movements as a vice president first of the AF of L and later of the AFL-CIO.

A. Philip Randolph, 1889–1979, seen here at a 1976 commemoration of his eighty-seventh birthday at City Hall, attended, among others, by Bayard Rustin; Mayor Abraham Beame; then AFL-CIO secretary-treasurer Lane Kirkland; and Frederick O'Neal, president of the Associated Actors and Artistes. *(1976, Robert F. Wagner Labor Archives, Central Labor Council Collection, photograph by Al Ben-Ness)*

Activism was part of Local 65's way of life; here "65ers" in their United Warehouse and Wholesale Workers Union baseball uniforms march to admit Negroes to big league baseball. *(Circa 1948, Robert F. Wagner Labor Archives, District 65 Collection)*

As the war ended, the union culture molded by the Depression, the rise of the CIO, and the war years reached its pinnacle. For many New York workers, it was a way of life centered around the union hall.

At 13 Astor Place, Local 65 of the Retail, Wholesale and Department Store Union had an eleven-story union hall named for the imprisoned labor hero, Tom Mooney. The hall buzzed with activity—union meetings, a hiring hall and health center, a cooperative store, cultural events, education, and social affairs—even the Camera Club of rank-and-file members who took the pictures below.

The wide-ranging union culture in District 65 is a well-documented example, but other unions were also involved. Fur workers and hotel trades workers, among many, participated in the Labor Sports Federation. A CIO labor chorus also contributed to a lively cultural scene.

KENNETH SHERBELL, District 65 staff member:
"We thought in terms of organizing ourselves to meet all of our problems, a total life around the union, as a union. We used to have slogans like 'Play together, fight together, live together.' It was great. We lived life to the hilt. It was deadly serious and the stakes were high, but I look back on it, I wouldn't trade it for anything."

Left. A vote at a District 65 meeting. *(1940, Robert F. Wagner Labor Archives, District 65 Collection)*

Below. "Of course we're bachelors." *(Undated, Robert F. Wagner Labor Archives, District 65 Collection)*

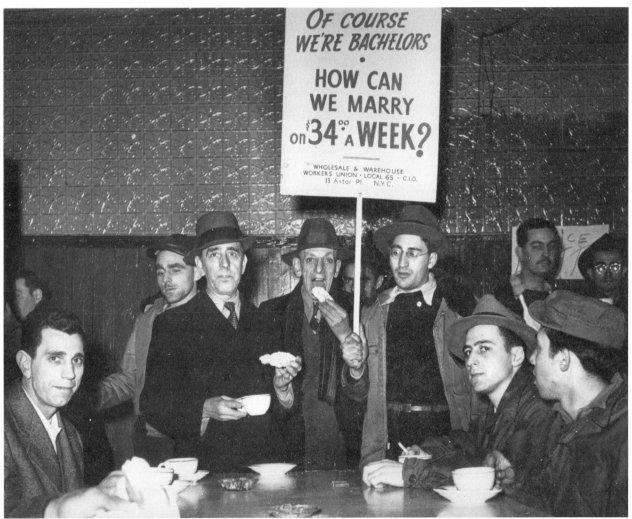

OF COURSE
WE'RE BACHELORS
·
HOW CAN
WE MARRY
on $34⁰⁰ A WEEK?

WHOLESALE & WAREHOUSE
WORKERS UNION · LOCAL 65 · C.I.O.
13 Astor Pl. N.Y.C.

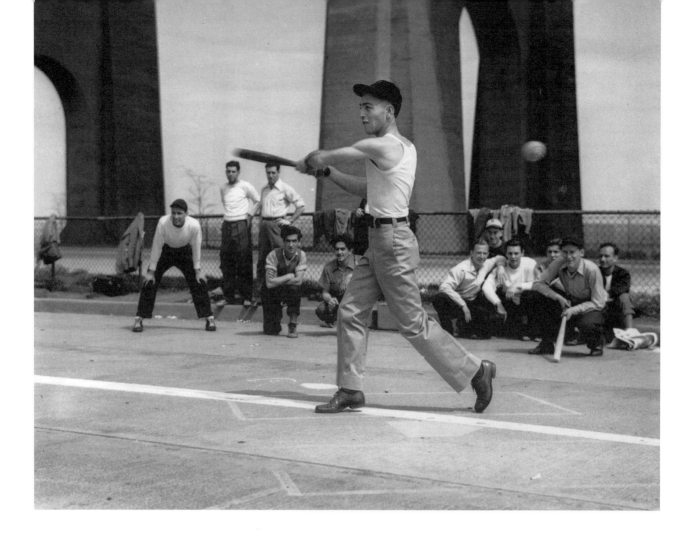

Club 65: a baseball game on Randall's Island. *(1942, Robert F. Wagner Archives, District 65 Collection)*

JOSHUA B. FREEMAN, Historian:

"In working-class New York it was neither unusual nor considered odd for an enthusiasm for literature to mingle with a love of baseball, or for one family member to dash off to see Sinatra while another headed off to the symphony. It was this rich, complex stew—the product of a particular history, occupational structure, population mix, and social geography—that made the New York working class so vibrant. Over and over authors have celebrated New York as the cultural, artistic, and financial capital of the twentieth century, as the capital of the world. Yet almost never do they acknowledge the extent that it was the sensibility, energy, skill and sophistication of the working class that helped establish the city as the symbol of modernity, opportunity, and creativity.

"For ordinary New Yorkers, daily life at home and work could simultaneously reinforce ethnicity and its transcendence, breed a narrow sense of community and an expansive one. To my mind it was precisely this tension—part of a broader tension between parochialism and universalism—that lay at the heart of the culture of ordinary New Yorkers and gave it such extraordinary creative power."

A Club 65 outing. *(Circa 1941, Robert R. Wagner Labor Archives, District 65 Collection)*

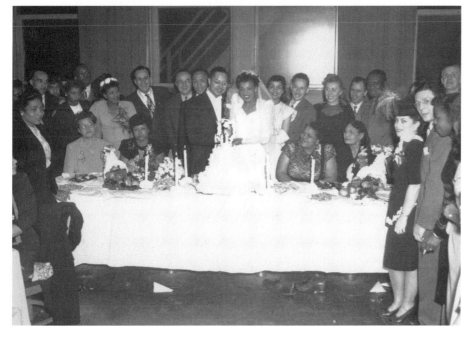

Union officer Morris Doswell's wedding reception at the union hall. *(1947, Robert F. Wagner Labor Archives, District 65 Collection)*

In 1992 District 65 made history by becoming the first union known to file for protection to reorganize under Chapter 11 bankruptcy laws. An aging membership and the erosion and dispersal of its core workplaces were contributing factors. Tom Mooney Hall was sold and is currently being renovated as luxury condominiums.

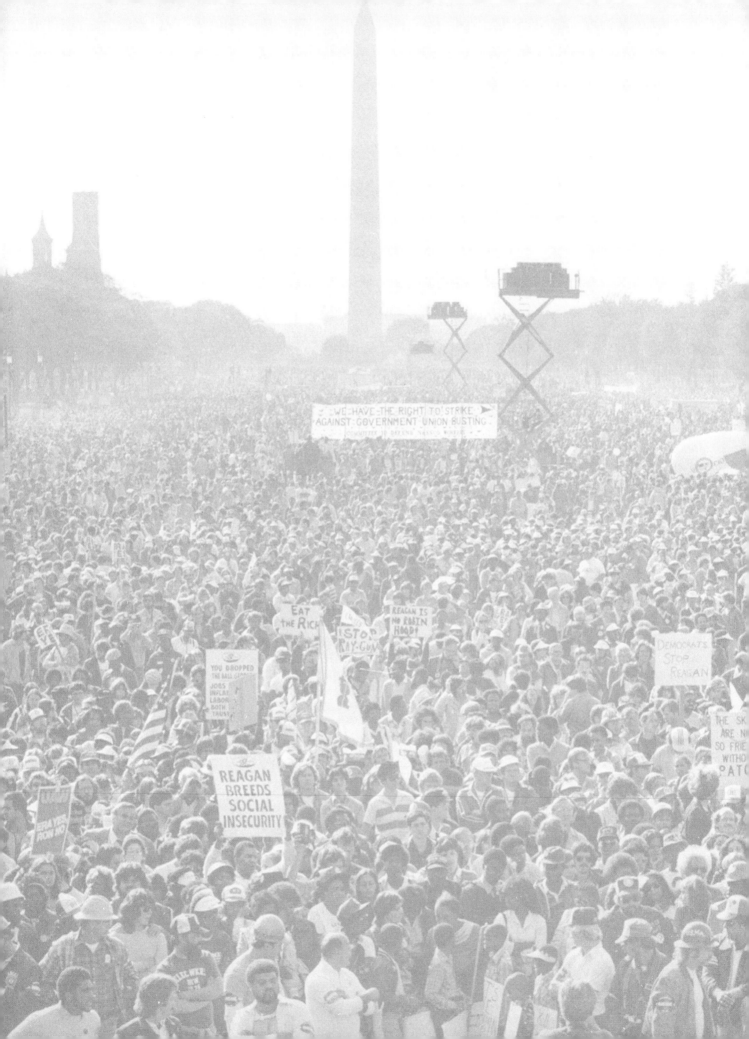

REBUILDING A CULTURE OF SOLIDARITY

4

Labor's cultural and legislative gains of the 1930s and 1940s suffered set-backs as the second half of the century progressed. Consumer mass culture, improved living standards, and the growth of suburbs undermined labor's communal life and values, while divisive issues and hostile legislation weakened once-powerful unions. Signs of strength appeared in new places, however, as organizing succeeded in new occupational sectors and among new constituencies.

Divisive issues such as the Taft-Hartley Act, McCarthyism, labor racketeering, and the Vietnam War undermined the unity that had been so hard won. Employers' offensives forced labor to concentrate on limited issues where consensus could be found.

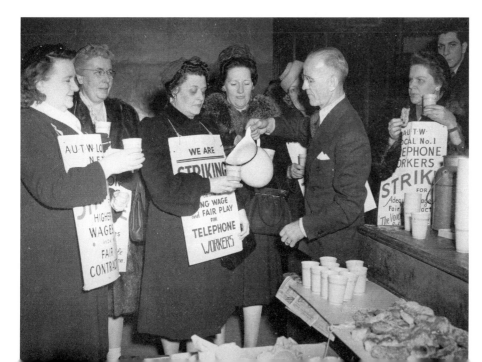

Union officer Ken Bartlett serves coffee to striking telephone workers in the St. Alphonsus Church hall, Lower Manhattan. The 1947 strike by the National Federation of Telephone Workers (predecessor of the Communications Workers of America) consolidated telephone locals across the country, leading to the first nationwide agreement with AT&T. *(1947, Robert F. Wagner Archives, Communications Workers of America Collection)*

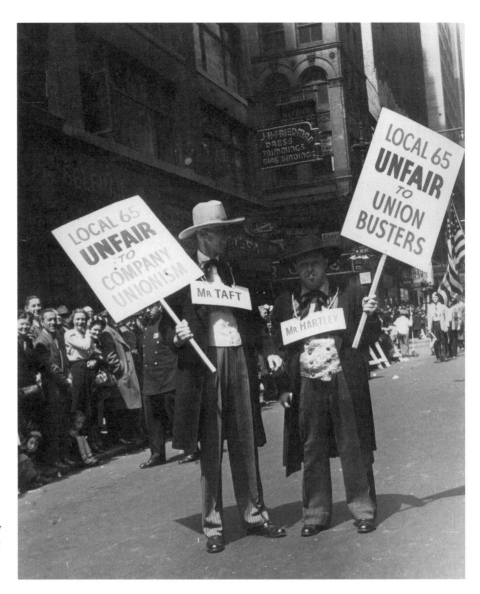

Local 65 members make fun of Senator Robert Taft and Congressman Fred Hartley in a May Day parade. *(Circa 1947, Robert F. Wagner Labor Archives, District 65 Collection)*

Organized business—the National Association of Manufacturers and the U.S. Chamber of Commerce—used the record-breaking strike wave of 1945–1946 as an opportunity to launch an "open shop" campaign, and in 1947 Congress passed the Labor Management Relations (Taft-Hartley) Act over President Harry S Truman's veto. The Act was a calamity for labor—it outlawed the closed shop, jurisdictional strikes, and secondary boycotts; unlocked the door to state open-shop (so-called "right-to-work") laws; and required union officers to sign affidavits swearing they were not members of the Communist Party, punishable by a $10,000 fine or ten years' imprisonment. Wagner Act protections for unions' right to organize were dramatically weakened. John L. Lewis said the Act relegated labor to the "status of second class citizenship."

LEON SVERDLOVE, retired president, Jewelry Workers Local 1:

"We were part of a left group that would meet, you know, outside of the union. They said the proper thing to do was to pass a resolution opposing the Marshall Plan as a capitalist threat to the rights of the workers in Europe. And by that time several of us felt, what's the point? We were in the leadership and whatever we asked the members to do, they figured, 'You want to be against the Marshall Plan? That's all right. We'll vote for you. You're nice guys.' We had paid our fare because of the contracts we brought them, the way we ran the union, the newspaper we put out. But the Marshall Plan is going to fail because Local Number 1 with its 2,500 members votes against it? It was laughable. Of course, nothing terrible happened. We never did bring that resolution. So people [in the Communist Party] were looking down their noses at us as having sold out or betrayed the interests of the working class, but it made no sense to us.

"And it was even more dramatic when it came to the Taft-Hartley Act. If you didn't sign, you weren't subject to NLRB agencies—you couldn't have elections, you couldn't present grievances against the employer for unfair labor practice. If we don't sign, we're going to leave ourselves wide open to charges by the International [union] that we're not protecting the interests of the members and would make us subject to possible expulsion. That's exactly what happened in so many left-wing unions. We signed the Taft-Hartley Act. How could you exist without the Labor Board? You just couldn't do it.

"We were in the vanguard, but we looked back and we couldn't see anybody anymore. Going back to the struggle for the eight-hour day in 1886, our union participated in the famous May Day demonstration in Union Square. When we signed our first agreement in 1933, May Day was an unpaid holiday, but it was a declared holiday and we used to get a pretty nice contingent of maybe six or seven hundred people to show up for a May Day parade. But as the years went by, the contingent got smaller and smaller till there we were, the executive board of the union and maybe two dozen others, carrying the banners in the name of the Jewelry Workers. This must have been as late as 1950. The International had sent a photographer down one time and they took pictures of us marching and showed them at the next convention—"See the Commies!" [Laughs] At least if there had been several hundred people behind us!"

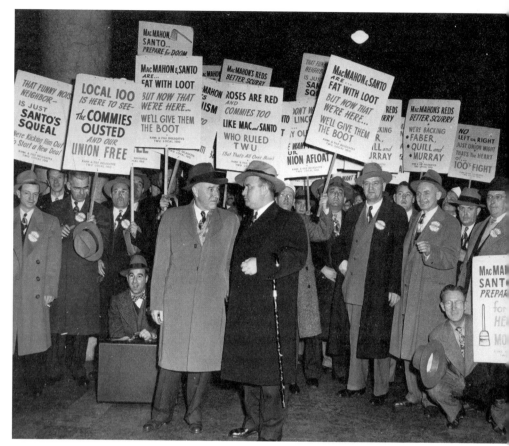

Right. "Clean sweep" picket line to oust Communist union officials. *(1948, Robert F. Wagner Labor Archives, Transport Workers Union Collection)*

Below. Brooms lashed together over the NMU headquarters on West Seventeenth Street, symbolizing the clean sweep election. *(1948, Library of Congress, New York World-Telegram and Sun Collection)*

At first many union leaders, some with solid anti-Communist reputations, refused to sign the non-Communist affidavits. But as McCarthyism and the Cold War intensified, organized labor came under heavy attack for harboring Communists or their allies. As Leon Sverdlove explained, refusal to sign the affidavits deprived a union of the services of the National Labor Relations Board. Several union leaders who had worked closely with Communists, including Joseph Curran of the National Maritime Union and Michael Quill of the Transport Workers Union, publicly severed their ties with their former allies. In 1948–1949 the national CIO disbanded the Greater New York Industrial Union (CIO) Council and expelled eleven national unions representing a million CIO members. Communists, once respected or tolerated, had become serious political and legal liabilities to their unions.

HARRY FLEISCHMAN, Socialist Party activist and Voice of America radio producer:

"In 1952, I wrote a Labor Day script which I started out with the tune 'Solidarity Forever.' Well, some GI hearing this in Korea decided that 'Solidarity

Forever' was a Communist song, and he wrote to his congressman who got in touch with Joe McCarthy, and Joe McCarthy was at this time investigating the Voice of America. He was on his campaign to kill it. And I was scheduled to be called before McCarthy. Well, the people at the Voice got scared stiff when they heard this. They asked me if I could do something about it. 'Can you get labor people to say something nice about "Solidarity Forever"?' I said, 'Sure, that's no problem.' We got statements from George Meany, Walter Reuther, James Carey, David Dubinsky, and Jacob Potofsky, all of them testifying that 'Solidarity Forever' was a good old American labor song written long before there was a Communist party anywhere, and that it was used regularly by the AF of L and the CIO. It so happened that the AF of L had not been singing the song at its union conventions, but that year they did. And so did the CIO."

SOLIDARITY FOREVER

When the union's inspiration through the workers' blood shall run
There can be no power greater anywhere beneath the sun
Yet what force on earth is weaker than the feeble strength of one?
For the union makes us strong!

They have taken untold millions that they never toiled to earn,
But without our brain and muscles, not a single wheel can turn;
We can break their haughty power, gain our freedom when we learn,
That the union makes us strong.

It is we who plowed the prairies, built the cities where they trade,
Dug the mines and built the workshops, endless miles of railroad laid.
Now we stand outcast and starving, 'mid the wonders we have made
But the union makes us strong.

In our hands is placed a power greater than their hoarded gold
Greater than the might of armies magnified a thousandfold
We can bring to birth a new world from the ashes of the old
For the union makes us strong.

Solidarity forever, solidarity forever,
Solidarity forever, for the union makes us strong.

Tune to labor's anthem: "John Brown's Body." Words by Industrial Workers of the World bard and organizer Ralph Chaplin, written in 1915.

Picketing at the Board of Education, the Teachers Union fights a losing battle against the persecution of suspected Communists in the school system. *(1950, Robert F. Wagner Labor Archives, United Federation of Teachers Collection, photograph by Mildred Grossman)*

The Board of Education investigated hundreds of teachers during the 1950s under the power of the state's Feinberg Law (1949), which mandated the elimination of members of the Communist Party from public schools and colleges. More than 435 teachers were dismissed as a result of these hearings, as were dozens of others questioned by the U.S. Senate committee investigating Communist influences; many more were persecuted and intimidated.

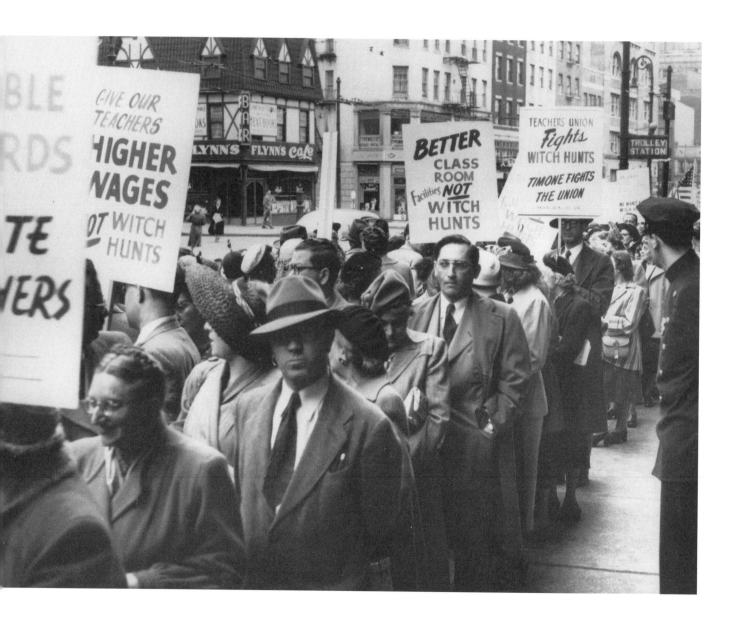

State and federal committees heard sensational testimony about labor rack-eteering in the Teamsters and other unions in the early 1950s. In 1953 the AF of L expelled the International Longshoremen's Association (ILA), and for a time the federation supported the efforts of rank-and-file reformers. The AF of L and the CIO sought to counter the postwar assaults against them by merging in 1955 and issuing a strong Ethical Practices Code com-mitting the organization to fight corruption in any of its unions.

Brooklyn longshoremen's union head Tony Anastasia, in fore-ground, and friends. Note their "Vote ILA" buttons. *(Undated, George Meany Memorial Archives, Seafarers Log)*

JOHN J. "JOHNNIE" DWYER, rank-and-file longshoremen's leader whom screen-
writer Budd Schulberg used as the model for Terry Malloy in *On the Waterfront*:
*"I came back from the CCC [Civilian Conservation Corps] and I said to my
father, 'Why don't you get me a job on the waterfront?' He said, 'Stay away
from the waterfront,' but I started shapin' and I been there up until 1953
when I took on the ILA, to try to beat them with the IBL [International
Brotherhood of Longshoremen]—which we didn't succeed, by two hundred
and some odd votes. And then the ILA had a special convention, just for
John Dwyer, what they called 'deep six' you. I wasn't allowed back in the
union for ninety-nine years, so I got another fifty or sixty years before they
let me back. I guess I was born a rebel. We had a meeting at St. Veronica's*

when the ILA all came down. They wanted to take four men from the dock—which was something new and unheard of in them days—and put them in the hold gang. The meeting only was five minutes old, I guess, and I got up for a point of information, and I said, 'You're not going into the hold! I'm leaving this hall and if anybody's with me, I wish they'd follow me.' And the hall emptied out and left the dais up there with six or eight union officials. I was fired. I'd been going to the Xavier Labor School. Father Corridan and Father Carey taught there.

"After the ILA was kicked out, September 1953, first, George Meany met with Paul Hall [president of the Seafarers International Union], and then I met with Paul and Meany, and they were going to do everything they could. We used to go around to all the piers every morning. We had, maybe, a hundred or two hundred guys. But when the vote came, it wasn't there. They were telling them, 'You'll lose your welfare, your pension, if you go with the IBL.' But we came close. Gave 'em a scare, anyway. And I think that the Longshoremen are better off today than they were in them days, anyway."

• • •

What was known as the "Little Wagner Act" was finally put forth in 1958, giving city employees the right to organize. The first collective bargaining agreement after the act was negotiated by the American Federation of State, County, and Municipal Employees, District Council 37, in 1959.

JOHN BOER, former president of District Council 37 AFSCME:
"Wagner tried to avoid an implementation of actual collective bargaining. In fact at Easter in that particular year, he just up-stick and sailed away or flew away to Bermuda. He was due back on Easter Monday and we prepared what we called Bermuda Day for him. In other words, we urged people to walk out and come down to City Hall. And much to our surprise it was the biggest demonstration seen up to that time. It was Bermuda Day—I remember pushing it by calling it the Easter Rebellion—there were a lot of Irish still then. And they were waving onions . . . Bermuda onions! Anyway, this was the straw that broke the camel's back, and that led to the first approximation of collective bargaining. I was told that at the first bargaining session, the assistant director marched to the head of the table and said, 'Well, alright, let's get the hearing started.' And he had to be told this was no longer a hearing and he was not to sit at the head of the table."

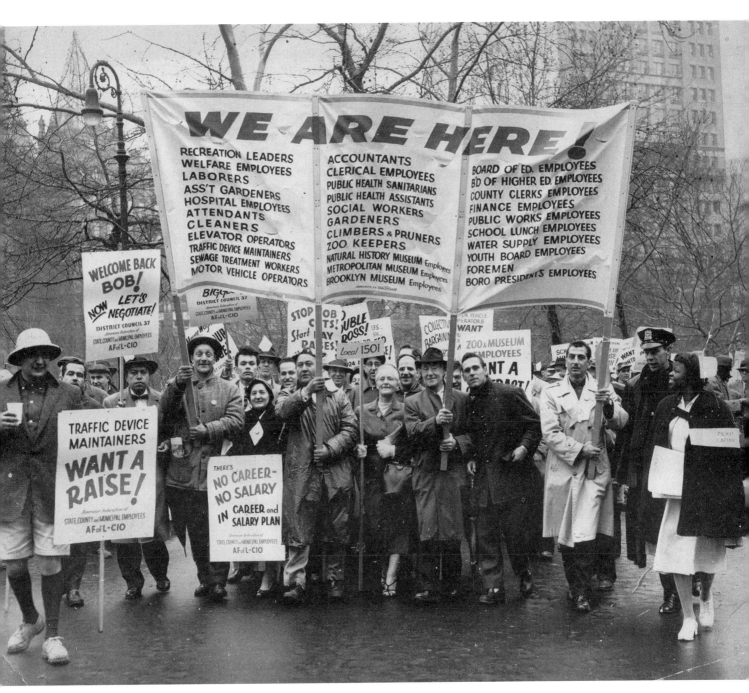

The Wagner Act specifically excluded public employees, but New York City municipal workers used tactics such as this Bermuda Day, in 1954, to force Mayor Robert F. Wagner (son of the senator who wrote the National Labor Relations Act that bears his name) to bargain with public employees. *(1954, AFSCME DC 37)*

David Selden, together with Teachers Guild members George Altomare, Jules Kolodney, Albert Shanker, Rebecca Simonson, and Guild President Charles Cogen, crafted a unified organization from dozens of teachers' organizations in 1960. The first United Federation of Teachers (UFT) strike was called on November 7, 1960, the day before John F. Kennedy was elected president. More than 5,500 teachers walked out. Mayor Wagner appointed a fact-finding labor committee to study collective bargaining for teachers and to recommend what actions should be taken. In December 1961, a collective bargining election was held and the UFT scored a resounding victory. The UFT was the first teachers' union the United States to win collective bargaining for teachers.

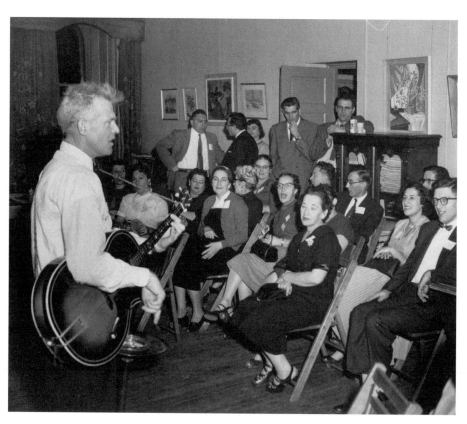

David Selden, veteran American Federation of Teachers (AFT) union organizer, leads a round of labor songs in one of many social evenings spent organizing New York City teachers. *(1956, Robert F. Wagner Labor Archives, United Federation of Teachers Collection, photograph by Heinz Weissenstein)*

Albert Shanker, 1928–1997.
(Robert F. Wagner Labor Archives, United Federation of Teachers Collection)

ALBERT SHANKER, 1928–1997

While working as a teacher in Junior High School 126, Shanker joined the Teachers Guild. He became a full-time AFT organizer in 1959 and played a critical role in helping to found the UFT in 1960. Shanker was elected UFT secretary in 1963 and president in 1964. During his presidency, he led the teachers in contentious strikes to improve working conditions and secure higher wages. In 1967, after a fourteen-day strike, he was jailed for the first time under a Taylor Law injunction. In 1968, Shanker made national news when he was jailed in the Ocean Hill–Brownsville strike, a conflict between the UFT, the City, and community control supporters over due process for teachers. Under his leadership the UFT became a powerful political force in both national educational policy and New York politics. He led the movement to merge the UFT and other New York AFT locals with the New York State Teachers Association (an NEA affiliate) to form New York State United Teachers (NYSUT) the most powerful state teachers' union in the country. In 1975 he joined Victor Gotbaum, head of District Council 37 AFSCME, and other labor leaders in helping to resolve the fiscal crisis by bailing out the city with union pension funds. Shanker became president of the American Federation of Teachers in 1974 and played important roles in the New York City Central Labor Council, the AFL-CIO, and the Jewish Labor Committee.

GEORGE ALTOMARE, social studies teacher and a founder of the UFT:

"I began teaching in Astoria Junior High School in 1953 along with Al Shanker and Dan Sanders. Al's mother worked in the same garment shop as my mother, who was the shop chairlady for the Amalgamated Clothing Workers. We almost immediately joined AFT Local 2, the Teachers Guild. At that time there was no collective bargaining for teachers anywhere, and the Guild, as small as it was, maybe 1,200 paid members, was one of the multitude of teacher organizations. Dave Selden was the only paid staff member of the Guild. He immediately took the three of us under his wing and together we worked fanatically trying to build membership, to unify all teachers under one organization, and to achieve collective bargaining and a first contract. The older leadership of the Guild, many of them veteran Socialists, saw us as 'Young Turks.' They did not disagree with us in theory, but they thought we were too impatient given our small size. I felt you had to act in order to grow; they felt you had to grow in order to act.

"In February 1959, there was a wildcat evening school strike, initially led by no organization. The strikers were high school teachers, most of whom were not members of the Guild. Al, Dave, and I urged and succeeded in getting the Guild to back the strike and not cross the picket lines. The strikers were out for one month. They used a new tactic of mass resignations to win a doubling of their pay from twelve dollars to twenty-four dollars a night. While on the picket line we met top leaders of the High School Teachers Association, one of the more important teacher organizations. I invited them to my house for secret meetings to discuss how to merge the HSTA with the Guild for the purpose of creating one unified organization for militant action.

"When the HSTA refused to merge because of their insistence on restoring a higher salary differential for high school teachers, I took it upon myself with a high school teacher friend and HSTA board member, John Bailey, and the covert support of Dave and Al, to create the CATU—Committee for Action Through Unity. As a student and teacher of history, I knew the strategic value of building a "front" organization. We used CATU to recruit potential members and collect dues to be put in escrow to force a merger between the Guild and the High School Teachers. In a couple of months, we were able to enroll 1,500 dues-paying members, mostly from the high schools. When it became public who was behind CATU, the Guild considered a motion to censure me as an executive board member. But Al Shanker,

*who was now working as a Guild staff member, and Dave Selden spoke in
my defense and urged cooperation and merger with CATU. On March 16,
1960, the merger with CATU was approved by the Guild delegate assembly
and the UFT was born."*

• • •

A New York City Central Labor Council group, including Harry Van Arsdale, Jr., Edward
J. Cleary, Jr., Thomas Van Arsdale, and labor educator Lois Gray, leaving for an educa-
tional trip to Puerto Rico and the Caribbean in 1958. This historic trip resulted in the
founding of the Central Labor Council's Hispanic Labor Committee and the Santiago Igle-
sias Society, an influential club within IBEW Local 3. (*Private collection of Edwin Lopez*)

Drug and hospital workers organizing in front of Mount Sinai Hospital. *(1959, Local 1199, Health and Hospital Workers)*

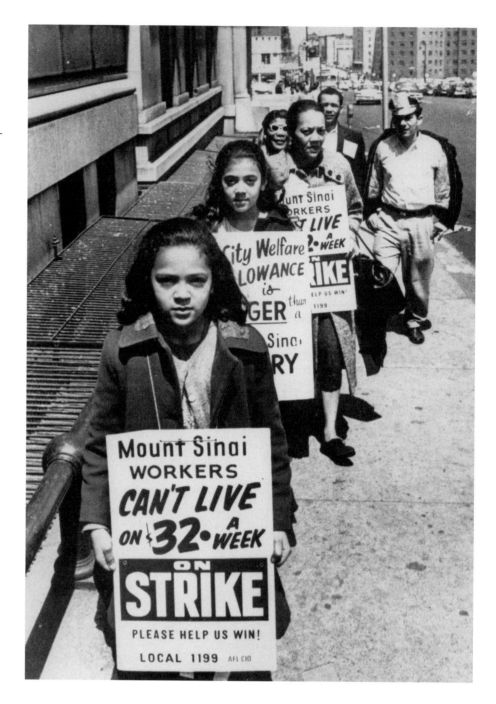

Activists from the pharmacists union, led by pharmacist Leon Davis, began to organize non-professional hospital workers in the late 1950s. In 1959 a strike against seven private hospitals set the stage for a massive organizing drive. Large numbers of poorly paid workers, the majority of them black and Puerto Rican women, joined Health and Hospital Workers Local 1199, which also went on to organize professional and technical workers and became one of the largest and strongest unions in the city.

The civil rights movement, the anti-war movement, and the women's movement transformed the national political landscape and the New York labor movement in the 1960s and 1970s.

Kennedy's campaign inspired labor and civil rights activists, and included many volunteers who may never have previously participated in presidential elections. He spoke eloquently for the continuation of New Deal social programs and for focusing national attention on helping the poor.

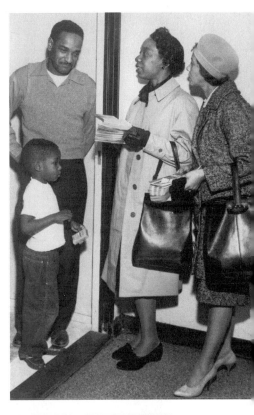

Right. Door-to-door canvassing in support of presidential candidate John F. Kennedy in Harlem. *(1960, ILGWU Archives, Kheel Center, Cornell University); Below.* John F. Kennedy campaigning at Electchester with Harry Van Arsdale (center) and Mayor Wagner. *(1960, Robert F. Wagner Labor Archives, Reiss Collection)*

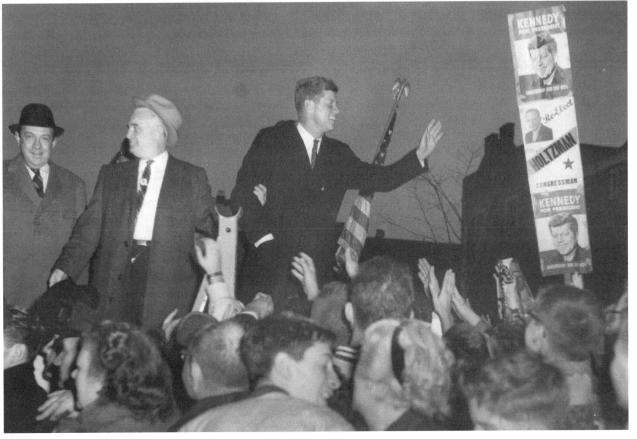

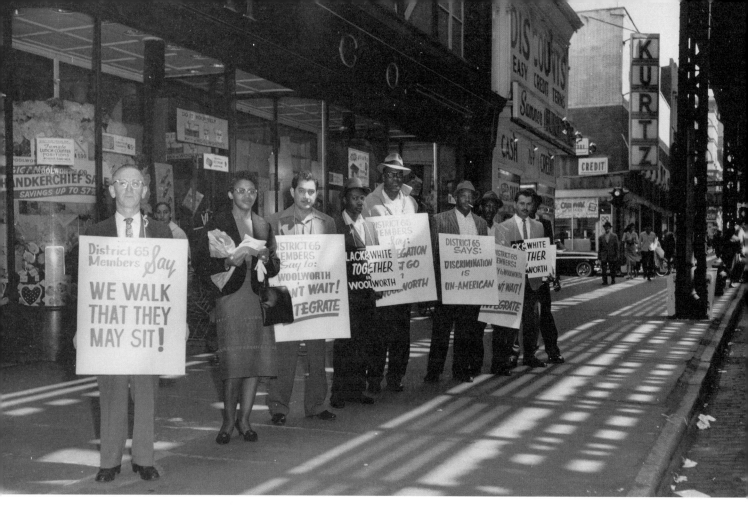

"We Walk That They May Sit": District 65 picket line under the Third Avenue El in support of Woolworth sit-ins. A help-wanted sign in the first window reads: "Female lunch counter positions." *(1960, Robert F. Wagner Labor Archives, District 65 Collection)*

New York unionists, along with much of the national labor movement, were constant participants in the civil rights movement. They supported the demonstrations of the students in the South for equal rights; marched on Washington, D.C., in 1963 in support of civil rights legislation; demonstrated in Selma and Montgomery, Alabama, for the right of blacks to register and vote; and were closely allied with Rev. Martin Luther King, Jr. They had also organized the "fair housing" struggles right after World War II.

RUTH "TOBY" KESSLER TAYLOR, clerical worker and housewife:

"We were one of the first tenants to move into Stuyvesant Town, shortly after my husband was discharged from active duty in World War II, in about 1947. I had applied the day it was announced in the newspaper that this was housing built for veterans and their families. I instinctively knew that he would come back alive, and being very positive and also very practical, I had applied. We were accepted. You had to come down in person for an interview—how much money do you earn and so on. At that time my husband was working in the union shop where he left to go into the service—May Knitting. He was guaranteed his job by union contract when he returned. Shortly thereafter he went on staff at District 65. We qualified.

"We were not happy about the clause in the lease which stated 'white Caucasians only.' It no long appears in any lease today. It's illegal—one of the things we helped eliminate in our fight against discrimination at Stuyvesant Town. After we left the interview, we vowed that we would take the apartment only on the condition that we would make every effort to change things. We couldn't in good conscience live there knowing that other veterans because of their skin color, who needed the apartment as desperately as we needed one, were being excluded.

"We invited the Hendrix family to share our apartment with us not more than six months after we moved in. My husband, Jesse, knew Hardine through District 65. Both Rae and Hardine came from Birmingham, Alabama. They had one child—Dean was about two years old. They were living in a rat-ridden place in Harlem. Rae would spend all of her nights sitting up and making sure Dean was not bitten by a rat. Hardine mentioned this to my husband knowing that we had just moved into Stuyvesant Town, thinking wouldn't it be great if they could get an apartment there. And that's how the idea originated. Jesse invited Rae and Hardine to the house one evening with their baby. It was a fun evening. Rae and I became close friends and we still are to this very day.

"We proceeded with a public announcement that our friends, the Hendrixes would be taking over our apartment while I was going to the country with the kids. With their agreement, we vowed that this was not going to be a private affair but involving all the veterans that lived in Stuyvesant Town. We organized a Committee to End Discrimination in Stuyvesant Town. I would say that out of 8,999 tenants that lived there, 8,990 signed the petition we circulated to support this action. Everyone was in favor of this being integrated housing for veterans and their families at rentals they could afford.

"What happened, Metropolitan got real rough and wanted to evict the most active people on the committee, approximately thirty-five. They proceeded to do so [evict them], when the mayor intervened. We appealed to Mayor Impellitteri. And the result was that they agreed to give the Hendrix family an apartment, open up housing for a certain percentage of blacks, and remove the 'white Caucasians only' clause in the lease. [Also in] the agreement was that the Kessler family was to move out. And we did. We moved out to Long Island, to Clearview Gardens, where we continued to organize for integrated housing!"

Social Service Employees Union (SSEU) welfare workers struck in 1965 for a salary increase, caseload reduction, and an end to "midnight raids" on welfare clients.

BERNIE CACCHIONE, social worker and SSEU organizer:

"Each center contained a staff of social investigators who had about eighty or ninety cases each. It was enormous. There was a 40 percent a year turnover. The pressure was agonizing. There had been a union there in the forties called the United Public Workers, Local 1. It had been demolished. McCarthyism had not just weakened it, but eliminated its existence. This had happened in the early fifties. By 1964 there were still many people who would not talk about unions or politics, they were so afraid of being fired from that period. I mean, this was 1964! And the atmosphere was as anti-union as could be. This was the first generation that had grown up in an anti-union atmosphere. When they hit high school and college the memories of the thirties were gone. I had to go out and deal with people who considered unions to be vile and disgusting. Or else they felt they didn't belong

Striking welfare workers take a coffee break outside Welfare Headquarters at 250 Church Street. Bernie Cacchione serves coffee to fellow picketers Kitty Stein, Anthony Curcio, Joan Strumer, and Marty Kramer. *(1965, Robert F. Wagner Archives, Social Service Employees Union Collection, Daily News photograph by Gene Kappock)*

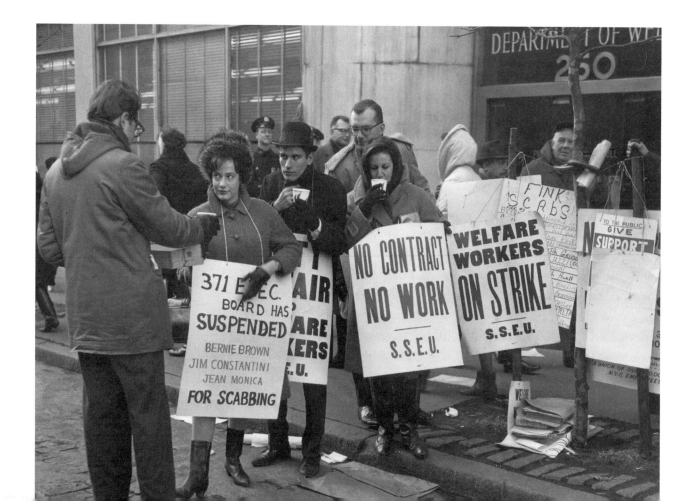

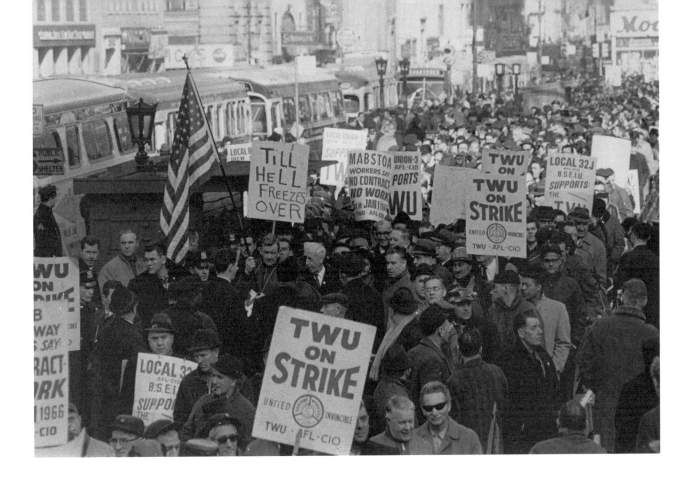

here. The line was that we were professionals. We were people especially
chosen for the Bureau of Child Welfare because we were exceptionally
gifted. And we were an elite. And besides a union had no place in social
work, amongst professionals. And this was civil service on top of that, and
who ever heard of a union doing anything meaningful in civil service. And
besides, what about my individuality?"

Street demonstration during the
1966 transport workers' strike.
(1966, Transport Workers Union)

Transit workers, whose average basic wage was below the federal poverty
guidelines for a family of four, shut down buses and subways for two weeks
in January of 1966. Despite hostility from the city's newspapers and from
newly elected Republican mayor John Lindsay, and despite the jailing of
Mike Quill and eight other union leaders for ignoring a court injunction to
return to work, the 35,000 strikers gained significant increases. Quill had a
heart attack in jail and died two weeks after the settlement. Fourteen thou-
sand people came out in bitter weather to bid him farewell.

This strike and the earlier social workers' strike resulted in the abandon-
ment of a 1946 state law that required the immediate firing of public em-
ployees who went on strike. It was replaced in 1967 by the Taylor Law,
which set up procedures for public employee union recognition and collec-
tive bargaining. Public employee strikes remained illegal, but the conse-
quences were now financial penalties rather than job loss.

MICHAEL J. "MIKE" QUILL, 1905–1966

Quill, who served in the Irish Republican Army before coming to New York City, was one of the founders of the Transport Workers Union (TWU). He became president and full-time organizer in 1935 and was active in the CIO when the TWU joined in 1937. Quill was elected to the New York City Council on the American Labor Party ticket in 1937 and served intermittently until 1949. Active in the city's CIO Council, Quill was an eloquent spokesman and acted as labor's liaison to city government. His close ties to Communists, strong support for Irish nationalism, and efforts for civil rights made him a constantly controversial leader, though he became an anti-Communist later in his career. His frequent threats of a transit strike also added to his influence in city politics, and often provoked controversy.

Michael J. "Mike" Quill, 1905–1966. *(Transport Workers Union)*

The Miss Union Maid contest was not just one of looks—contestants, all members of unions, wrote essays on the topic "Why the Union Is Important to Me." Labor Day parade float; note the portraits of labor leaders on the lampposts. *(1968, Robert F. Wagner Labor Archives, Union Label Collection)*

Confrontation between Ocean Hill–Brownsville community members and striking teachers. *(1968, Robert F. Wagner Labor Archives, Sam Reiss Collection)*

A conflict between the job security and due process rights of teachers and community control of schools in Ocean Hill–Brownsville sent 54,000 teachers throughout the entire New York City school system out on strike three different times in 1968, shutting down the schools. The UFT's contract was ultimately upheld, but at the cost of an animosity between the predominately white union and portions of the black community that would last for years.

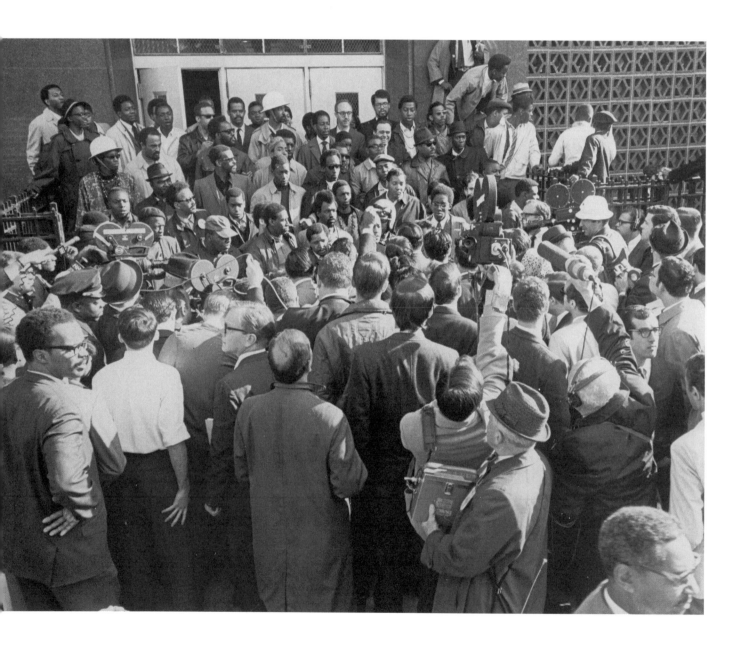

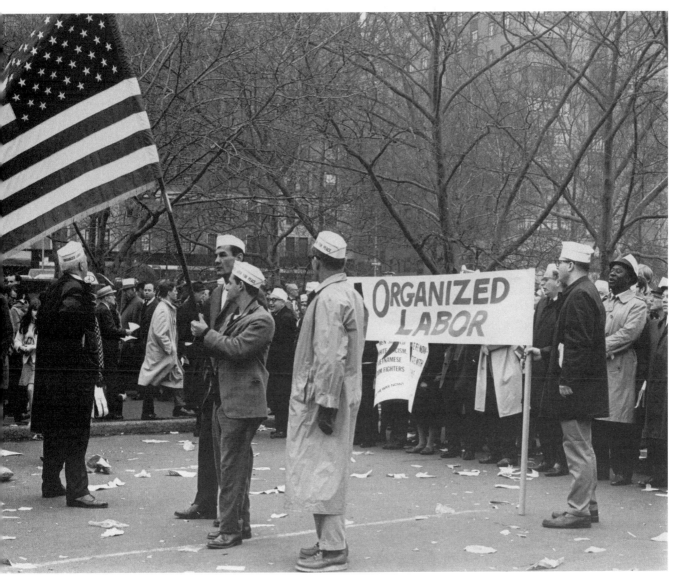

Labor for Peace demonstration, with District 65 leaders David Livingston, Cleveland Robinson, and Frank Brown visible on right behind banner. *(Circa 1968, Robert F. Wagner Labor Archives)*

The Vietnam War divided the nation, and it divided the labor movement. Public sector unions and others challenged AFL-CIO president George Meany's support of the war, while the majority of labor leaders, especially those in the building trades, were firmly behind him.

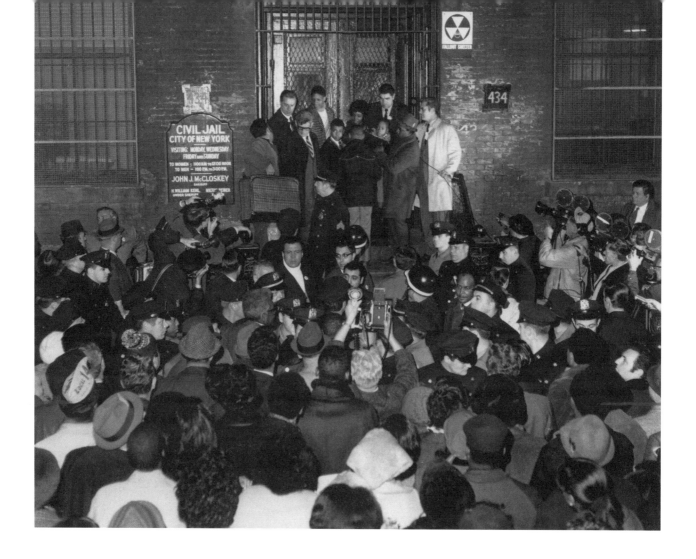

Young, black, and beautiful public employee organizer Lillian Roberts became a cause célèbre after she was jailed for sparking a series of wildcat strikes in state hospitals, thereby forcing Governor Nelson Rockefeller to the bargaining table. Shown here taking leave of her children with District Council 37 AFSCME leaders Jerry Wurf (wearing glasses) and Victor Gotbaum (back row, to right of Roberts). *(1969, Public Employee Press, District Council 37 AFSCME)*

LILLIAN ROBERTS, organizer of public workers:

"What you saw in all the pictures was me ready to serve my term, which was a month, with my children and different labor people there. I felt that nobody should take my place. If anything, I think Jerry [Wurf] might have been criticized because they felt he should have gone since he gave the order. But I didn't feel that way because, after all, if you're a woman and you're out there and you're working, you don't want to be treated differently. So I stood my ground. But it was very difficult for me because my kids were very young and it was Christmas. I felt very bad for them. I didn't feel bad for me, I could take it. I mean, a month is not a long time in one's lifetime and I probably needed to get more rest because I had really been pounding it out there. But there was such an outcry, and this is where I was very grateful to the labor movement. Everybody said, "She's not going to spend Christmas there. We'll burn the place . . ." They was just hysterical about it. So finally Governor Rockefeller said I could come out Christmas eve, but I'm not to have any kind of press, you know, like 'I won' statements. So I graciously came out Christmas eve and went home."

In 1960 federal employees finally gained the right to organize through an executive order drafted by New York lawyer Ida Klaus, who had also drafted New York City's "Little Wagner Act," which gave city employees the right to organize. The first nationwide strike by federal employees was a one-week walkout by postal workers in 1970. Precipitated by rank-and-file members and led by New York's Letter Carriers Local 36, the largest letter carriers local, the walkout spread from New York across the country. President Richard Nixon called in federal troops and National Guardsmen to replace the New York workers, and federal injunctions against the strikers were obtained.

New Yorker Morris "Moe" Biller, head of the Metro Area Postal Workers Union, and later president of the American Postal Workers Union, leads a picket line at Manhattan's main post office. *(1970, Robert F. Wagner Labor Archives, Metro Area Postal Workers Union Collection)*

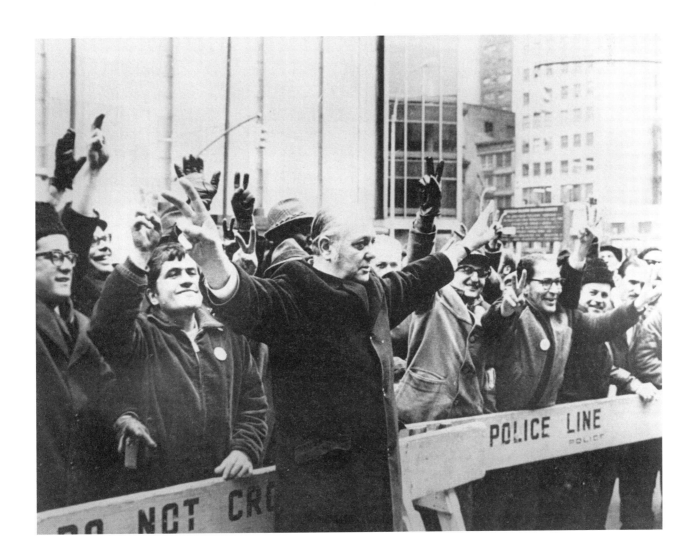

Santiago Iglesias Society members, joined by Congresswoman Bella Abzug, demonstrate at Hunts Point Market in the Bronx against grape growers. *(1973, private collection of Edwin Lopez)*

One of the biggest challenges facing the labor movement in the past few decades is the attempt to organize low-wage newcomers, as legal and illegal immigrants make up an increasing percentage of the workforce. New York unions have supported labor organizing campaigns on behalf of low-wage workers throughout the country.

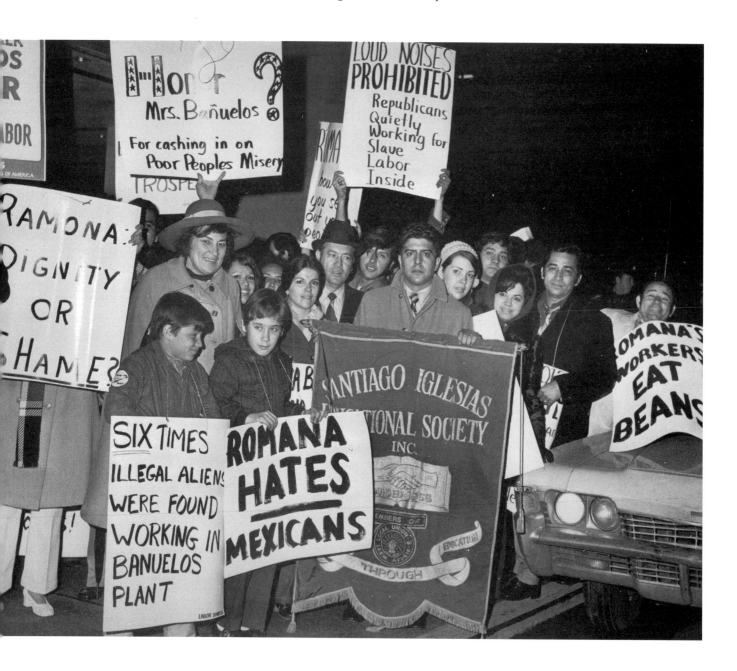

In 1974–1975 New York City experienced the worst economic downturn since the Great Depression, with unemployment topping 11.5 percent . A fiscal crisis occurred when the banks threatened to extend no further credit to the city. Mayor Abraham Beame gave in to the bankers' demands for control of the city budget, setting up the Municipal Assistance Corporation and an Emergency Financial Control Board. They eliminated many services, ended free tuition at City University, raised transit fares, and laid off or froze the wages of public employees. Municipal unions were an easy scapegoat for the city's budget woes—easier than dealing with the eroding tax base resulting from business migration to the Sunbelt and "offshore," which lost the city some 700,000 manufacturing jobs. Within two years, 60,000 city workers had been fired (although some were later recalled). Ironically, while bankers blamed municipal workers for the crisis, it was these workers' unions that bailed out the city by purchasing billions of dollars worth of Municipal Assistance Corporation bonds.

The fiscal crisis in a cartoon by Gene Suchma from the *Public Employee Press. (1977, AFSCME, DC 37,* Public Employee Press)

Workers in the last decades of the century continued to try to build labor solidarity across cultures and to win union recognition and rights for unorganized workers, despite points of division within the labor movement and an often hostile political atmosphere in the country at large.

In 1981 striking air traffic controllers led 250,000 New York unionists in the first Labor Day parade since 1968, but these and other demonstrations could not stem the large-scale corporate offensive against labor in the 1980s. Union strength and membership declined significantly during the Reagan-Bush years.

New York labor supported striking air traffic controllers with a "stall in" at La Guardia Airport. *(1981, Robert F. Wagner Labor Archives, Central Labor Council Collection, photograph by Dan Miller)*

Defying federal law, air traffic controllers struck in 1981 when the Federal Aviation Administration refused to address job stress and other safety issues. Reagan responded with mass dismissals of strikers, jail terms, and huge union-busting fines against Professional Air Traffic Controllers Organization (PATCO), encouraging a good deal of hostility against the labor movement nationwide. More than 400,000 union members and supporters, including many New Yorkers, responded with a march in Washington, D.C., for jobs, justice, human rights, and social progress and against the disastrous economic and social policies of the Reagan administration.

Solidarity Day, September 19, 1981, drew union members from around the country to Washington, D.C., to protest President Ronald Reagan's policies. *(AFSCME, DC 37, photograph by George Cohen)*

Coalition of Labor Union Women supports organizing drive at the A&S department store in Brooklyn. *(Circa 1982, Robert F. Wagner Labor Archives, Central Labor Council Collection)*

Members from sixty unions founded the Coalition of Labor Union Women in 1974. Women's participation in the labor movement had been growing in the latter half of the century, as health care, education, and public sector workers, large numbers of them women, were organized for the first time. As the number of women in unions grew, and as the feminist movement focused attention on women's issues, activist women within the labor movement helped to reshape the way unions supported women.

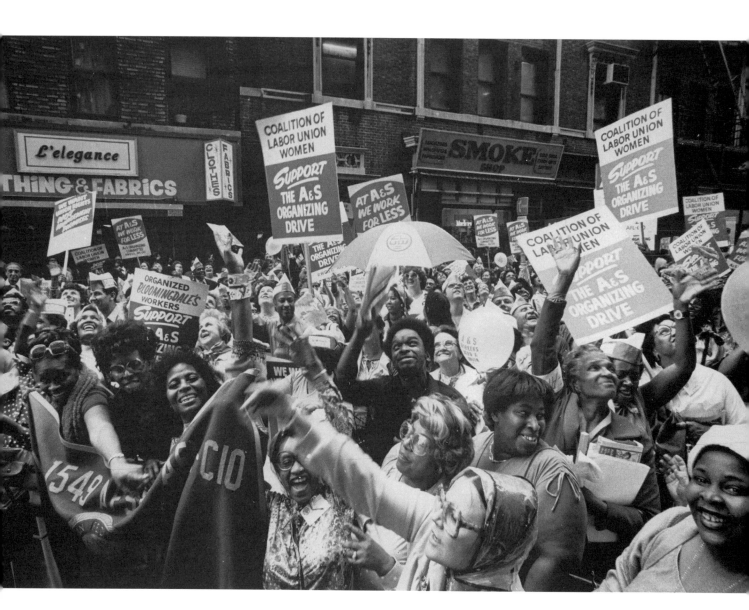

RALPH FASANELLA, 1914–1997

Serving in the anti-fascist Abraham Lincoln Brigade of American volunteers in the Spanish Civil War and later in World War II, Fasanella was an organizer for the United Electrical, Radio and Machine Workers of America (UE). He taught himself painting, and in 1972, when *New York* magazine "discovered" him and described him as "possibly the best American primitive since Grandma Moses," he was working for his brother in a Bronx gas station. Copies of his compassionate portrayals of working people and immigrant life in New York City adorn the offices of many labor educators and union officers.

Ralph Fasanella, 1914–1997, shown here in a photograph taken by Charles Rivers, whose son is looking on. *(Robert F. Wagner Labor Archives, Charles Rivers Collection)*

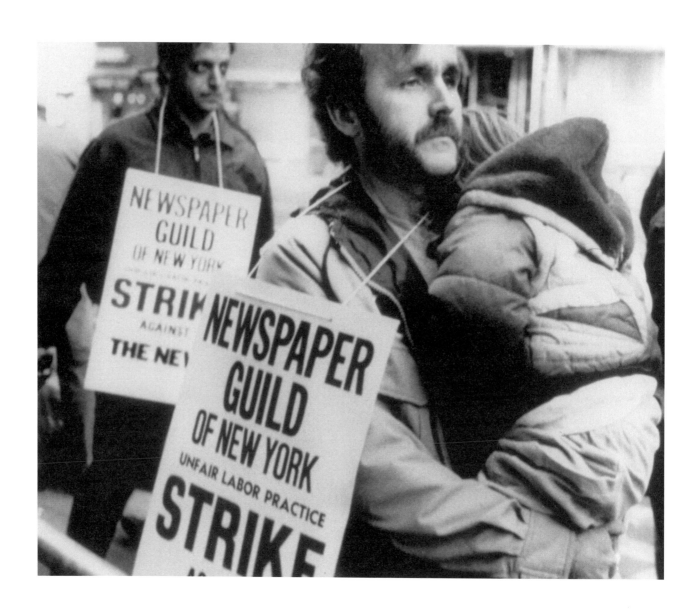

Father and child during the *Daily News* strike. *(1990, Strike support slide show, Newspaper Guild Local 3)*

In 1990 the desperate struggle of *New York Daily News* employees against the Chicago Tribune Company resulted in a renewed solidarity among unions and labor supporters. Angered by the *Tribune*'s refusal to bargain, its hiring of replacement workers to write the nation's third-largest paper, and its attempt to use homeless people to distribute the paper, New York showed itself to still be a "Union Town." After 146 days on the picket line the strike was settled when the paper was sold. Replacement workers were dismissed, but 800 jobs were eliminated.

In the 1980s and 1990s a largely female workforce built a labor movement of clerical workers at university campuses. Contracts at Columbia, New York University, Yale, and other private universities were pacesetters in improving conditions, including parental leave, support for childcare, equal pay for work of comparable value, and domestic partner benefits.

AFT Local 3882 president Trudy Rudnick being led away in handcuffs for using a bullhorn in direct defiance of police orders. *(1993, photograph by Gary Schoichet)*

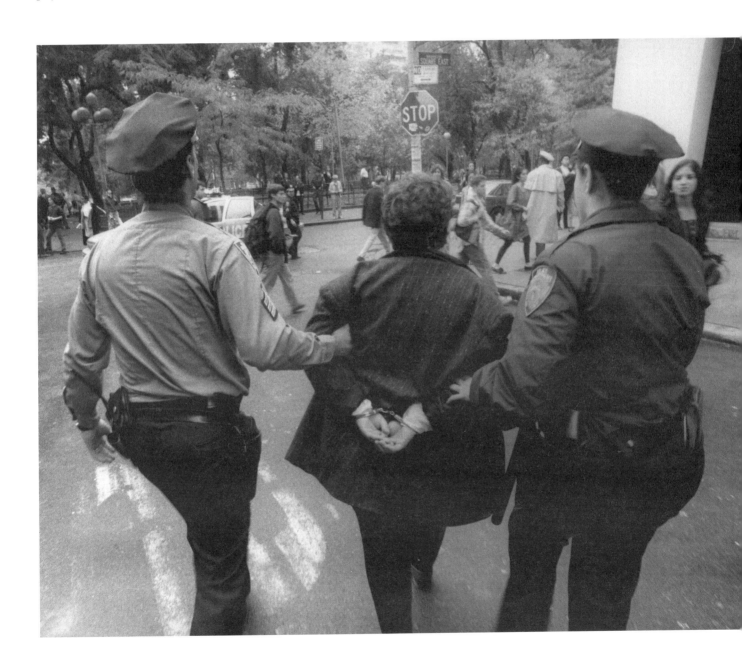

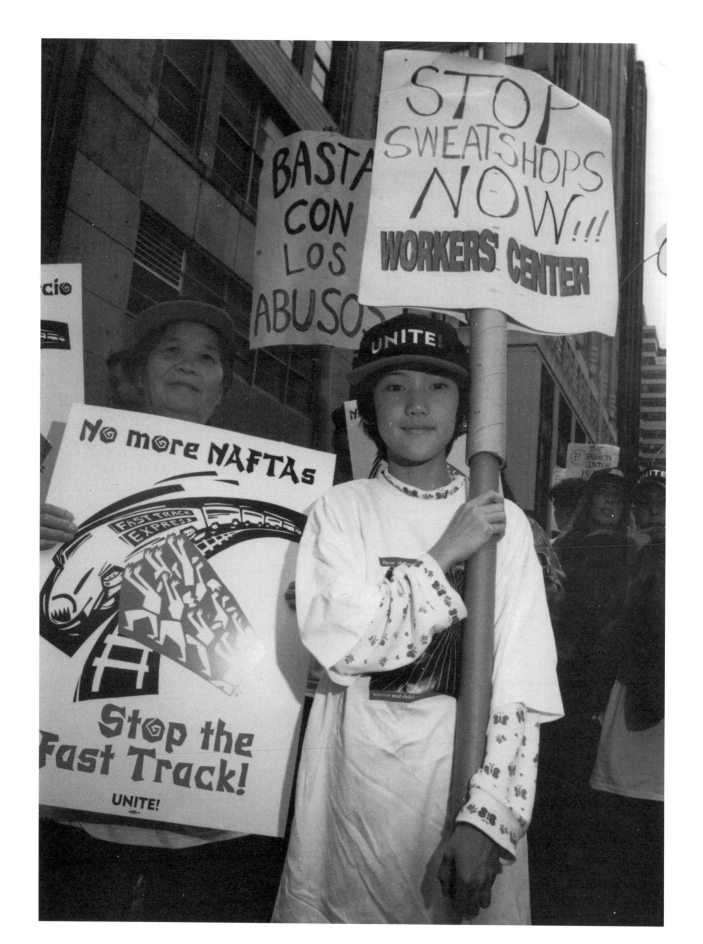

Above. United Mine Workers won their eleven-month strike against Pittston with much labor solidarity and civil disobedience. Here New York Telephone workers represented by CWA Local 1101 join striking miners in occupying a Pittston plant. *(1989, photograph by Earl Dotter)*

Opposite. In 1993 the North American Free Trade Agreement—bitterly opposed by organized labor, which feared massive job losses—was passed by Republicans with President Bill Clinton's support. The intensity of demonstrations against fast track negotiating authority for NAFTA surprised Congress in 1997; as a result, fast track was defeated. *(1997, UNITE)*

5

NEW YORK LABOR ENTERS THE TWENTY-FIRST CENTURY

New technologies and newly globalized economic structures are radically transforming New York City's workplaces. Skills that once commanded decent wages are becoming obsolete overnight. Manufacturing now accounts for only 7 percent of the jobs in the city. Knowledge-based skills are taking over where craft-based skills once reigned, and the division between skilled and unskilled is growing. At the same time, even professionals are finding that they need unions.

Despite these transformations, working New Yorkers face many of the same problems at the turn of the twenty-first century that they faced at the turn of the twentieth. Though the languages and ethnicities are new, the most basic problems are not. More than 40 percent of New York City's children were poor at the end of the twentieth century; nearly a quarter of heads of working families did not earn wages above poverty level; and the wages of the top 20 percent of the workforce rose rapidly as wages for the bottom two-thirds declined. Statewide, nearly 30 percent of workers were employed in contingent work arrangements, work part-time, or were self-employed.

Workers organizations are beginning to look to, and be transformed by, new constituencies. New tools and strategies, including plans for transportable benefits, living wage campaigns, and the use of the internet are changing union organizing. As the labor movement struggles to rebuild the culture of solidarity that transformed New York City during key decades of the twentieth century, it will look very different than it did in the past.

Newly elected AFL-CIO president John J. Sweeney, flanked by his leadership team and labor leaders, at a rally in support of garment workers in New York. Pictured, from left, are Rich Trumka (AFL-CIO giving "thumbs up"), Linda Chavez-Thompson (AFL-CIO), Sweeney, Jay Mazur (UNITE), Edgar Romney (UNITE Local 23-25); behind Sweeney are Gerald McEntee (AFSCME) and Brian McLaughlin (NYC Central Labor Council). Their "UNITE!" hats celebrate the 1995 merger of the International Ladies Garment Workers Union and the Amalgamated Clothing and Textile Workers Union, now the Union of Needletrades, Industrial and Textile Employees, as well as their hopes for the labor movement. *(1995, photograph by Earl Dotter)*

The 1995 AFL-CIO convention in New York City elected John J. Sweeney and his "New Voice" slate in the organization's first-ever hotly contested election. The historic convention also amended the federation's constitution to increase the number of vice presidents from thirty-three to fifty-one with ten seats dedicated to women and people of color, and voted to greatly expand its efforts at organizing unorganized workers.

Asian Pacific American Labor Alliance pamphlet in English, Chinese, Korean, and Vietnamese, with May Chen in center holding banner. *(1995, Tamiment Institute Library)*

MAY CHEN, organizer and officer, Local 23-25 UNITE:

"I was very excited to participate in the famous Chinatown Strike of 1982 with Chinese immigrant workers from my neighborhood fighting for the union. For so many years, Asian Americans felt excluded and even attacked by organized labor. By the mid to late 1980s Asian American workers were getting involved in unions and finding each other to form ethnic labor

committees. *In 1992, we joined together on a national level to establish the Asian Pacific American Labor Alliance (APALA) with support from the AFL-CIO. Garment workers from New York formed the backbone of this new organization, working together with city employees, restaurant workers, hospital workers, electricians, carpenters, postal workers, and many others to add our Asian Pacific American voices to the labor movement."*

Miriam Frank and Desma Holcomb co-authored *Pride at Work: Organizing for Lesbian and Gay Rights in Unions*, a bargaining guide published in 1990 to raise lesbian-gay consciousness in unions and union consciousness in the gay and lesbian community. More than 8,000 copies have been distributed nationally.

CONNIE KOPELOV, retired labor educator and working-women's historian:
"When I look at the picture of this beautiful union family—out and proud—I remember how it used to be and still is for many gays and lesbians: full of evasions, silences, fears of disclosure, hiding relationships. I used to recruit a gay male friend to escort me to union dinner dances. May the future bring openness and acceptance to all."

Domestic partners Desma Holcomb, Miriam Frank, and their daughter, Ruth Frank-Holcomb, at the 1995 New York City Labor Day parade. *(Robert F. Wagner Labor Archives, photograph by Dorothee Benz)*

NANCY CHAN, testimony at the New York City Central Labor Council Labor Day breakfast, September 1999:

"I came to the United States in 1984 and have been working in the garment industry as a seamstress for almost fifteen years. I used to work in a union garment factory, and I was a member of UNITE. Three years ago, the factory I worked in shut down. Garment manufacturers and retailers are sending most of their work abroad. There is not much work here in the U.S. I was unemployed for an entire year.

"Since I need to help support my family, two months ago, I had no choice but to start work in a non-union garment factory in Brooklyn. I used to have benefits, but now I do not. There are only about ten workers in my shop, but I see my boss giving out a lot of work to illegal homeworkers every day. If we complain about anything, our bosses say. 'You are lucky to have a job.'"

YVES JOCELYN, testimony at the New York City Central Labor Council Labor Day breakfast, September 1999:

"I've worked for five years for a company that distributes advertising circulars to people's doorways. I drive a van, which supplies teams of carriers on the streets who go door to door. This is a very hard job. The carriers have to walk long distances in the rain and snow. They sometimes get attacked by dogs or abused by building security people. They get paid $5.15 an hour, the federal minimum wage, but they don't get paid for all hours worked. The company expects them to load the vans and travel as far as New Jersey without getting paid until they get out of the van. None of the employees gets workers compensation, disability insurance, unemployment insurance or other government benefits, such as the normal employer contribution to Social Security. It's a disgrace. We are treated like second-class workers. We are forced to use a single dirty toilet and drink from a hose.

"We ask the major newspapers, which use these distribution companies, to talk to our employers. Every newspaper in New York city says that hardworking new Americans should have equal rights with all other workers. Like the farm workers on Long Island, those of us who work in the heart of Brooklyn have a right to be treated like human beings. . . . The time has come to rally the whole community of New York City to live up to the high standards set by the editorial writers of our great newspapers."

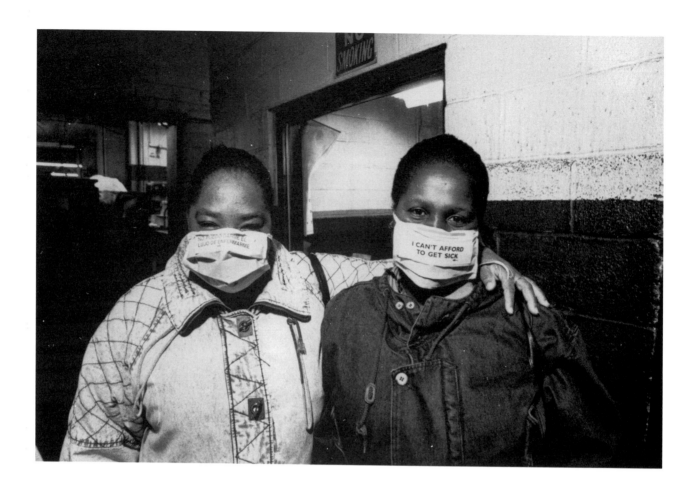

"I Can't Afford to Get Sick"—two women in a health care campaign. In 1999 the percentage of New Yorkers without health insurance was higher than the national average, and fewer New York workers have employer-provided health and pension coverage than twenty years ago. *(Circa 1985, photograph by Gary Schoichet)*

DENNIS RIVERA, president, 1199 National Health and Human Service Employees Union, SEIU, AFL-CIO:

"As we enter the third millennium, it remains a national scandal that the wealthiest country in the world is the only industrial nation without health insurance for all its people. Since President Clinton was the first elected on the promise of national health care as a right, the uninsured have increased by 10 percent. In the year 2000, we have 45 million Americans without insurance and an equal number who are underinsured. In New York State, the number of uninsured are now 3.2 million, 2 million of whom are in the world's richest city. Parallel to this disgrace is the fact that less than 15 percent of our salaried workers are in unions today, half of what it was a half-century ago. With 9 million people, we healthcare workers are the largest single sector of the workforce in the United States, but only about 1 million of us are in unions. Inasmuch as the labor movement is the largest component of national health insurance—and workers are the largest component of the uninsured—we must have two overriding strategic goals: the achievement of national healthcare, and a labor movement that organizes a majority of American workers. That's the imperative for the twenty-first century.

MOHAMMED BEDIR, testimony at the New York City Central Labor Council Labor Day breakfast, September 1999, intrepreted from Arabic:

"I've worked for one limousine service for the past twelve years, one of eight companies all owned by the same company, employing close to 2,000 drivers in all. Limousine drivers first started organizing a few years ago because we were treated like second-class workers. We were at the mercy of the company. They would give out the best work to their friends and we could not make enough to support our families. We did not have any medical benefits. We didn't even have workers' compensation. Neither the company nor the government provided us with any benefit, even unemployment insurance. Thanks to the union, we now have workers' comp at no cost like other workers.

My family comes from Egypt, and other drivers come from every continent. The boss tried to take advantage of us because we were immigrants

Union members join District Council 37 administrator Lee Saunders and UFT president Randi Weingarten leafleting in Union Square, in preparation for a May 1999 rally at City Hall that drew over 40,000 workers. Led by a coalition of progressive elected officials and labor unions, the rally denounced planned state budget cuts in health and education, and the exploitation of working welfare recipients doing city jobs. *(1999, DC 37,* Public Employee Press *photograph by George Cohen)*

Food service workers on opening night at the Metropolitan Opera, protesting the anti-union campaign waged by the Met and its food service company. Hotel Employees and Restaurant Employees Local 100 organizer José Guzman was among thirty-one arrested for committing civil disobedience by passing out leaflets to opera-goers on Lincoln Center Plaza. *(1999, HERE Local 100, photograph by John Stamm)*

and didn't have any power or know our rights. We now have union committees fighting in all forty-two major limousine companies in New York City. Someday soon, all of New York City's 12,000 black-car drivers will be union members."

EMELINA ORTIZ, testimony at the New York City Central Labor Council Labor Day breakfast, September 1999:

"I work at the Metropolitan Opera restaurant, and have been working there for nine and a half years. There are ninety-five food service workers there, and most cannot afford to pay for the health insurance. I do pay for it, but I have to sacrifice so my child can have this basic benefit. We signed a letter asking for the right to choose if we want union representation. They said no, and since then it feels like management is at war with us. They fire people unfairly, like my co-workers here, and threaten us."

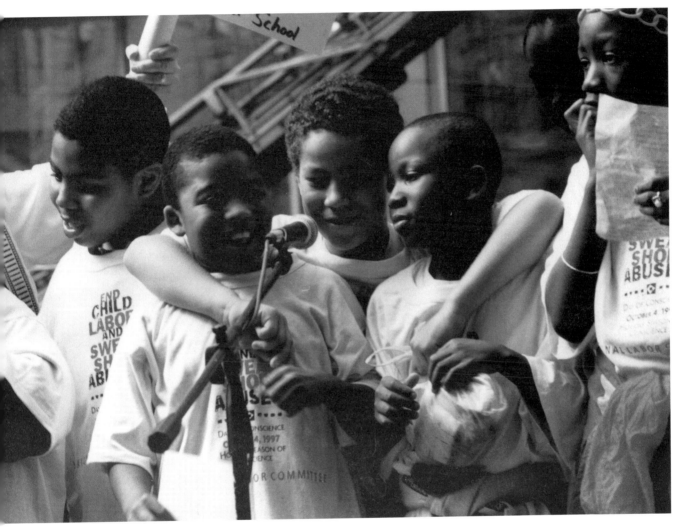

The next generation of New York workers participating in a UNITE rally against sweat-shops and child labor. *(October 1997, photograph by Gary Schoichet)*

Afterword

JOHN J. SWEENEY, PRESIDENT, AFL-CIO

Historically, unions have been the leading advocates for progressive public policy, from the establishment of public schools and the outlawing of child labor early in this century, to the creation of Social Security and the minimum wage in the 1940s, to the struggles over good jobs, universal health care, and equal pay for women workers that are taking place as we approach the twenty-first century.

Today, we can take inspiration from the extraordinary people presented in this volume. Through their examples, we can begin to revitalize the social movement for public policies that change the direction of our society—not back to an idealized vision of how things used to be, but to a new future filled with the kind of hope we used to hold.

A future where people not only work hard and play by the rules, but change the rules when they don't work anymore.

A future where your lot in life is determined by what you do, not by the color of your skin, the accident of your birth, or the selection of your partner.

A future in which honest labor raises the standard of living for all, rather than enormous wealth for just a few.

A civilized world in which love replaces hate, peace replaces war, and justice triumphs over greed.

A bigger, stronger labor movement can be the core and catalyst for that new social movement extending well beyond our ranks, a movement that will push for public policies promoting economic security and social justice.

We must all come together—union members, students, academics, religious and civil and human rights activists—and create that movement. As Dr. Martin Luther King, Jr., said so eloquently in the late 1960s, our nation stands at the crossroads and we must choose between community and chaos. And as the great civil rights movement changed our world in the 1960s, we can change our world today if we have the courage and commitment to do so.

A Timeline of New York City Labor History

1776 New York printers organize and strike in support of independence.

1825 The United Tailoresses of New York, a women's union, is organized and strikes for higher wages.

1833 General Trades' Union of New York is organized and initiates a wave of labor militancy ending in the panic of 1837 and the subsequent depression. This confederation of tradesmen serves as a model for confederations in over a dozen other American cities. Free universal public education and restrictions on child labor are two of its major goals.

1842 The Croton Aqueduct is put into service, and city dwellers celebrate the arrival of clean water with parades, fireworks, music, and fountains.

1850 The earliest lasting trade union results when a number of local printers' societies meet in New York to discuss standards of craftsmanship, union discipline, and apprenticeship. This meeting leads to the formal founding two years later of the National Typographical Union, renamed the International Typographical Union after the affiliation of Canadian locals.

1863 The first union of musicians is organized in New York City.

1865 Bricklayers found their first permanent national organization, the Bricklayers International Union.

1867 New York passes the first tenement housing statute in the country, requiring a privy and a fire ladder for every twenty tenants and setting standards for ventilation, rear courts, and the proportion of a lot that can be covered by a building.

1869 The Knights of Labor is organized; secretly builds toward one large industrial union.

1874 The Cigar Makers' National Union (founded in 1864) is the first union to use the union label designating that their product was made by union members under union conditions.

1880 Better mail service and the widespread introduction of telephone and telegraph vastly improve communication in the growing city; New York is the national center for telegraphy, and most services and companies evolve here.

1881 New York cigarmaker Samuel Gompers presides over the founding of the Federation of Organized Trades and Labor Unions (FOTLU), the predecessor of the American Federation of Labor. Its primary objective was to further labor's legislative goals, including abolition of child and convict labor, compulsory school attendance, the eight-hour day, abolition of conspiracy laws as applied to labor, and a protective tariff.

The first permanent national organization of carpenters, known as the Brotherhood of Carpenters and

Joiners, spearheads the movement for the eight-hour workday.

1882 Thomas Edison's Pearl Street Station begins operation, the first successful commercial production of electricity.

Union Square is the site of the first Labor Day observance.

1883 The Brooklyn Bridge is completed. By 1910 the Manhattan, Williamsburg, and Queensborough Bridges are complete, as well as eight bridges that connect the Bronx to Manhattan over the Harlem River. Today more than 2,000 bridges are used by pedestrians, motor vehicles, subways, and railroads, and New York City boasts the oldest and largest motor vehicle bridge infrastructure in the world.

1884 Plumbers organize the National Association of Plumbers, Steam Fitters and Gas Fitters in New York City.

1885 The first collective bargaining agreement in the building trades is gained by bricklayers.

1886 The Federation of Organized Trades and Labor Unions calls on workers nationwide to strike on May 1 for an eight-hour workday. In New York City, 10,000 workers march in torchlight procession up Broadway to Union Square. In Chicago the eight-hour struggle results in the Haymarket tragedy, anti-labor hysteria, and the discrediting of the Knights of Labor.

In Columbus, Ohio, in December, FOTLU reorganizes as the American Federation of Labor; Samuel Gompers is elected president.

1887 Painters found the Brotherhood of Painters and Decorators.

1888 The AF of L charters the first national union of sheet metal workers.

United Hebrew Trades is founded.

1890 The new Croton Aqueduct is finished, more than three times the size of the original.

The AF of L carries on the fight for an eight-hour workday with mass meetings and a strike fund. The Brotherhood of Carpenters and Joiners strike for the eight-hour workday and are successful in 137 cities. Printers and some other building trades also prevail, but the AF of L leadership soon withdraws support when compromises are offered by some owners.

The AF of L charters a national union of retail clerks, the Retail Clerks National Protective Association.

1890s The word "skyscraper" becomes common, as competition to build ever-taller buildings increases with the development of metal frame skeleton construction techniques. New York has always been identified with skyscrapers and has more than any other city in the world.

1891 The AF of L charters the first national union of electrical workers after electricians from across the nation meet at the 1890 St. Louis exposition of "electrical wonders."

1892 The Workmen's Circle, a mutual aid society for Jewish workers founded on socialist principles, holds its first meeting; by 1925 the group boasts 85,000 members.

1896 The AF of L charters the American Federation of Musicians.

1897 The *Jewish Daily Forward* is first issued. It becomes one of the most important socialist papers in the nation and a leading voice of Yiddish-speaking Jewish immigrants, with a circulation of 200,000 in the 1910s.

1899 Ten- to fifteen-year-old newsboys strike against the *World* and the *Journal* when the wholesale price of the papers increases by 20 percent. Sales plummet, and after two weeks—during which the newsboys form a trade union, a strike committee, and a committee on discipline—a compromise settlement is reached.

The AF of L charters the Team Drivers International Union, predecessor of the International Brotherhood of Teamsters, Chauffeurs, Warehousemen and Helpers of America, to better conditions of team drivers. They worked a fourteen-hour day six days a week and a half-day on Sundays, after which they had to groom their teams.

1900 New York is headquarters to sixty-nine of the hundred largest corporations in the United States.

The Port of New York becomes the busiest port in the world and remains so for more than fifty years.

1901 The New Tenement House Law—a model for those enacted in cities across the nation—orders windows cut in 350,000 previously airless rooms and mandates yearly inspections of tenements.

Members of the White Rats Association walk off stage in the Vaudeville union's first strike.

The Socialist Party is founded.

1903 The Women's Trade Union League is founded to fight for better working conditions for women.

1904 The first segment of the Interborough Rapid Transit (IRT) subway system between the Brooklyn Bridge and 145th Street and Broadway is opened. IRT construction began in 1900, and more than a hundred workers died during the construction of the first thirteen miles of subway tunnels and track line.

A transit strike on IRT, for a nine-hour workday and wage increase, is defeated.

1905 Industrial Workers of the World (IWW) starts organizing in an era of "yellow-dog" contracts, blacklists, labor spies, injunctions, and anti-labor vigilantes. The IWW held its founding convention in Chicago in 1905.

New York cloakmakers organize a union of all crafts within the ladies' garment industry and obtain a charter from the AF of L for the International Ladies' Garment Workers' Union.

1906 The Rand School of Social Science is established as a center for socialist and labor education. The school operates until 1956 after which its library, donated to New York University, becomes the Tamiment Library. The New York City Central Labor Council, Tamiment Institute, and NYU establish the Robert F. Wagner Labor Archives in 1977 to preserve the history of New York labor.

1907 The last horsecars are removed from the streets of Manhattan.

Construction of the Catskill water system begins; by 1917 water from the Catskills is flowing into all five boroughs.

A mass meeting of 125,000 unemployed workers is held at Grand and Allen Streets to start a rent strike; the strike saves 2,000 families from eviction.

Immigrants make up 41 percent of the city's population; the percentage of immigrants from northern and western Europe declines from 87 percent (in 1882) to 19 percent.

1908 The forty-seven-story Singer Building is completed, becoming America's tallest building.

1909 "Uprising of the 20,000": shirtwaist makers, most of them young immigrant women, follow Clara Lemlich out on strike, against the advice of Samuel Gompers.

The Croton Reservoir system is expanded into the Catskill watershed.

1910 Electric washing machines are introduced.

Cloakmakers strike involving 60,000 workers, mostly Jewish and Italian men, leads to "Protocol of Peace" agreement between owners and the ILGWU; workers win a fifty-hour week, overtime pay, legal holidays, and preferential shop.

1911 On March 25, 146 young shirtwaist makers die in the Triangle Shirtwaist Factory Fire, leading to reforms in fire laws and working conditions. However, fire traps and dark and unhealthy sweatshops continue to exist, due to lack of funds for enforcement.

The findings of the Factory Investigation Commission, led by Robert F. Wagner and Alfred E. Smith, lead to a new code regulating health and safety conditions, hours, home work, and tenement labor and mandating inspections.

In March, the Wage Earners Suffrage League is founded, with Leonora O'Reilly as president and Clara Lemlich as vice president. In 1912, an overflowing crowd of working women attend a rally at Cooper Union.

1912 Eighteen thousand hotel workers strike, led by IWW organizers. A few hotels settle, but most hire strikebreakers. Strike leaders are blacklisted but go on to organize in other cities.

After an organizing drive initiated by United Hebrew Trades, and following a New York State commission report that found 80 percent of fur workers suffering from occupational disease, 20 percent of them from tuberculosis, fur workers strike for thirteen weeks. Despite violent anti-strike employer tactics, the workers win union recognition, a forty-nine-hour week, and overtime pay in an agreement modeled after the "Protocol of Peace" that followed the 1910 cloakmakers strike.

The historic strike in the textile mills of Lawrence, Massachusetts, led by the IWW and involving thousands of women workers of twenty-five nationalities, gains massive national support and inspires the song "Bread and Roses."

1913 Grand Central Terminal opens; by the 1990s more than 140,000 commuters pass through it daily.

The United States Department of Labor is created.

The Actors Equity Association is founded, in a hotel at Columbus Circle.

1914 The Amalgamated Clothing Workers Union is founded at Webster Hall, in Manhattan, in December.

The first cross-country telephone call is made between New York and San Francisco.

1915 Mohawk Indians arrive in New York City to work on Hell Gate Bridge over the East River. More bridgemen come in the 1930s to work on the George Washington Bridge and Rockefeller Center. Many settle in the North Gowanus neighborhood of Brooklyn.

1916 After five years during which the ILGWU grows to become the third-largest union in the AF of L, the "Protocol of Peace" ends when 60,000 cloakmakers strike and win union recognition, the right to strike, and a standard collective bargaining agreement.

The AF of L charters the American Federation of Teachers.

The Child Labor Act is passed but is declared unconstitutional in 1918, with Oliver Wendell Holmes dissenting. Child labor is banned again in 1936, with the ban upheld by the Supreme Court in 1941.

A transit strike is settled by compromise, but companies try to form a company union and a second strike is called. All public transit in the city is paralyzed. The New York Public Service Commission intervenes and requires arbitration but the strike continues. Five thousand socialist women march on the picket line, and city unions rally in support. A general strike of New York's half a million unionized workers is called, but AF of L leaders advise against it and it fails. Transit workers stay out but are defeated. Company unionism prevails in transit until the 1930s.

The Amalgamated Association of Street Railway Employees is founded on Staten Island by mostly Irish-born trolley workers.

Finnish carpenters living in Sunset Park in Brooklyn build the first cooperative apartment house in New York City.

1917 The United States Supreme Court upholds the eight-hour workday.

1919 Actors strike for thirty days, closing thirty-seven plays in eight cities and preventing the opening of sixteen others. Actors' Equity emerges as a much stronger union, having gained thousands of members during the strike.

The Communist Party USA is founded in the wake of the Bolshevik Revolution.

1920 Nearly 40 percent of the city's population is foreign-born, with Russian Jews the largest group, followed by Italians, who constitute almost as many as the Irish and German-born combined.

1920–1921 New York clothing manufacturers try to return to the open shop and eliminate the Amalgamated Clothing Workers from the men's garment industry. Union president Sidney Hillman offers concessions, but the offer is rejected and a lockout ensues. The strike lasts from December to June. After smaller firms sign and their workers go back, the strike continues until an agreement is reached that maintains a union shop and a forty-four-hour week, with some wage concessions.

1923 The Amalgamated Clothing Workers opens the Amalgamated Bank of New York, one of a number of labor banks started at that time, and the only one that still exists.

1925 The Brotherhood of Sleeping Car Porters is

founded by A. Philip Randolph in Harlem. After affiliation, it becomes the voice of black workers in the AF of L.

1926 Twelve thousand New York fur workers strike for seventeen weeks under the leadership of Ben Gold, winning the first forty-hour, five-day workweek in the industry.

1927 The Amalgamated Clothing Workers of America build the Amalgamated Apartments in the Bronx, one of the first examples of good, affordable housing provided for its members by a union.

1929 After a major expansion, Newark Airport becomes the busiest airport in the world.

The New York Stock Exchange Market crashes on October 29.

1930 The Chrysler Building opens and for a very short time is the tallest building in the world.

The George Washington Bridge is completed, with a main span of 3,500 feet.

1931 Rockefeller Center, John D. Rockefeller's "Acropolis of America," is under construction; workmen decorate the bare girders with a Christmas tree to lift their spirits, starting a tradition that continues to this day.

New York City Building Trades Workers complete construction on the Empire State Building. In just nineteen months, steelworkers, masons, glaziers, pipefitters, and workers in dozens of other trades build the 102-story building, with seventy-three elevators, sixty miles of water pipes, and five acres of windows. Opening during the Depression, it finds few tenants at first but wins acclaim as the tallest building in the world.

Metropolitan Life Insurance Company completes a study of 126 asbestos workers for Johns-Manville and Raybestos Manhattan. The study, showing signs of lung damage in 67 percent of the workers, was not published until 1935.

The percentage of the nation's imports passing through New York drops to 50 percent, but the assessed valuation of the city's properties reaches an all-time high of $19 billion.

1932 Election of New York governor Franklin Delano Roosevelt to the presidency; he is reelected 1936, 1940, and 1944. Senator Robert. F. Wagner serves as legislative whip to FDR's New Deal.

The Norris–La Guardia anti-injunction law is passed, outlawing "yellow-dog" contracts. After co-sponsoring this law, which assists union organizing efforts across the nation, Fiorello La Guardia goes on to serve three terms as mayor of New York City (1934–1945).

One-fourth of the population of New York City is out of work and one-third of the city's manufacturing plants are closed.

The New Deal Recovery Program offers relief for the needy, improvements in wages and decreases in hours in the low-paid sweatshop industries, abolition of child labor, and security for the unemployment and the elderly.

1933 Dorothy Day publishes the first issue of the *Catholic Worker* on May 1, inspired by the papal encyclicals *Rerum Novarum* (1891) and *Qudragesimo*

Anno (1931) and the Gospels of the New Testament. The Catholic Worker movement embraced voluntary poverty, personal responsibility, and social justice through nonviolent activism.

The National Industrial Recovery Act (NIRA) Section 7(a) establishes the right of workers to organize into unions of their choice without employer interference, and of unions to bargain collectively.

The Chinese Hand-Laundry Alliance holds its founding meeting at the Transfiguration Catholic Church on Mott Street.

Transit workers employed by the IRT Company, many of them Irish immigrants who came to the United States after the Irish Rebellion (1919–1923), begin to organize the union that will become the Transport Workers Union (TWU), named for the union founded in Ireland by James Connolly and James Larkin.

The Civil Works Administration (CWA) is established to provide temporary work on public projects for the unemployed.

Heywood Broun's August 7 column in the *New York World Telegram* calling for unionization among newswriters leads to the founding of the American Newspaper Guild. Broun became the Guild's first president and guided the union through its first six years.

1934 The National Labor Relations Board is established to deal with disputes arising out of Section 7(a) of NIRA.

In response to the rise of Nazism in Europe, the Jewish Labor Committee is founded by Jewish leaders of the ILGWU, ACTWU, the Workmen's Circle, the *Jewish Daily Forward,* and others.

Harlem "Jobs for Negroes" boycott: After several years of attempting to break through the color barrier keeping blacks confined to the most menial jobs, sixty-two Harlem organizations band together to demand that Blumstein's, Harlem's largest department store, hire blacks. A two-month boycott ends when the store agrees to hire fifteen black clerical and sales employees. Other stores are targeted, but with less success.

1935 The Committee for Industrial Organization is set up within the AF of L, including United Mine Workers of America, Amalgamated Clothing Workers of America, United Textile Workers, and others. With John L. Lewis as chairman and Sidney Hillman as secretary, the committee seeks to organize unorganized workers on an industrial basis. Member unions are suspended by the AF of L in January 1936, expelled in 1937, and form the Congress of Industrial Organizations (CIO) in 1938.

The Works Progress Administration (WPA) is established to provide jobs for people out of work; its budget represents more than half the total federal budget for the year. Though nearly one-seventh of the national funds are spent in New York City, there are still more than three applicants for every available job.

The AF of L charters the America Federation of State, County, and Municipal Employees; shortly thereafter, the CIO charters opposing unions of federal, state, and county workers.

New York City locals of the Retail Clerks refuse to pay per-capita taxes to their moribund parent union and constitute themselves as the "New Era Committee." The CIO grants the committee a charter in 1937 as the United Retail Employees and establishes

a Department Store Organizing Committee under Sidney Hillman. The name is later changed to the Retail, Wholesale and Department Store Union.

1936 The fledgling New York City Housing Authority, pressured by reformer Mary K. Simkhovitch, completes a 210-unit low-rent housing unit, First Houses, on the Lower East Side.

The Triborough Bridge opens, built with $44.2 million in WPA grants and using land occupied by ten blocks of old-law tenements for its approach and supports.

CIO unions win recognition and first contracts in the rubber, auto, and steel industries.

Militant rank-and-file seamen walk out for nine weeks in the spring, seeking wages on a par with West Coast workers. They return only to strike again in November together with West Coast unions. Joseph Curran chairs the Seamen's Defense Committee. The strike ends with no gains after eighty-six days, but it lays the groundwork for a new CIO union, the National Maritime Union, founded in July 1937 with Curran as its first president.

1937 The New York State Labor Relations Act is signed into law.

1938 The Committee for Industrial Organization becomes the Congress of Industrial Organizations (CIO). The CIO's constitution includes promotion of the organization, collective bargaining, adherence to wage contracts, and promotion of favorable legislation. John L. Lewis is the CIO's first president; Philip Murray and Sidney Hillman are vice presidents, and James B. Carey is secretary.

Fair Labor Standards Act sets a forty-hour workweek and a twenty-five-cent minimum wage.

1939 North Beach Airport, soon renamed La Guardia, opens. Built with $45 million in WPA money, it is the first airport in the United States to be financed, designed, and built with federal cooperation. It is also the first commercial airport in the city.

1941 A TWU bus strike brings buses to a standstill for twelve days; demands include an eight-hour day and a forty-hour week. The strike is settled by arbitration.

Ten days after Mussolini's declaration of war against the United States, New York labor leaders Luigi Antonini, Augusto Bellanca, Eduardo Molisani, Carlo Tresca, Arturo Giovannitti, and others found the Italian-American Labor Council. The anti-fascist IALC's first act is to lobby successfully on behalf of Italian Americans against the implementation of the Enemy Alien Act.

1941–1945 During World War II seventy-five thousand male and female workers at the Brooklyn Navy Yard work around the clock in three shifts. New York City's largest heavy industrial site, the plant closes in 1966.

The War Manpower Commission, with labor representation, is established. A no-strike pledge is honored for the duration of the war by the CIO and AF of L.

1945 Thirty-five thousand longshoremen strike.

1947 Three hundred thousand telephone workers in thirty-five states participate in the first nationwide strike, lasting twenty-four days.

The Labor-Management Relations (Taft-Hartley) Act is passed over President Truman's veto.

1948 Subway fare rises to a dime (it had been a nickel since the subway opened in 1904).

Idlewild International Airport opens; renamed for John F. Kennedy in 1963.

1949 The CIO expels eleven unions as "Communist-dominated."

1950 The Brooklyn-Battery Tunnel opens, the world's largest at the time.

New York City's transportation system begins carrying the equivalent of the world's population each year.

Seven percent of the nation's manufactured goods are made in New York City.

1951 Water from the Delaware River finally flows into the city as a system first planned in 1921 overcomes many financial and legal roadblocks.

1954 New York's airports serve 37 percent of all domestic fares.

1955 The Third Avenue elevated line is demolished, letting in daylight for the first time in nearly fifty years.

Despite the enormous influx of immigrants to New York, the population remains fairly constant because of the middle-class exodus to suburbia.

The AF of L and the CIO merge. At the first convention, held in New York City, George Meany is elected president.

1958 Mayor Robert F. Wagner issues Executive Order 49, or "Little Wagner Act," as a road map for municipal unionism. The next year District Council 37 negotiates the first collective bargaining agreement with the city resulting in wage increases for thirty-three civil service titles.

1959 Local 1199 hospital strike affects six voluntary hospitals. The strike lasts for six weeks and is settled after a grievance procedure in hospitals is established for hospital workers. In 1963, a year after a second 1199 hospital strike, Governor Nelson Rockefeller signs a law extending collective bargaining rights to workers in voluntary hospitals and opening the way for the organization of thousands of hospital workers by 1199.

1960 Containerized shipping begins to transform the shipping industry, and the Brooklyn and Manhattan waterfronts gradually become obsolete as new facilities are built in New Jersey.

New York labor leaders A. Philip Randolph (Brotherhood of Sleeping Car Porters) and Cleveland Robinson (District 65) lead other blacks inspired by the civil rights movement to form the Negro American Labor Council in order to fight racism within the AFL-CIO.

1962 School supervisors organize for the first time, forming what becomes the Council of Supervisors and Administrators. In 1969, the Council signs the first comprehensive contract for school supervisors in the United States.

After a one-day strike of 20,000 teachers, the United Federation of Teachers, the new amalgamation of some seventy professional associations crafted by the

Teachers Guild, signs its first contract with the Board of Education.

International Brotherhood of Electrical Workers Local 3 strikes for eight days, led by Harry Van Arsdale, Jr., to win work week of five days, five hours each.

1962–1963 Printers strike at New York City's four major daily newspapers over wages and new technology, and five other papers lock out union workers. After 114 days Local 6 of the International Typographical Union settles for a wage increase but no agreement on new technology. The cost of the strike to unions and to publishers is extremely high and contributes to the closing or merging of some of the papers.

1963 New York black trade unionists A. Philip Randolph and Cleveland Robinson, together with civil rights leader Bayard Rustin, organize the national March on Washington for civil rights legislation. More than a hundred thousand people participate and hear Rev. Martin Luther King, Jr., make his famous "I Have a Dream" speech. The march plays a major role in the passage of the 1964 Civil Rights Act.

New York City still has 33,000 manufacturing establishments employing 927,000 workers.

The city's clothing factories make 28 percent of the nations' total apparel, and its publishing houses and print shops handle 19 percent of the nation's printing.

A taxi drivers' and mechanics' organizing drive by the New York City Central Labor Council leads to a union chartered in 1966.

The last reservoir is added to the city's water supply network. The current system includes an up-state watershed of nearly 2,000 square miles, nineteen collecting reservoirs, and 346 miles of tunnels.

The International Longshoremen's Association in New York reaches a four-year contract agreement, the first long-term settlement in its ninety-two-year history, and a model guide for other Atlantic and Gulf Coast ports.

Queens resident Michael Stewart, age twenty-one, is the first African American apprentice accepted for membership by the International Association of Bridge and Structural Iron Workers Union.

Equal Pay Act limits discrimination in compensation and hiring.

1965 Social Service Employees Union welfare workers, 8,000 strong, strike for salary increase, case reduction, and an end to "midnight raids" on welfare clients.

1966 At 5 A.M. on January 1 the greatest urban transportation strike in American history paralyzes New York City. Led by Mike Quill, the Transport Workers Union shuts down buses and subways for two weeks.

The first strike by the faculty of a four-year institution of higher education is led by Israel Kugler, president of the United Federation of College Teachers, affiliated with the American Federation of Teachers, against St. John's University. The Catholic university with campuses in Brooklyn and Queens dismissed thirty-one teachers because of their union organizing activities. The strike lasted a full year and attracted nationwide support. Although the thirty-one teachers were never reinstated and had to find jobs elsewhere,

the strike was an academic and public relations disaster for St. John's, while the UFCT and the dismissed teachers were lionized as champions of academic freedom.

1967 New York State Legislature passes the Taylor Law regulating public employee collective bargaining through the Public Employee Relations Board after the 1946 Condon-Wadlin Act, which provided immediate dismissal of striking public employees, proved unworkable.

1968 Ten thousand sanitation workers go on strike; tons of garbage pile up.

In a series of three strikes, the longest lasting five weeks, 54,000 teachers in the New York City school system walk out over a dispute between the community-run school board in Ocean Hill–Brownsville and the UFT teachers there. The conflict was between the job security and due process rights of teachers and community control of the schools. The UFT ultimately prevailed, but at the cost of animosity between teachers and the black community that would last for years.

Actors Equity strikes nineteen Broadway shows and ten touring companies, winning a new three-year contract after three days.

1969 Workers at the Bronx Bureau of Child Welfare hold a one-day work stoppage and picket their offices.

1970 Eighteen percent of the city is foreign born, the lowest proportion since the nineteenth century.

The World Trade Center twin towers are completed, once again giving New York the tallest building in the world for a time. Each tower is 110 stories tall and contains 4 million square feet.

Postal workers stage a one-week walkout, the first nationwide strike by federal employees. Instigated by rank-and-file members and led by the largest Letter Carriers local, New York City's No. 36, the walkout spreads from New York across the country. Nixon calls in federal troops and National Guards to replace the New York workers, and federal injunctions against the strikers are obtained.

1971 On January 14–19, 25,000 police officers led by the Patrolmen's Benevolent Association undertake a series of labor protests—walkouts, slowdowns, and a refusal to answer non-emergency calls. Conflict with Mayor John V. Lindsay had been building since his election in 1965, over wages, a civilian review board, and anti-corruption investigations. On February 5 the policemen win a court decision granting some of their pay claims.

1974 Coalition of Labor Union Women (CLUW) is founded, with members from sixty unions.

1974–1975 New York City's fiscal crisis takes place during the worst economic downturn since the Great Depression.

1975 The first strike in the nation by hospital house staff, conducted by the Committee of Interns and Residents, lasts for three days and results in a two-year agreement with improvements in working conditions, hours, salaries, and benefits.

1976 New York Committee on Occupational Safety and Health (NYCOSH) begins meeting, opens offices on Union Square in 1980.

1977–1980 The Amalgamated Clothing and Textile Workers' Union (ACTWU) campaign to organize the J. P. Stevens company's southern textile mills spearheads labor's efforts to organize in the mostly non-union South. The company's tactic is to tie up the union in years of court proceedings even after the union won representation elections. The union counters with an innovative corporate campaign directed at all financial institutions represented on Stevens' board of directors. A settlement reached in fall 1980 represents a partial victory for the union, but during the campaign organized labor gains considerable public sympathy. The union's campaign was later dramatized by Martin Ritt's popular motion picture, *Norma Rae*.

1979 Bread and Roses, an innovative cultural program, is launched by Local 1199 of the National Union of Hospital and Health Care Employees. Led by Executive Secretary Moe Foner, it includes free lunchtime performances in hospitals; art and photography exhibits in Gallery 1199, the only permanent exhibition hall in the U.S. labor movement; original musical revues based on workers' experiences; and more.

1980 Subway and bus workers shut down New York City transportation for eleven days. The strike results in a contract with pay raises and cost-of-living adjustments.

In a five-to-four decision, the U.S. Supreme Court finds in favor of Yeshiva University and against a group of faculty seeking collective bargaining rights. The decision held that since faculty taught, gave grades, designed curriculum, and were on admittedly advisory personnel committees, they were management and therefore not entitled to the protection of the National Labor Relations Act.

1981 Air Traffic Controllers strike when the Federal Aviation Administration refuses to address job stress and other safety issues. President Reagan responds with mass dismissals of strikers, jail terms, and union-busting fines that result in the destruction of the controllers' union, PATCO. For decades, anti-union employers emulate the government's tactic of firing and replacing strikers, thereby seriously weakening the labor movement.

Striking air traffic controllers lead 250,000 New York City union members up Fifth Avenue in the first Labor Day parade since 1968.

On September 19, Solidarity Day, more than 400,000 union members and supporters march in Washington, D.C., for jobs, justice, human rights, and social progress and against the disastrous economic and social policies of the Reagan administration.

1982 Four hundred thousand New York City unionists celebrate the centennial of the first Labor Day parade with the largest parade ever held in the United States.

Twenty-five thousand Chinatown ILGWU members, 90 percent of them women, carry out job actions and massive rallies in Columbus Park. Their militancy wins a new contract.

The city begins a $6.3 billion program to rehabilitate the subways, which are in need of repair after years of deferred maintenance.

The first contract in the nation granting benefits to domestic partners is negotiated between the *Village Voice* and District 65, UAW.

1983 Thirteen thousand Amalgamated Transit Union members strike Greyhound Bus lines to fight

concessions demanded by the company. The strike ends with job rights of strikers protected, but workers accepting concessions.

1986 Jacob K. Javits Convention Center opens; in the mid-1990s it is estimated to account for nearly 2 percent of the city's economy.

Activists in District Council 37, Teamsters Local 237, CWA Local 1180, AFT Local 3882, the UFT, and others found the Lesbian and Gay Labor Network. The AFL-CIO at its national convention passes a resolution against discrimination on the basis of sexual orientation and in 1997 recognizes "Pride at Work," a national organization of lesbian and gay labor caucuses, as one of its constituent organizations.

1987 Manhattan's last cargo pier, Pier 42 on the East River, is vacated by the Dole Fruit Company. Thirty-five years earlier New York's waterfront docks handled more than 32 million tons of fruit shipments per year.

The last part of a 1948 master plan for sewage disposal is complete when the Red Hook treatment plant opens in Brooklyn. The system handles nearly 16 billion gallons daily, but pollution of the waters surrounding the city is still a problem.

1989 More than 8,000 machinists strike Eastern Airlines, and flight attendants and pilots refuse to cross their picket lines. Nearly two years later, the nationwide strike ends when the airline shuts down operations.

One hundred and fifty-five thousand members of Communications Workers of America strike three of the seven regional Bell companies. NYNEX workers successfully strike for seventeen weeks against the company's attempt to shift costs of health insurance primarily to employees.

The Teamsters Union reluctantly accepts the terms of a pre-trial agreement, which stop a Justice Department suit against the union. The agreement calls for changes in the Teamster constitution providing for election of the next international president in 1991 by delegates directly elected by the membership. The Brooklyn-based Association for Union Democracy, founded in 1969 by Herman Benson and devoted to promoting the principles and practices of internal union democracy, crafted the election guidelines.

1990 Some 900 drivers and maintenance workers walk off the job when talks with Greyhound break down over demands for givebacks. Greyhound hires untrained "replacement workers" who pose serious safety problems for picketing workers and the public.

The *New York Daily News* provokes a strike and hires "scabs" and an army of homeless people to write and distribute the nation's third-largest paper. After 146 days, the strike is settled when the paper is sold; replacement workers are dismissed, but 800 jobs are eliminated.

Haitian, Hispanic, and African American workers at Domsey, a used clothing exporter in the Williamsburg section of Brooklyn, strike for six months and are fired. The following year a National Labor Relations Board judge finds the company guilty of treating workers "like animals" and orders it to pay back wages to fired strikers.

Immigrants from more than a hundred countries live in New York City; 28 percent are foreign born and

41 percent of persons five and over speak languages other than English at home.

Two percent of the nation's manufacturing is done in New York City.

1991 Lawyers and staff of New York City's Legal Services strike for sixteen weeks and win substantial wage and pension increases.

Insurgent Ron Carey, head of Queens UPS Local 804, is elected president of the International Brotherhood of Teamsters in a hotly contested, federally monitored election.

1992 More than 3,000 delegates from thirty unions meet in Washington, D.C., to found the AFL-CIO's Asian Pacific American Labor Alliance.

1995 In the first contested election in AFL-CIO history, Service Employees' International Union President John Sweeney and his entire slate, including a Chicana woman, Linda Chavez-Thompson, as executive vice president, are elected and launch an effort to revitalize the labor movement by cementing relations with allies in the academic community and launching major organizational drives throughout the country.

The ACTWU and the ILGWU merge to form the Union of Needletrades, Industrial and Textile Employees (UNITE).

1996 Seven thousand members of the Service Employees' International Union (SEIU) strike against the Brooklyn Hospital Center and twelve other members of the League of Voluntary Hospitals. The two-month strike ends when management drops its demand for a two-tier pay schedule and fewer sick days.

The Personal Responsibility Act becomes law, intended to move millions of welfare recipients, including thousands of New Yorkers, into jobs or "workfare."

1997 The United Parcel Service (UPS) strike by the Teamsters' Union represents a turning point after years in which labor has been on the defensive. The union gains tremendous public support by defending wages and benefits of temporary workers and challenging the company's arrogant policies. The settlement represents a major victory for the Teamsters' Union leadership, which is later dissipated by a financial scandal that results in President Ron Carey's expulsion from the union, and still later in the election of James P. Hoffa as union president.

1998 A U.S. Department of Housing and Urban Development study of the shortage of affordable housing in forty-three cities finds that New York City has the worst housing crunch in the nation. More than 360,000 working poor families are forced to spend at least half their income on rent.

New York's Local 1199, through its National Union of Hospital and Health Care Employees, consummates a merger with the SEIU, bringing close to 250,000 health care employees in New York State alone under one organizational roof.

1999 In a historic vote, the American Medical Association's House of Delegates rejects the advice of its top leadership and votes to form a national labor organization. The unit will represent employed physicians in negotiations with hospitals, health plans, and universities concerning employment contracts and patient care. AMA leaders estimated that such a union could assist up to 108,000 or 17 percent of the nation's physicians.

Suggestions for Further Reading

BOOKS

Bernhardt, Debra, et al. *New Yorkers at Work: Oral Histories of Life, Labor and Industry*. An eight-part radio series. New York: Robert F. Wagner Labor Archives, 1985.

Binder, Frederick, and David Reimers. *All the Nations under Heaven: An Ethnic and Racial History of New York City*. New York: Columbia University Press, 1995.

Buhle, Mari Jo, Paul Buhle, and Dan Georgakas, eds. *Encyclopedia of the American Left,* 2nd ed. New York: Oxford University Press, 1998.

Dubofsky, Melvin. *When Workers Organize: New York City in the Progressive Era*. Amherst: University of Massachusetts Press, 1968.

Ewen, Elizabeth. *Immigrant Women in the Land of Dollars: Life and Culture on the Lower East Side, 1890–1925*. New York: Monthly Review Press, 1985.

Fink, Leon, and Brian Greenberg. *Upheaval in the Quiet Zone: A History of Hospital Workers' Union, Local 1199*. Champaign: University of Illinois Press, 1989.

Fraser, Steve. *Labor Will Rule: Sidney Hillman and the Rise of American Labor*. New York: Free Press, 1991.

Freeman, Joshua B. *In Transit: The Transport Workers Union in New York City, 1933–1966*. New York: Oxford University Press, 1989.

———. *Working-Class New York: Life and Labor since World War II*. New York: New Press, 2000.

Garson, Barbara. *The Electronic Sweatshop: How Computers Are Transforming the Office of the Future into the Factory of the Past*. New York: Simon & Schuster, 1988.

Jackson, Kenneth J., ed. *The Encyclopedia of New York City*. New Haven: Yale University Press, 1995.

Kessler-Harris, Alice. *Out to Work: A History of Wage-Earning Women in the United States*. New York: Oxford University Press, 1982.

Kwong, Peter. *Forbidden Workers: Illegal Chinese Immigrants and American Labor*. New York: New Press, 1997.

Mandel, Bernard. *Samuel Gompers, A Biography*. Yellow Springs, Ohio: Antioch Press, 1963.

Naison, Mark. *Communists in Harlem During the Depression*. New York: Grove Press, 1983.

Orleck, Annelise. *Common Sense and a Little Fire: Women and Working-Class Politics in the United States, 1900–1965.* Chapel Hill: University of North Carolina Press, 1995.

Pesotta, Rose. *Bread upon the Waters.* Edited by John Nicholas Beffel. New York: Dodd, Mead, 1944.

Stein, Leon. *The Triangle Fire.* Philadelphia: Lippincott, 1962.

Tax, Meredith. *The Rising of the Women: Feminist Solidarity and Class Conflict, 1880–1917.* New York: Monthly Review Press, 1980.

Walkowitz, Daniel J. *Working with Class: Social Workers and the Politics of Middle-Class Identity.* Chapel Hill: University of North Carolina Press, 1999.

Winslow, Calvin, ed. *Waterfront Workers: New Perspectives on Race and Class.* Champaign: University of Illinois Press, 1998.

The WPA Guide to New York City: The Federal Writers' Project Guide to 1930s New York: A Comprehensive Guide to the Five Boroughs of the Metropolis—Manhattan, Brooklyn, the Bronx, Queens, and Richmond. New York: New Press, 1992. (Reprint of 1938 original.)

Yellowitz, Irwin. *Labor and the Progressive Movement in New York State, 1897–1916.* Ithaca, N.Y.: Cornell University Press, 1965.

OTHER SOURCES

American Social History Project: http://www.ashp.cuny.edu/ This site contains a link to the ever-expanding History Matters website, which is a rich resource of additional websites and teaching materials about U.S. history, including labor and social topics.

New York City Labor Chorus cassettes and CDs of the repertory of the multicultural and generational chorus, founded in 1992 among representatives of two dozen city unions. Available from NYC Labor Chorus, c/o Fund for Labor Education, 2109 Broadway, Suite 206, New York, NY 10023.

Sources

PHOTOGRAPHS

Space constraints made it necessary to use abbreviated citations for the sources of the photographs in the text. Below are the full names of the archives and collections.

ARCHIVES

AT&T Archives

Centro de Estudios Puertorriqueños, Hunter College, CUNY, Justo A. Martí Collection

Columbia University A. C. Long Health Sciences Library, Archives and Special Collections

Fordham University Archives, Xavier Labor School Collection

Joint Electrical Industry Board Archives

Theodore Kheel Center for Labor-Management Documentation, Cornell University:
 International Ladies' Garment Workers Union Archives
 Amalgamated Clothing Workers of America Records
 Hospital Workers Collection

Library of Congress, Prints and Photographs Division:
 New York World-Telegram & Sun Collection
 Bain Collection

George Meany Memorial Archives

Museum of the Chinese in the Americas

New York City Municipal Archives

New York State Archives and Records Administration

New York Stock Exchange Archives

Schomburg Center for Research in Black Culture, Photographs and Prints Division, the New York Public Library, Astor, Lenox and Tilden Foundations

Tamiment Institute Library, New York University:
 John Albok Collection, photographs by John Albok
 Roberta Bobba–Peter Martin Collection

Elizabeth Gurley Flynn Collection

General Picture File Collection and Vertical Files (the sources when none is specified in the text)

Greenwich House Collection

Liberation News Service Collection

Rose Pastor Stokes Collection

Robert F. Wagner Labor Archives, New York University:
 American Federation of State, County and Municipal Employees, District Council 37 (AFSCME, DC 37) Local 375, Civil Service Technical Guild Collection
 AFSCME DC 37 Local 371, Social Services Employees Union Collection
 Communications Workers of America Collection
 District 65 Collection
 General Picture File Collection (the source when none is specified in the text)
 Jewish Labor Committee Collection
 Metro Postal Workers Union Collection
 National Maritime Union Collection
 New York City Central Labor Council Collection
 Sam Reiss Collection, photographs by Sam Reiss
 Charles Rivers Collection, photographs by Charles Rivers
 Rose Schneiderman Collection
 Transport Workers Union Collection
 Union Label and Service Trades Council of Greater New York Collection
 United Federation of Teachers Collection

UNION PHOTO MORGUES

AFSCME DC 37

Communications Workers of America

Health and Hospital Workers Local 1199
Hotel and Restaurant Employees Local 6
International Brotherhood of Teamsters Local 237
Laborers' Union Local 79
Newspaper Guild Local 3
Transport Workers Union of America
Transport Workers Union Local 100
United Auto Workers Local 259

OTHER INSTITUTIONS

New York Building Congress
New York City Fire Department Photo Unit

PRIVATE COLLECTIONS

Jon Bloom
Marion Casey
Martin and Katherine Daly
Miriam Frank and Desma Holcomb
Al Kolkin
Edwin Lopez
Annie B. Martin
Mel and Shirley Small

PHOTOGRAPHERS

Bob Adelman
Dorothee Benz
George Cohen
Earl Dotter
Jack DuMars
Charles Harbutt
Rivka Katvan
Dan Miller
Donna Ristorucci
Gary Schoichet
Anna Strout

COMMERCIAL PHOTO ARCHIVES

Black Star
Daily News
Corbis/Bettmann

ORAL HISTORIES

Unless otherwise noted, the oral histories are from the Robert F. Wagner Labor Archives in the following collections:

New Yorkers at Work (more than a hundred interviews conducted primarily by Debra Bernhardt in the early 1980s)

Civil Service Technical Guild Oral History Project

Lower East Side Oral History Project

Other oral histories are from:

Lower East Side Tenement Museum

Museum of the Chinese in the Americas

South Street Seaport

Triborough Bridge Oral History Project

COMMENTARY

The quotes from labor economist Lois Gray and historians Betty Caroli, Joshua Freeman, Alice Kessler-Harris, Beatrix Hoffman, and Daniel Walkowitz are taken from papers given at the "Ordinary People, Extraordinary Lives" conference in 1995 and the drafts of essays they prepared for a longer version of this book that should one day be published. Joshua Freeman has developed his essay into a book, *Working-Class New York: Life and Labor since World War II* (New Press, 2000).

The quotes from current labor leaders were solicited for this book

Index

Page numbers in italics refer to captions of illustrations.

Abbott, Berenice, 60
Abzug, Bella, *170*
ACA Gallery, 60
actors, 106–7
Actors' Equity, 106–7, *106*, 196, 197
Adelman, Bob, *35*
African Americans, *see* blacks
air traffic controllers strike, 172–73, *172*, 204
Albert, Marge, 64
Albok, John, 7
Alexander Archer Studio, *138*
Alleyne, Tony, *65*
Alteration Painters, Local 1, 114
Altomare, George, 154, 156–57
Amalgamated Association of Street Railway Employees, 197
Amalgamated Clothing and Textile Workers Union (ACTWU), *182*, 204
Amalgamated Clothing Workers of America (ACWA), 62, 197
 Amalgamated Cooperative Apartments built by, *30*, 198
 Amalgamated Housing Corporation of, *30*, 31
 founding of, 196
 Hillman's leadership of, 137
Amalgamated Transit Union, 204–5
American Civil Liberties Union (ACLU), 94
American Federationist, 97
American Federation of Labor (AFL), 92, 112
 banner of, *91*
 Building Trades Department, emblem of, *11*
 Davis-Bacon Act pushed by, *23*

Federation of Organized Trades and Labor Unions, predecessor of, 193, 194
 founded by Gompers, 11, 12
 ILGWU leaves and rejoins, 127
 merges with Congress of Industrial Organizations, 25, 151, 201
 Union Label Department of, 97
 Union Label parade (1938), *52*
American Federation of Labor- Congress of Industrial Organizations (AFL-CIO)
 AFL and CIO merge to form, 25, 151, 201
 on discrimination by sexual orientation, 205
 Sweeney elected president of, 182, *182*
American Federation of Musicians, 195
American Federation of State, County and Municipal Employees (AFSCME), *168*
 chartered by AFL, 199
 Civil Service Technical Guild, Local 375, 26
 District Council 37, 63, 152, *153*, *171*, *173*, 187
 District Council 37, training program for Work Experience Program (WEP) workers, 85, *85*
American Federation of Teachers (AFT), *154*, 155, 197
American Labor Party (ALP), 126, 127, 137, 164
American Medical Association (AMA), 206
American Postal Workers Union, *169*
Anastasia, Tony, *151*
Andrade, Kathy, 69

Antonini, Luigi, 200
Aronov, Sylvia, 117
artists, 59, 60, 82, 175
Artists' Committee of Action (Artists' Union), 60
arts and theater, 58–60, 82, *82*, 106–7
Asian Americans, 46, 49, 81, 87, 183–84, *183*
Asian Pacific American Labor Alliance (APALA), *183*, 184, 206
Association of Catholic Trade Unionists, 34
AT&T
 Archives, *18*
 strike against (1947), *145*
AT&T Long Lines operators, *18*
Atkinson, William, 68–69
Avrutin, Harry, *119*
Axelrod, Izzie, 114

Bacon, Robert, *23*
Bahr, Morton, 86
Bailey, John, 156
banana ships, 44, *44*
Banks, Gilbert, 32–33
Barbaro, Frank, 44
Barnum (play), *82*
Bartlett, Ken, *145*
Beame, Abraham, *139*, 171
Bedir, Mohammed, 187–88
Beichman, Arnold, 31
Belkin, Harry, 13
Bellanca, Augusto, 200
Benicci, Julia, 49
Ben-Ness, Al, *139*
Benson, Herman, 205
Benz, Dorothee, 8, *184*

Berkman, Brenda, 73
Berknopf, Al, 125
Bible, 90
Biller, Morris "Moe," *169*
birth control movement, 103, *103*
Black, Matthew, *75*
blacks, *79*, 110, 111, 126, 132, 158, 166
 as construction workers, 32–33
 domestic work by, 54, *55*
 employed in department stores,
 68–69
 as municipal employees, 19
 in segregated work gangs, 26
 as sewer construction workers, 19
 during World War II, 138–39
Bloom, Jon, *109*
Board of Education (New York City),
 150, *150*
Boer, John, 63, 152
bonus marchers, 118, *118*
Bookkeepers, Stenographers, and Ac-
 countants' Union, *119*
boycotts
 of Harlem department store, 199
 of Judy Bond (firm), 71, *71*
Brandeis, Louis, 99
Brando, Marlon, 2
Brennan, Peter, 34, *34*, 203
bricklayers, 22, 193, 194
Bricklayers International Union, 193
bridge workers, 13, *13*, 14, *14*
Brooklyn Battery Tunnel, 26
Brooklyn Bridge, *13*, 14, 194
Brooklyn Navy Yard, 62, *62*
Brookwood Labor College, 108, *108*,
 109, *109*
Brotherhood of Carpenters and Joiners,
 193–94
Brotherhood of Painters and Decorators,
 194
Brotherhood of Sleeping Car Porters,
 106, 111, 139, 197–98
Broun, Heywood, *124*, 199
Brown, Frank, *167*
building codes, 28
Bunker, Archie (character), 2

Bureau of Child Welfare, New York City,
 83, 163
bus drivers, 28

cab drivers, 65, *65*
Cacchione, Bernie, 162–63, *162*
Calhoun, Paul, *46*
Camera Club (District 65), 3, 4, 140
Carey, James B., 200
Carey, Philp A., *36*
Carey, Ronald E., 206
Caroli, Betty Boyd, 53
carpenters, 22, 54, 92, 193–94
Casey, Marion, 67
Catholic Worker, 198–99
Central Labor Union, 93
Central Trades' Union, *138*
Central Union Label Council, 97
Chamber of Commerce, U.S., 146
Chan, Nancy, 185
Chaplin, Ralph, 149
Chavez, Cesar, 32
Chavez-Thompson, Linda, *182*, 206
Chen, May, 183–84
Chicago Tribune Company, 176
child labor, 47–48, *47*, *189*, 197
Child's (restaurant chain), 113
Chinatown (Manhattan), *46*, 183
Chinese Exclusion Acts (U.S.,
 1882–1965), 46
Chinese Hand-Laundry Alliance, 46, 199
Chinese immigrants, 46, 183
Chrysler Building, *21*, 198
cigar industry, 51, *51*
Cigar Makers' National Union, 193
City College, 7, 120
civil disobedience, 34, *35*
civil engineers, 26
Civil Rights Act (U.S., 1964), 34
civil rights movement, 34, *35, 160, 160,*
 202
civil service employees, *see* municipal
 employees
Clearers Local 390, 59
Cleary, Edward J., Sr., 17

Cleary, Edward J., Jr., 17, *157*
Clement, Victor A., 22
clerical work, 64, *64*
clerical workers, 119, 177
Clinton, Bill, *179*
Coalition of Labor Union Women
 (CLUW), 174, *174*, 203
Cogen, Charles, 154
Cohen, George, 8, *85, 173, 187*
Columbia Presbyterian Medical Center, 73
Columbia University Health Sciences Li-
 brary, *73*
Committee for Action Through Unity
 (CATU), 156–57
Committee to End Discrimination in
 Stuyvesant Town, 161
Committee of Interns and Residents,
 203
communications industry, 18, *18*, 86, *86*
Communications Workers of America
 (CWA), 86
 Local 1101, 86, *179*
 Local 1150, 18, 134
 as National Federation of Telephone
 Workers, *145*
 strike against regional Bell companies
 by, 205
Communist Party (U.S.), *115*, 120
 evictions stopped by, 117
 Feinberg Law and, 150
 Flynn in, 94
 founding of, 197
 Marine Workers Industrial Union and,
 129
 in organizing CIO, 114
 under Taft-Hartley Act, 146–48
Condon, Mary, 45
Con Edison, 62
Congress of Industrial Organizations
 (CIO), 114, 200
 founding of, 199
 Greater New York Industrial Union
 Council of, *124*, 148
 merges with American Federation of
 Labor, 25, 151, 201
Connolly, James, 199

construction industry, 32
 civil engineers in, 26
 Davis-Bacon Act on wages in, 23
 racial discrimination in, 34
 segregated work gangs in, 26
construction workers, *16, 33,* 40
 blacks as, 32–33
 bricklayers, 22
 carpenters, 22, 54
 civil engineers, 26
 electricians, 17, 31, 35
 ironworkers, 21, *21,* 22
 laying pipes in Manhattan, *20*
 plumbers, *25*
 protests by, 41
 sandhogs (tunnel workers), 14, *14,*
 26, *27*
 sewer construction workers, *19*
CORE (Congress of Racial Equality), 33
Council of Supervisors and Administra-
 tors, 201
Cravotta, Joe, 78
Cross, Ed, 26
culture industry, 82
Curcio, Anthony, *162*
Curran, Joseph, 130–32, 148, 200
cutters, *48, 69*

Davis, Leon, 158
Davis, Stuart, 60
Davis-Bacon Act (U.S., 1931), *23,* 62
Day, Dorothy, 198–99
Debs, Eugene V., 105, *105,* 106
Declaration of Independence, 90
De Palma, Victor, 6, *6*
department stores, 68–69, *68,* 122-23
Dewey, John, 60
Dewey, Thomas, 113
Dineen, Joan, 67
discrimination
 in employment, 34
 by sexual orientation, 205
 at Stuyvesant Town, 160–61
District 65, *see* Retail, Wholesale and De-
 partment Store Union

domestic work, 44, 45, *45*
 by blacks, 54, *55*
 by Chinese, 46
Doswell, Morris, *143*
Dotter, Earl, 8, *179, 182*
Downstate Medical Center (Brooklyn),
 34, *35*
Dreier, Mary E., 28
Dubinsky, David, 126, 127, *127*
DuMars, Jack, *86*
Dwyer, John J. "Johnnie," 151–52

Eastern European Jews, 28, 47, 51, 53,
 54, 98, 99, 100, 112, 127, 134
Edison, Thomas, 194
elections, 105, 126
electricians, 17, 31, 35
1199 National Health and Human Ser-
 vice Employees Union (SEIU), 186,
 206
Emergency Financial Control Board, 171
Empire State Building, 17, 198

Fable Toy Company (Brooklyn), 79, 79
Fairchild Publications, 108
Fair Employment Practices Commission
 (U.S.), 139
Fasanella, Ralph, 175, *175*
Federal Arts Project, *59,* 60
federal employees, 169
Federation of Organized Trades and
 Labor Unions (FOTLU), 193, 194
Feinberg Law (New York State, 1949),
 150
Filardo, Anne Levine, 22, 54
financial industries, *88, 89*
Fire Department, New York City, *73*
firefighters, 73, *73*
fiscal crisis, 171, *171*
Fiscal Policy Institute, 89
Flaxer, Abram, 118
Fleischman, Harry, 148–49
Flynn, Elizabeth Gurley, 94, *94,* 106
Foner, Moe, 204

food service workers, 188, *188*
Food Workers Industrial Union, 112–13
Fordham University Archives, *36*
Frank, Miriam, 184, *184*
Frank-Holcomb, Ruth, *184*
Frank Leslies' Illustrated, 93
Freeman, Joshua B., 142
Friedman, Samuel H., 108

Garcia Rivera, Oscar, 126
garment industry, *48,* 49, *80, 81*
 child labor in, 47–48
 cutters in, *69*
 decline of, 71, *80, 81*
 general strike (1909) in, 98
 Patterson (New Jersey) textile strike in,
 104, *104*
 Protocol of Peace (1910) in, 99
 Triangle Shirtwaist Factory Fire in,
 100, 100–101, *101*
Gellert, Hugo, 60
General Trades' Union of New York, 193
George Meany Memorial Archives, 6, 11,
 65, 137, 151
German immigrants, 11, 53, 120
Gilmore, John, 26
Gimbel's, *68*
Giovannitti, Arturo, 200
Gleason, Jackie, 2
Gold, Ben, 198
Goldman, Emma, 103, *103,* 106
Gompers, Samuel, 1, 12, *12*
 AFL founded by, 11, 193
 on Factory Investigating Commis-
 sion, 28
 Lemlich and, 98, 196
 on McGuire, 92
 as president of AFL, 194
Gotbaum, Victor, 155, *168*
Gottfried, Erika, 5
Gray, Lois, 40, *157*
Great Depression, 22, 114
Greater New York Industrial Union
 Council, *124,* 148
Greek immigrants, 21

Green, William, 120, *137*
Greenpoint Hospital (Brooklyn), 59
Greenwich House, *45*
Grossman, Mildred, 6, *7, 150*
Gumpertz, Bob, 8, *78, 81*
Guzman, José, *188*

Hall, Paul, 152
Hall, Sonny, 28
Handlin, Mary, 45
Harbutt, Charles, 67
Hartley, Fred, *146*
Hat and Cap Makers' Union, 102
Health and Hospital Workers Local
 1199, 158, *158*, 201
health insurance, 186, *186*
Hector, Adele Arico, 134
Hendrix, Hardine, 161
Hendrix, Rae, 161
High School Teachers Association, 156
Hill, Joe, 94
Hillman, Sidney, 62, 126, 137, *137*, 197,
 199, 200
Hillman houses, *30*
Hine, Lewis, 5–6
Hispanic workers, 32, 40, 49, 51, 69, 79,
 132, 157
H.L. Green (stores), 122, 123
Hochberg, Esther, *117*
Hoffa, James P., 206
Hoffman, Beatrix, 104
Hoge, Kitty, *45*
Holcomb, Desma, 184, *184*
Holmes, Oliver Wendell, 197
Hoover, Herbert, 118
Horn and Hardart Automat, *112*, 113
hospital workers, 63, *63*, 73, *73*, 158, *158*
Hotel, Restaurant and Club Employees,
 Local 6, *84*
hotel and restaurant industry, 66, *66*, 67,
 67, 84, *84*, 112–14, *112*, 188
Hotel Employees and Restaurant Em-
 ployees, Local 100, *188*
Hotel Olympics, *84*
Hotel Trades Council, 84, 112, *112*, 113

housing, 28–30, *29, 30*, 117, *117*, 206
 at Stuyvesant Town, 160–61
hunger, 117
Hunter College, 66

immigration and immigrants, 1-2, 53, 91,
 170, 196, 205–6
 Chinese, 46
 in cigar industry, 51
 domestic work by, 44
 in garment industry, 49, 81
 Koreans, 87, *87*
 in sweatshops, 80
Impellitteri, Vincent, 161
indoor plumbing, 20, 25, 28
Industrial Workers of the World (IWW),
 94, 106, 195, 196
Inside Bakery Workers, Local 1585,
 124
International Brotherhood of Electrical
 Workers (IBEW)
 Local 3, 17, 31, 35, *36*, 62, *62*, 202
 Santiago Iglesias Educational Society
 in, 32, *157, 170*
International Brotherhood of Longshore-
 men (IBL), 151, 152
International Brotherhood of Teamsters,
 Chauffeurs, Warehousemen and
 Helpers of America, 195, 205, 206
 Local 237, *39*
International Ladies' Garment Workers
 Union (ILGWU), 197
 Archives (Kheel Center, Cornell Univer-
 sity), *30, 48, 69, 71, 80, 81, 99, 101,
 127, 128, 136, 159*
 Chinatown job actions by, 204
 Dressmakers Union Local 22, *5*
 Dubinsky leadership of, 127
 founding of, 195
 general strike called by (1909), 98
 Italian Dressmakers' Union, Local 89,
 49
 Judy Bond campaign of, 71, *71*
 Local 25 of, 4
 merger of ACTWU with, *182*

Pins and Needles (play) produced by,
 128
 Protocol of Peace between owners and,
 196
 "Workers' University" of, 108
International Longshoremen's Associa-
 tion (ILA), *129*, 151–52, *151*, 202
International Mercantile Marine (firm),
 132
International Seamen's Union (ISU),
 129–32
International Typographical Union, 53,
 76–77, 193, 202
Irish immigrants, 11, 14, 26, 45, 53, 67,
 92, 94, 133, 152, 164
iron products industry, 50
ironworkers, 21, *21*, 22
Iron Workers Union, Local 20, 22
Italian-American Labor Council (IALC),
 200
Italian immigrants, 11, 49, 53, 98, 100,
 111, 134

Jacobowitz, David Isaac, 51, *51*
Jacobson, David, 26
Jewelry Workers, Local 1, 147
Jewish Daily Forward, 195
Jewish Labor Committee, 134, 199
Jocelyn, Yves, 185
Joint Electrical Industry Board Archives,
 31, 36
Judy Bond (firm), 71, *71*
"Jugoslavs" (photo, De Palma), 6

Kahn, Ethel, 47–48
Kappock, Gene, *162*
Katvan, Rivka, *82*
Keane, Martin, 22
Keating, Philip, 3
Kennedy, John F., 159, *159*
Kessler, Jesse, 161
Kessler-Harris, Alice, 104
Kheel, Theodore, 76
Kheel Center (Cornell University)

ILGWU Archives, *30, 48, 69, 71, 80, 81, 99, 101, 127, 128, 136, 159*
 Local 1199 Collection, 63
King, Martin Luther, Jr., 76, 160, 191, 202
Kirkland, Lane, *139*
Kirwan, Katie, 13
Klaus, Ida, 169
Klein, Carl, *45*
Knights of Labor, 90, 93, 193
Koch, Ed, 83
Kolkin, Al, *60*
Kolkin, Lucille Gewirtz, 60, *60*
Kolodney, Jules, 154
Kopelov, Connie, 184
Korean immigrants, 87, *87*
Kramer, Marty, *162*
Kugler, Israel, 202

labor colleges, 26, 108
Labor Day, 92, 93, *93, 94*, 194
Laborers' Union, 40
 Local 79, *40*
Labor for Peace, *167*
LaGuardia, Fiorello, 122, 126, 198
Larkin, James, 199
Leather Workers, Local 1, 47
legislation
 on child labor, 47
 Chinese Exclusion Acts, 46
 Civil Rights Act (1964), 34, 202
 Davis-Bacon Act, *23*
 National Industrial Recovery Act, 119
 National Labor Relations (Wagner) Act, 120
 Taft-Hartley Act, 146
Leifer, Laurie, *79*
Lemlich, Clara, 98, 196
Lesbian and Gay Labor Network, 205
lesbian and gay rights, 184
Lewis, John L., 114, *124*, 146, 199, 200
Liberal Party, 127
Liberation News Service, 8, *79*
Library of Congress, *44, 123*
 Bain Collection, *94*

New York World-Telegram and Sun Collection, *56, 58, 62, 75, 129, 148*
limousine drivers, 187–88
Lindsay, John V., 163, 203
Livingston, David, *167*
Lobman, Ethel, 120-22
Local 65, *see* Retail, Wholesale and Department Store Union
Local 1199, National Union of Hospital and Health Care Employees, *see* National Health and Human Services Employees Union Local 1199
London, Meyer, 105
Long, Cynthia, 35, *35*
longshoremen, 44, 57, *75*
Lopez, Edwin, 32, *157, 170*
Lopez, José, 32
Louis, Wing Hay, 46
Lower East Side (Manhattan), 28, 53
Lower East Side Tenement Museum, 48
Lusk, Clayton, 107

MacArthur, Douglas, 118
McCarthy, Joseph, 149
McElroy, Robert, 115
McEntee, Gerald, *182*
McGuire, Peter J., 92, *92*
McLaughlin, Brian, *182*
Macy's, 68–69
Madel, Sam, 57
Malloy, Edward J., 40
Manhattan Bridge, *14*
manufacturing, 1, 43, 181
Marcantonio, Vito, 126
Margolin, Julius, 57
Marine Workers Industrial Union, 129
Marshall Plan, 147
Martin, Annie B., *76*
Marx, Karl, 90
May Day parades, 120-22, *121, 134*, 147
Mazur, Jay, 81, *182*
Meany, George, 25, *25*, 32, *137*
 as first president of AFL-CIO, 201
 International Longshoremen's Association and, 152

strike against WPA called by, 24
 Vietnam War supported by, 167
mechanics (technicians), 78, *78*
Meckle, Patricia, 18
Meisler, George, 123-24
merchant seamen, 57, 115, 129–32, *129*
Messenger, The, 111, *111*, 139
Metro Area Postal Workers Union, *169*
Metropolitan Opera, 58, 188, *188*
Miller, Dan, 7–8, *172*
Miller, Geraldine, 54
Miller, Lenore, 69
Mills, Ogden, *124*
Mills, Saul, *124*
Missouri, U.S.S. (ship), *60*
Miss Union Maid contest, *165*
Molisani, Eduardo, 200
Mooney, Tom, 140
Moriarty, Kathleen, *67*
Morrisey, Pinky, 58
Mount Sinai Hospital (Manhattan), *158*
Municipal Assistance Corporation, 171
municipal employees
 bridge workers, 13, *13*
 bus drivers, 28
 civil engineers, 26
 firefighters, 73, *73*
 during fiscal crisis, 171
 hospital workers, 63
 right to organize extended to, 152, *153*
 teachers, 74–75, *74*, 150, *150*, 154–57, *154*
 transit workers, 163, *163*, 164
 welfare workers, 83, *83*, 162–63, *162*
Murray, Philip, 200
Museum of the Chinese in the Americas, 46, *46*
musicians, 193, 195
Muste, A.J., 109

National Association for the Advancement of Colored People (NAACP), 96
National Association of Letter Carriers, Local 36, 169, 203

National Association of Manufacturers (NAM), 146

National Association of Plumbers, Steam Fitters and Gas Fitters, 194

National Federation of Telephone Workers, *145*

National Health and Human Service Employees Union (SEIU), Local 1199, 158, 186, 204, 206

National Industrial Recovery Act (U.S., 1933), 119, 199

National Labor Relations Act (U.S., 1935), 120

National Labor Relations Board (NLRB), 119, 199

Taft-Hartley Act and, 146–48

National Maritime Union (NMU), *57*, 115, *129*, 132, *148*, 200

National Press Club, *25*

Negro American Labor Council, 34, 201

newsboys, 195

Newspaper Guild, *124*, 199

Local 3, *176*

New York Building Congress, 41

New York Call, 106–7

New York Child Labor Committee, *47*

New York City, 1

collective bargaining agreements in, 40

divisions within population of, 89

fiscal crisis in (1974–75), 171, *171*

housing in, 28

subways of, 14

New York City Building and Construction Trades Council, 17, 40

New York City Central Labor Council, *157*, 185, 187–88, 202

Van Arsdale as president of, 31

New York City Central Trades and Labor Council, 24

New York City Cigar Makers' Union, 12

New York City Municipal Archives, *13, 14, 19, 20, 27, 64*

Federal Arts Project WPA Collection, *59*

New York City Woman Suffrage Party, *96*

New York Committee on Occupational Safety and Health (NYCOSH), 203

New York Daily News, 52, 176, *176,* 205

New York Hospital, *63*

New York Plan for Training, 34

New York State

Archives and Records Administration, *29, 50*

Feinberg Law of, 150

Taylor Law in, *155,* 163

New York State Building and Construction Trades Council, 17, 34

New York State Factory Investigating Commission, *5,* 28, *29, 50,* 101, 196

New York State Federation of Labor, *25*

New York State United Teachers (NYSUT), 155

New York Stock Exchange, *88*

New York Taxi Drivers Union, Local 826, *65*

New York World-Telegram and Sun, 56, 58, 62, 75, 129, 148

Nixon, Richard, 34, 169, 203

non-union workplaces, 40, *40,* 185, 187–88

Normandie (ship), 57

North American Free Trade Agreement (NAFTA; 1993), *179*

Nuchow, Bill, *65*

Occhiogrosso, Ben, 74–75

Ocean Hill-Brownsville controversy, 166, *166,* 203

O'Connor, Carroll, 2

Oil, Chemical and Atomics Workers Union, 76

O'Keefe, Bill, 17

O'Neal, Frederick, *139*

oral history, 8

O'Reilly, Leonora, 96, *96,* 196

Ortiz, Emelina, 188

painters, 13, 114, 194

Painters Union, 120

Palter, Rita, *47*

Patrolmen's Benevolent Association (PBA), 203

Patterson (New Jersey), 104, *104*

Perkins, Frances, 28, 130

Pernick, Saul "Solly," 58–59

photographers, 3–8

Photo League, 3

Pins and Needles (play), *128*

Pittston (firm), *179*

plumbers, *25,* 194

Pollock, Jackson, 60

postal workers, 169, *169*

Powell, Adam Clayton, Jr., 126

Powers, Bertram, 53, 76–77

printers, *52,* 53, 76–77, *77,* 193, 202

Professional Air Traffic Controllers Organization (PATCO), 173, 204

Protocol of Peace (1910), *99,* 196, 197

public housing, 28

Puerto Ricans, 32, 51, 66, 126, 157, 158

Quill, Michael J. "Mike," *133,* 148, 163, 164, *164,* 202

Randolph, A. Philip, *111, 139*

Brotherhood of Sleeping Car Porters founded by, 111, 197

job discrimination protested by, 34

March on Washington (1941) called by, 138–39

March on Washington (1963) called by, 202

Negro American Labor Council formed by, 201

Rand School of Social Science, 107, *107,* 108, 195

Ravena, Al, *56, 62*

"RC Pipers" (photo), 19, *19*

Reagan, Ronald, 83, *173*

Red Falcons of America (youth group of Socialist Party), 121–22

Red Scare (1919–1920s), 106, 111

Reed, Clarence, 66

Reed, John, 104

Reiss, Sam, 7, *33, 74, 77*

restaurants, 66, 67, *67*, 188

Retail, Wholesale and Department Store Union, 69

 Camera Club of District 65, *3, 4*

 District 65, *65*, 125, *125*, 140, *140, 141, 146, 160, 167*

 founding of, 200

 Local 1-S, 68

Retail Clerks National Protective Association, 194

Ristorucci, Donna, 8, *39*

Ritt, Martin, 204

Rivera, Dennis, 186

Rivers, Charles (Constantinos Kapornaros), 21, *175*

Robbins, Al, 57, 131

Robert F. Wagner Labor Archives, *12, 14, 30, 93, 97, 120, 167, 184, 195*

 Actors' Equity Collection, *106*

 Central Labor Council Collection, *34, 139, 172, 174*

 Charles Rivers Collection, *21, 115, 175*

 Civil Service Technical Guild Collection, *16, 37*

 Communications Workers of America Collection, *145*

 District 65 Collection, *68, 125, 140–43, 146, 160*

 Hotel Trades Council Collection, *112*

 Jewish Labor Committee Collection, *5, 134*

 Metro Area Postal Workers Union Collection, *169*

 National Maritime Union Collection, *57*

 New Yorkers at Work Collection, *35*

 Sam Reiss Collection, *33, 74, 77, 159, 166*

 Saul Mills Collection, *124*

 Schneiderman Collection, *95, 96, 102*

 Social Service Employees Union Collection, *83, 162*

 Transport Workers Union Collection, *133, 148*

Union Label Collection, *52, 119, 138, 165*

 United Federation of Teachers Collection, *7, 150, 154, 155*

 Utility Workers Local 1-2 Collection, *39*

Roberts, Lillian, 168, *168*

Robinson, Cleveland, *167*, 201, 202

Rockefeller, John D., *30*

Rockefeller, Nelson A., 31, 168, *168*, 201

Rome, Harold, *128*

Romney, Edgar, *182*

Roosevelt, Franklin D., 118, 126, *128, 136*

 blacks and, 138–39

 elected president, 198

 Hillman and, 137

Roth, Ed, 3, 4

Rubenstein, Harry, *65*, 69

Rubin, Jay, 112–14

Ruderman, Evan, *36*

Rudnick, Trudy, *177*

Russell, Rose, 7

Russian Labor Association, *94*

Rustin, Bayard, *139*, 202

Sacco, Nicola, 111, *111*

St. John's University, 202–3

Sanders, Dan, 156

sandhogs (tunnel workers), 14, *14*, 26, 27

Sanger, Margaret, 103

Santiago Iglesias Educational Society (IBEW, Local 3), 32, *157, 170*

Saunders, Lee, *187*

Schneiderman, Rose, *95*, 100–102, *102*

Schoichet, Gary, 8, *177, 186*

Schomburg Center for Research in Black Culture (New York Public Library), 24, *55, 117, 118*, 124

Schulberg, Budd, 151

segregation, 26

Selden, David, 154, *154*, 156

Service Employees' International Union (SEIU), 206

 Local 1199, 186

sewer construction workers, *19*

sex discrimination, 35, 67, 95, 97, 160

Shanker, Albert, 154–57, *155*

Sheepshead Bay (Brooklyn), 23

Shelley, Percy Bysshe, 115

Sherbell, Kenneth, 140

shipping industry, 57, 60–62, 75, 129, 132, 148, 11–52, 200

 banana boats and docks, 44, *44*

 containerization of, 75

 decline of, 43

 shape-ups in, *56, 57, 57*

Simkhovitch, Mary K., 200

Simonson, Rebecca, 154

sit-down strikes, 122, 123, 130

Sloan, John, 104

Small, Mel and Shirley, *51*

Smith, Alfred E., 28, 196

Soalt, Jerry, *80*

socialism, 105

Socialist Party, 120, 195

 Red Falcons of America (youth group) of, 121-22

Social Service Employees Union (SSEU), 162–63, *162*, 202

Solidarity Day (1981), *173*, 204

"Solidarity Forever" (song, Chaplin), 148–49

South Street Seaport Museum, 60

Soyer, Raphael, *59*, 60

Squibb Company, 76, *76*

stagehands, 58–59, *58*

Stamm, John, *188*

Standard Gaslight Company, 17

Stein, Kitty, 162

Stewart, Michael, 202

Store Workers, Local 1250, 123

Stouffer's restaurant, 67

strikes

 during 1945–46, 146

 Actors' Equity (1919), 106–7, *106*

 against AT&T (1947), *145*

 against *New York Daily News*, 176, *176*

 against WPA projects, 24

 of air traffic controllers, 172–73, *172*

strikes (continued)
 by cab drivers, 65
 by carpenters, 92
 in Chinatown, 183
 by federal employees, 169
 IBEW general strike (1941), 62
 ILGWU general strike (1909), 98
 by merchant seamen, 130–32
 Patterson (New Jersey) textile strike,
 104, 104
 sit-down strikes, 122, 123, 130
 by teachers, 154–56, 166, 166
 by transit workers, 163, 163
 at Waldorf Astoria Hotel (1934), 113
 by welfare workers, 162
Strout, Anna, 87
Strumer, Joan, 162
Stuyvesant Town (Manhattan), 160–61
subways, 14, 14
Sverdlove, Leon, 147, 148
sweatshops, 80, 189
Sweeney, Charlie, 26
Sweeney, John J., 182, 182, 191, 206
Szeliga, Loretta (Postek), 67

Taft, Robert, 146
Taft-Hartley (Labor Management Rela-
 tions) Act (U.S., 1947), 146–48, 201
Talbot, Harry, 27
Talentyre, Norman, 115
Tamiment Institute Library, 49, 92, 98,
 100, 104, 105, 107, 108, 111, 139,
 183, 195
 Elizabeth Gurley Flynn Collection, 94
 Greenwich House Collection, 45
 John Albok Collection, 134
 Liberation News Service Collec-
 tion, 79
 New York Child Labor Committee
 pamphlet, 47
 Roberta Bobba—Peter Martin Collec-
 tion, 111
Taylor, Ruth "Toby" Kessler, 160–61
Taylor Law (New York State; 1967), 155,
 163, 203

teachers, 74–75, 74, 150, 150, 154–57,
 154
 Ocean Hill-Brownsville controversy,
 166, 166
Teachers Guild, 154, 156–57
Teachers Union, 7, 150
telecommunications industry, see commu-
 nications industry
Theatrical Wardrobe Union, Local 764
 (IATSE), 82
Tiffany, Louis Comfort, 45
toy industry, 79, 79
transit workers, 28, 163, 163, 164
Transport Workers Union (TWU), 28,
 132–33, 133, 164
 bus strike of 1941 by, 200
 founding of predecessor of, 199
 under Quill, 164
 strike of 1966 by, 163, 202
Tresca, Carlo, 111, 200
Triangle Shirtwaist Factory Fire, 2,
 28, 48, 96, 100–101, 100, 101,
 196
Truman, Harry S, 146
Trumka, Rich, 182
tunnel workers, 5
Tunnel Workers, Local 147, 26
Tyler, Francine, 60
Tynan, Brandon, 106

unemployment, 54, 114–18, 120
Union of Needletrades, Industrial and
 Textile Employees (UNITE), 81, 179,
 182, 189, 206
Union Square (Manhattan), 93, 111, 115,
 121
United Auto Workers (UAW)
 District 65, 204
 Local 259, 78, 78
United Brotherhood of Carpenters and
 Joiners, 92
United Electrical, Radio and Machine
 Workers of America (UE), 175
United Farm Workers Organizing Com-
 mittee, 32

United Federation of College Teachers
 (UFCT), 202–3
United Federation of Teachers (UFT), 7,
 74, 154–57, 201–2
 Ocean Hill-Brownsville controversy
 and, 166, 166, 203
United Hebrew Trades, 194, 196
United Housing Foundation, 28, 33
United Mine Workers (UMW), 114, 179
United Public Workers, Local 1, 162
United Retail Employees, 199–200
United States
 federal employees of, 169, 169
 Great Depression construction pro-
 grams of, 22
 strike of air traffic controllers, 172–73,
 172
United Tailoresses of New York, 193
United Warehouse and Wholesale Work-
 ers Union, 140
university employees, 177
Upholsterer's Union, 112

Van Arsdale, Harry, Jr., 31, 31, 32, 114,
 157, 159, 202
Van Arsdale, Thomas, 157
Vanzetti, Bartolomeo, 111, 111
Vietnam War, 34, 167, 167
Vogel, Ruth, 29
Voice of America, 148–49

Wage Earners Suffrage League, 196
wages, Davis-Bacon Act on, 23
Wagner, Robert F., Sr., 28, 119, 120, 120,
 196, 198
Wagner, Robert F., Jr., 34, 153, 159
 "Little Wagner Act" of, 152, 201
 municipal employee unions and, 154
 Van Arsdale and, 31
waiters and waitresses, 66, 66, 67, 113
Waldorf Astoria Hotel, 66, 113
Walkowitz, Daniel J., 89
Warbasse Houses, 33
Water Tunnel #3, 37, 37

Weingarten, Randi, *187*
Weinstock, Louis, 120
Weissenstein, Heinz, *154*
welfare recipients, 85, *85*
welfare workers, 83, *83*, 162–63, *162*
White Rats Association, 195
Wilcox, Elizabeth, *73*
Williamsburg Bridge, *39*
Wire Cable Company (Brooklyn), *50*
women
 birth control movement of, 103, *103*
 as clerical workers, 177
 Coalition of Labor Union Women,
 174, *174*
 domestic work by, 44, *45*, 54, *55*
 as electricians, 35
 in hotel and restaurant industry, 67
 as secretaries, 64
Women in Apprenticeship Project, 35
Women's Trade Union League, 95, *95*,
 96, 101, 102, 195
Wong, Sau Kuen, *81*
Woolworth's (stores), 122, *123*, *160*
Workers Defense League, 34
working class, 2
Working Women's Society, 96
Workmen's Circle (Arbeiter Ring), 90,
 134, 194
Works Progress Administration (WPA),
 22, *23*, *24*, 199
arts projects under, 59–60
World Labor Athletic Carnival (1936),
 134
World War I veterans, 118
World War II, 60, 134–39, *138*, 200
Wo Sing Shirt Press, *46*
Wurf, Jerry, 168, *168*

Xavier Institute of Industrial Relations,
 36, 152

Zimmerman, Charles S., *5*
Zuckerman, Natalie, 28–29

About the Authors

Like many working New Yorkers, Debra E. Bernhardt and Rachel Bernstein are immigrants to the city. Debra hails from Iron River, a rust belt iron mining town in Michigan's Upper Peninsula; Rachel is from Los Angeles. Both grew up in labor culture. Debra's parents were unionized high school teachers, and her uncles were iron miners and members of the Steelworkers. Rachel is the daughter of a labor journalist father and a mother who worked as an organizer for the CIO's Operation Dixie, a brave attempt to organize the South in the early 1950s. Both earned Ph.D.s in labor history and have been teaching, researching, documenting, and writing about the history and culture of labor in their adopted and beloved city for two decades. Rachel teaches in NYU's Public History Program and has been working with Debra on public labor history projects since 1983. Debra began working at the Robert F. Wagner Labor Archives in 1979, two years after its founding. She currently heads the Archives. Her most recent success was leading a campaign designating Union Square as a national historic landmark.

Debra lives in Brooklyn, Rachel in Croton-on-Hudson, each with two wonderful children and an absolutely one-of-a-kind husband.

We have relied upon many New Yorkers in writing this book, represented here by George Andrucki, Sheetmetal Workers Local 28:

"Young workers have to learn about the labor movement. There's a lot that has to be taught to them. I learned it in school. I learned it in the shanty. I learned it in the shop. I learned it through experience. I learned it through listening down at the union meetings when I was young. The guys that got up and spoke on the floor were good. They were articulate, you know? They could explain things. The next generation got to be helped to understand. Education and idea sharing has to take place. How else can you reach a consensus to know this is the right path for us to go down? I mean, we're heading for 2000. All the doors have got to be open."

Please visit the *Ordinary People, Extraordinary Lives*
companion web site, featuring photos, audio clips,
and links to online resources:
http://www.nyupress.nyu.edu/labor